Restaurants, Catering and Facility Rentals

Restaurants, Catering and Facility Rentals

Arthur M Manask
with Robert D Schwartz

MUSEUMSETC | EDINBURGH & BOSTON

Foreword

DARRELL R WILLSON
Administrator
National Gallery of Art
Washington, DC

Cultural institutions (museums, aquariums, zoos, botanic gardens, and historic homes) reflect the collective generosity, gifts and talents of past and present-day individuals from around the globe, many of whom have dedicated their lives and careers to ensuring that the standards of excellence that have come to define modern museums and cultural institutions are neither diminished nor compromised.

For cultural institution visitors, the experience – the sense of enjoyment – comes not only from gazing upon an art object and the collection, nor just from participating in an educational presentation, nor even just from witnessing a live concert or animal presentation that helps to interpret and enliven what's been seen or read about. Rather, the overall, lasting impression visitors come away with is an amalgamation of all these inputs, especially the impression they are left with after dining in a cultural institution's restaurants, cafés, snack bars, stands or carts or partaking of an on-site catered special event.

Today, and even more so looking forward, museums and other cultural institutions must not only strive to acquire and display premier collections, they must also earnestly endeavor

to attain the same level of quality in all their foodservice operations and services. During a typical day at a cultural institution, visitors may spend several hours viewing top-quality exhibits, special exhibitions and/or live animal collections, like the pandas at the National Zoo. A pause for lunch or refreshments at one of the institution's dining options, should, ideally, serve as a no less pleasant respite. Given this expectation, it is truly essential that by their quality, variety and service, cultural institutions' dining options provide as much satisfaction, wonder, creativity, innovation and joy as visitors have experienced after viewing the exhibits and collection themselves.

Generally speaking, administrators at all types of cultural institutions face considerable competition for the resources necessary for daily operations, including collection management, exhibition, acquisitions, and educational, security and facilities programs. Nonetheless, it is increasingly important today that the revenue (earned income) that can be generated by a well-defined and successful foodservice, dining and special events program will contribute significantly to annual earned income available to underwrite and even expand cultural institutions' core activities. Correctly administered

cultural institutions' dining, restaurants, facility rentals, special events and catering services help create an enjoyable and memorable experience for visitors. They also generate goodwill and publicity, enhancing an institution's overall stature and importance in both the local and broader community.

I believe that all of us who administer guest services in cultural institutions should study the contents of this book, as it can help us improve the quality of our current dining and foodservices, enhance earned income, correct current short-comings and successfully introduce new facilities and services. I commend author Arthur M. Manask and co-author Robert D. Schwartz for providing another long-needed reference work that can help administrators overseeing restaurants, special events and catering at cultural institutions perform our jobs to our full potential.

Contents

This book is for instructional purposes only and is based upon examples of a cross-section of studies for the purpose of presenting direction for foodservice, catering and facility rental operations in cultural institutions. The studies in this book are intended to walk the reader through process and methodology to help educate by illustrating cultural institution issues and challenges and the path/roadmap towards solutions. As one gains experience in foodservice, catering and facility rental operations for museums, zoos, aquariums, botanic gardens, galleries and cultural institutions, one quickly learns that every facility is unique and presents its own specialized set of circumstances and challenges. While the analysis and proposed actions discussed in this book will serve as solid and dependable road maps, it is imperative for readers to remember that these studies and recommendations are intended to be general in nature and are not across-the-board real-time evaluations or solutions for all institutions. Organizations must initiate comprehensive studies and evaluation based on their own unique and individual circumstances, on a case-by-case basis, to develop successful foodservice, catering and facility rental strategies, operations and services for their museums, zoos, aquariums, botanic gardens, galleries, and other cultural institutions.

ESSAYS

Introduction and
Acknowledgements

This is a book that will be very helpful to museum and cultural institution administrators, staff and professionals that have operational or contractual oversight of the institution's restaurant, café, catering, venue or facility rentals. It includes examples of a range of studies based on scenarios and challenges we have most frequently encountered as museums and cultural institutions strive to manage efficient and profitable catering, dining and facility rental services. In order to maintain the anonymity of the institutions on which these studies are based, names, locations and other details have been changed. The principles, practices and conclusions, however, remain unchanged.

The studies are supplemented by informative essays from *The Manask Report*, a highly-regarded publication about how to increase earned income in these areas. The book also includes a comprehensive Glossary of terms used in the foodservice, catering, facility rental and dining world. This will enable you to better communicate with your restaurant or catering manager or operator in terms both they and you will understand.

Restaurant, foodservice operators and caterers that want to enter the cultural institution market or enhance and improve their techniques, services

and relationships will also find this book very useful and informative in understanding the distinctive operating environment of a cultural institution.

I started my career in the foodservice industry working for my father and (among others) opening and operating the J. Paul Getty Museum Tea Room in Malibu, California and the Plaza Café at the Los Angeles County Museum of Art when that museum originally opened. I also owned and operated a catering company long ago and frequently provided catering services within many cultural institutions from Santa Barbara to San Diego, California.

This book you are about to read celebrates our 20th year providing consulting services to museums, zoos, aquariums, botanic gardens and historic homes. I am very proud of our accomplishments and of our outstanding team of consultants and staff, many of whom have been working with us a good portion of this 20-year period.

I would like to thank the college student that found me through the internet about fifteen years ago and said, "I am doing a thesis on museum dining, searched high and low at our university library and online and found no publications or reference works whatsoever." That was my initial motivation to publish the first (and at the time only) book on foodservice in cultural

institutions about ten years ago.

A special thank you and gratitude to Woody Spivey, retired Deputy Director at the Phoenix Art Museum and past president of the Western Museum Association, my first cultural institution client who said, "Art, it is fabulous to know there are restaurant consultants like you to help us in the museum community. I didn't know a resource like you was out there, you should get more involved in our industry and spread the word." A thank you also to Ray Coen, the great marketing consultant to CEOs that provided his mentoring and guidance and has become a great friend for many years. We miss Warren Iliff, former CEO of Aquarium of the Pacific who left us all too young and was a mentor and promoter of our services in the zoo and aquarium world. And, last but not least, an important acknowledgement to the wonderful team that supports our clients and consultants: Susan Babcock Manask, Catherine V. Lorrimer, Krosheska Arias; and to the very best earned income cultural institution consultants in the industry: Don Avalier, Robert Schwartz, Joan Doyle, Marjorie Sheldon and Shelley Stephens.

Arthur M. Manask, FCSI
Co-Author

STUDIES

Restaurant Georges, Pompidou Centre, Paris

1

Boosting Rental and Foodservice Earned Income

The following report was prepared for a US regional museum with a variety of exhibits and themes. There are several hundred thousand visitors a year, mainly adults and families, and little seasonality – there's a steady year-round attendance. The organization has had a long-term contract relationship with the operator of the Museum Café. The café is doing all right and the operator is well-liked and respected by the museum staff and guests. However, the operation is getting tired, repetitive and in need of new life. The museum asked for an objective review of the café, the contract with the operator, and the possible changes needed to elevate both the visitor experience and the café.

This same operator also provides the on-site catering for facility rental customers. Facility rentals are active, but the museum does not have an understanding of whether the facility rental business and related catering is profitable after taking into account the museum staff costs – and hassles. The museum wants to better understand if the facility rental business can grow and what the potential income could be.

National Gallery of Ireland, Dublin

Facility rentals and catering services evaluation

Facility rentals, separate from membership and traditional fundraising, is of increasing importance in the museum world today. This increase in the importance of facility rentals can be attributed in part to an ongoing public demand for attractive cultural institution environments for staging events. But it must also be noted that the cultural institution industry itself has come to recognize the importance of facility rental income (and income/commissions from food and beverage catering) as an important source of additional earned income. How is the museum positioned to accommodate this demand for facility rentals today and in the future? Are the rental venues priced appropriately? Is the Special Events Department staffed and equipped adequately for future growth? What are the local market's pricing and policies? What is the museum's potential earned income from this department? How is the museum perceived by prospective users?

Historical activity

We reviewed historical financial data provided by the museum. This shows that the net proceeds from Special Events rental activity has shown a gross profit after accounting for the dedicated staff costs.

However, this gross profit calculation does not include cost for facility set up, tear down, security or any other incremental costs associated with facility rentals. This data was not readily available. Figure 1 shows a summary of the facility rental activity for Year 1 and Year 2 and projected income for Year 3.

	Year 1	Year 2	Year 3
Facility Rental Income	$ 180,944	$ 133,241	$ 236,987
Staff Salaries, Tax & Benefits	$ 101,433	$ 98,078	$ 121,706
Gross Profit	**$ 79,511**	**$ 35,163**	**$ 115,281**

Figure 1: Facility rental income

We also evaluated the sales mix and noted that, while most cultural institutions have reported a significant drop in corporate rental activity, this segment remains strong for the museum with 34% of events as shown at Figure 2.

This also shows us that proms are an active and profitable market for the museum. These typically are turnkey events that come complete with event planners, catering, chaperons, etc.; and would require very little of the museum staff.

We observed very little wedding activity, only one from Year 1 to Year 3. This is typically a strong market for venues like museums and tends to be recession-proof. The museum has perfect spaces for weddings of all sizes and should consider expanding this potential.

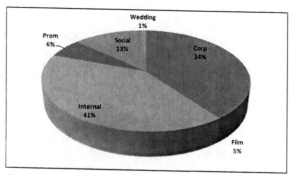

Figure 2: Special event by type, Years 1 - 3

Finally, the demand trends show us that the museum, like most other institutions, has peaks and valleys of activity, both by day of the week and by month of the year. This information is important to note as, currently, the museum does not differentiate facility rental pricing by day-of-week or time-of-year. As we have learned from hotels, airlines, resorts and other venues subject to cyclical demand, pricing strategies should be customized to take advantage of higher demand periods with higher prices, and attract business to lower demand periods with lower prices. This is illustrated at Figure 3.

This shows us that the facilities are in relatively high demand on Wednesdays and Saturdays. Fridays are in low demand, which is unique to the museum's geographic area and explained by high volume of late afternoon/evening

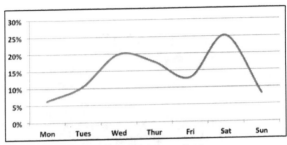

Figure 3: Special events by day of the week, Year 1 - Year 3

traffic with prospective facility rental users avoiding this day and time of day. This information allows us to recommend increased facility rental pricing for Wednesday, Thursday and Saturday and lower pricing for Sunday, Monday, Tuesday and Fridays.

This same type of analysis gives us an insight to seasonal demand or by month (see Figure 4). This illustrates the seasonality of demand which peaks in May, June and August; with low demand in July, October, November and even December (normally December is high in demand for holiday parties at most cultural institutions). The peak in April through June reflects prom activities. This also reflects the slowdown in Year 2 that was typical of many cultural institutions across the country as a reflection of the recession and slow recovery in Year 3.

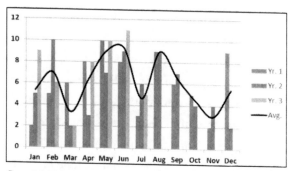

Figure 4: Special events by month, Year 1 - Year 3

Benchmarking data

We helped museum staff to develop a benchmarking tool used to collect key data from other cultural institutions in the museum's geographic market relative to Special Events. This included facility rental pricing, rental policies and catering arrangements. The museum sent the form out to ten institutions and received six responses. We had some similar data from previous studies in the museum's geographic market and supplemented this information for a more complete and museum-specific comparison.

Key observations from this data include:

- Museum facility rental prices are below market, an overall average of 71% of competitor pricing (refer to the chart in the Exhibits). This allows the museum to consider increasing rental pricing and still

remain competitive. While impossible to compare pricing on an "apples-to-apples" basis, we matched up similar-style venues of comparable size, and indoor and outdoor spaces, to achieve this calculation. This is how potential events hosts would view and compare the museum to the market (note – this comparison does not include hotels or banquet halls. Cultural institutions cannot compete, price to price, with these types of operations which do not charge room rentals and are set up to service only these types of events. We believe that the potential customer for facility rentals and special events at the museum is looking for the unique experience that is only found in cultural institutions; and is willing to pay for it.) This is shown by venue at Figure 5 (for more detailed results see the benchmarking study in the Exhibits section).

- Most competitive institutions in the geographic area of this museum allow personal/religious celebrations.
- All competitive institutions with few exceptions in the museum's area use exclusive caterers and receive some form of compensation from catering revenues.

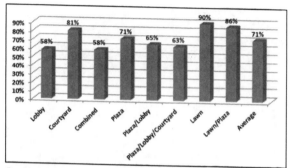

Figure 5: Museum facility rental pricing relative to market area

- A few museums in the geographic area require membership to rent facilities. One museum requires $10,000 corporate membership (no personal events allowed); and another museum includes the membership cost of $2,500 in their facility rental prices.
- Exclusive caterers own the liquor licenses.
- Exclusive caterers offer between 10%-30% discount for internal (museum-sponsored) catering.

Special Events Department structure and activities

The museum Special Events Department structure has three full-time and one part-time employee (shared with the Membership Department). However, two of these positions are dedicated to two annual events, the *Directors* and the *Festival*. This leaves only

Science Museum of Minnesota, Minnesota, USA

one full-time and the part-time position to focus on all other facility rentals and internal events.

The current staffing is adequate to handle the current level of rental activity; including not only the sale of the event (multiple phone calls, tours, staffing details, event set up details) but also being present at the event. This leaves little time for sales development or seeking business in targeted markets.

Currently, no one really "owns" the departmental financial results. There are various official and unofficial reports tracking various aspects of the facility rental business. Yet at month end, the actual accounting happens without any one person scrutinizing the revenues, costs and performance to budget.

At one time, a simple in-house profit and loss form (Excel-based) was used to calculate and track the profitability for each event. This included the rental fee income, operator commissions from catering, allocated cost for housekeeping, security and any unique costs for rentals, equipment, etc. Although the cost section of this reporting has been abandoned in recent years, it would be worthwhile to reactivate this basic in-house report as an effective tool used to monitor the real income to the museum from these functions.

We learned from interviews that multiple persons/ departments are working directly with the operator for their internal catering needs rather than going through the Special Events Department. While this may seem efficient in some ways, it can create inconsistencies in pricing and service levels and prove frustrating to the operator.

Self-catering (*Costco catering*) is not clearly defined and appears to be growing and out-of-control. Usually, this is limited to small staff meetings, birthday celebrations, pot luck events for the staff, etc.; but should not be allowed for events including the public or members. It is important to present a consistent image at all events that include public attendees. You never know who is in the group and may be considering the museum for a future event.

Facility rental marketing

Marketing of facility rental spaces by the museum is very limited. There is virtually no budget assigned to this purpose, leaving the Special Events Department to seek low/no cost initiatives to get the message out that the museum has wonderful event spaces available.

These efforts include:
- Getting short focused messages on the

marketing department email blasts
- A corner spot in quarterly mailings
- Memberships with local Chambers of Commerce
- Membership with local convention and visitors bureau
- Listing on BizBash (web based event planning site)

The museum website offers an easy-to-find link to event planning and the information provided is good. A nice picture of the spaces and basic information about capacities is offered, but no price information is included. There is an interactive form to fill out to get this information; but in today's internet world, many do not want to fill out forms, wait for calls or return emails to find out that the price range exceeds their budget. Many institutions are offering basic price ranges on their websites for facility rentals with a disclaimer "subject to final event details..."

The Special Events Department would like to update printed brochures and other marketing collateral materials. The in-house marketing department has the talent and capability to produce these materials, as well as video clips, but does not have the budget to dedicate to these efforts. The need

for upgraded materials is evident when you compare the museum's wedding materials currently in use with those of the competition.

There is opportunity to increase the awareness of the museum visitor that facility rental availabilities exist; through the use of banners, café table tents, inserts with admission tickets and maps.

Distinct advantages that the museum offers over many cultural venues in its geographic area are:

- Free, ample parking
- Freeway convenient
- Liberal event policies – allowing personal celebrations, weddings, religious events, proms, grad nights, reunions that many institutions do not accommodate.
- Space flexibility for indoor and outdoor events, both large and small
- Day and evening use
- Ability to do multiple events on the same day and time.

We noted that birthday parties, which were done at one time, are not advertised or encouraged. Occasionally, a birthday party may be booked, but the birthday package has not been offered at the museum. We are familiar with family-orientated cultural

institutions that are very aggressive with this market which can represent well over six figure income to the institution. These typically are children, science or zoo type institutions; but it would appear to us that the museum has a unique attraction that would make for a popular birthday party destination. This would include the *mining* activity in the atrium/courtyard and use of the classrooms. The beauty of birthday parties is that they can be scheduled when the education department does not have high demand for these facilities: weekends, holidays and summers. In the museum's geographic market, prices for a two hour birthday party range from $450 to $750.

Council Members, individuals who have donated a minimum of $15,000, are offered a free facility rental. However, it is not clearly defined as to when the space can be used or related catering costs. This offer should be defined to include information such as what space(s) are available, how far in advance space should be reserved, minimum food and beverage catering, etc.

Trustees, individuals who have donated a minimum of $10,000, are not currently offered a similar free event rental unless their donation level also qualifies them as a higher donor level member. However, many exceptions are granted for

discounted/free rentals as "negotiated" by the trustee. This can create opportunity for inconsistencies and the appearance of favoritism of one trustee over another. Trustees are predisposed to be active fans and users of the museum and should be encouraged to use it for their special events; but a defined policy covering this area is needed.

Interviews with staff revealed an image and public perception challenge for the museum. Potential customers may not consider investigating the rental facilities if they perceive the museum to be something different than it really is. It would appear important to investigate this perception, and if it is prevalent, create a marketing campaign to redefine the museum and the wonderful venues available there for all markets inside and outside, from sophisticated to casual.

Competing uses

We noted some internal conflict relative to competing uses by the various departments and groups within the museum. We deliberately label these as "competing uses" as we do not offer any recommendation of which use is more important or correct, simply that there are competing interests for the same spaces on the same dates.

These competing uses include Education Programming, Member events and other internal events. When these events are scheduled, these spaces are removed from the facility rental market. This is a typical conflict found in almost all museums we have worked with and there is no easy answer. Mission and mission-driven events are *raison d'être* but rely on operating income that is generated by Special Events and Facility Rentals. We observed that the vast majority of these issues are worked out amicably between the competing interests and do not require senior management intervention to resolve.

Recommendations: facility rentals
Facility rental pricing
With current pricing in place 10+ years and below the museum's geographic cultural institution market, there is an opportunity to increase pricing. We recommend adding a two-tiered pricing strategy that takes advantage of the higher demand periods. To this end, we recommend increasing facility rental pricing by approximately 10% for rentals on Wednesdays, Thursdays and Saturdays only. Leave the current pricing for the remaining days of the week. This would take the museum up to 79% of its geographic market for these days.

Venue	Current Pricing All Days		Suggested Pricing Sun/Mon/Tues/Fri		Suggested Pricing Wed/Thur/Sat		Apr/May/June Wed/Thur/Sat	
	1-400	400+	1-400	400+	1-400	400+	1-400	400+
Lobby	$ 2,500		$ 2,500		$ 2,750		$ 3,000	
Courtyard	$ 4,000		$ 4,000		$ 4,500	$.	$ 5,000	$.
Combined	$ 5,000	$ 6,000	$ 5,000	$ 6,000	$ 5,500	$ 6,600	$ 6,000	$ 7,250
Plaza	$ 5,000	$ 6,000	$ 5,000	$ 6,000	$ 5,500	$ 6,600	$ 6,000	$ 7,250
Plaza/Lobby	$ 6,000	$ 7,250	$ 6,000	$ 7,250	$ 6,600	$ 8,000	$ 7,500	$ 9,000
Plaza/Lobby/Courtyard	$ 7,000	$ 8,500	$ 7,000	$ 8,500	$ 7,700	$ 9,500	$ 8,500	$10,500
Lawn	$ 4,500	$ 5,500	$ 4,500	$ 5,500	$ 5,000	$ 6,000	$ 5,500	$ 6,500
Lawn/Plaza	$ 8,500	$ 9,500	$ 8,500	$ 9,500	$ 9,500	$10,500	$10,500	$11,500
Entire Museum	$12,500	$15,000	$12,500	$15,000	$13,750	$16,500	$15,000	$18,000
% of Market	71%		71%		79%		87%	

Figure 6: Museum facility rental pricing strategy

In addition to adding the second tier for the more popular days of the week, we also recommend increasing the facility rental pricing by another 10% for Wednesdays, Thursdays, and Saturdays in the higher demand months of April, May and June. These higher prices would take the museum to 87% of its geographic market as shown in the benchmarking data (for more detailed results see exhibit section).

Figure 6 shows the new recommended prices for these periods.

Approved catering list

The current "preferred" catering arrangement with the operator may be a deterrent to facility rental activity. While feedback regarding the operator has been mostly positive from museum staff, we have found that there is an increasing desire with the customer base to have a choice of caterers, styles of cuisine and price points. In the museum's

geographic area the operator would be considered a middle-market caterer, not the most or least creative or the highest or lowest cost. While the current policy does allow the customer to "buy out" the operator based on a sliding scale starting at $800 for up to 250 guests, 251 to 800 guests is $1,200 and a $2,000 fee if more than 800 guests for food (the operator owns the alcoholic beverage license and is the exclusive alcoholic beverage operator even when there is a third-party food operator) in order to use their own operator; this is often discouraged by museum staff and is rarely done.

We recommend expanding the "approved" list of caterers to a total of three. Select additional caterers that will position the operator in the middle of price and service style. The operator can still be featured as the preferred caterer on the website and marketing collateral, but the other two caterers, one with higher price points and service style and one with lower BBQ-style service and prices, can be offered as the alternatives. The operator would still do all of the alcohol service, regardless of the caterer chosen. We believe this would help to drive more facility rental business, increasing facility rental income and commissions from all caterers. Even if sharing with two other caterers, the operator would

likely maintain or improve their overall revenues and profits. Given that the operator is on-site and does all food preparation at the museum, this provides the operator a price/cost advantage over any other caterer that is preparing food in a kitchen elsewhere and bringing it to the museum.

Additional incentives can be built into the contracts with these caterers for business they bring to the museum. Currently, the operator pays 12% of catered food sales and 20% of alcohol sales in commissions to the museum. Incentives can include either reducing these percentages on business brought in by the caterer, or sharing in the rental fee collected for the event or some combination of the two methods. As this is truly incremental business that might not have come to the museum without the caterer arrangement, there is no real downside to this strategy.

A catering program with multiple caterers will also increase sales/marketing for the museum with the caterer's sales staff, websites, advertising, marketing and promotion; as compared to the current program which is limited to the operator who does very little promotion in any of these areas.

Special Events Department staffing
If, with the above strategies, the facility rental

business increases as expected, the Special Events Staff to support this growth will need to increase as well. We expect that at minimum, two full time positions (vs. the one position of today) will be required to handle inquiries, tours, event planning and staffing as well as a supervisory presence at each event. We will assume the addition of another position in the financial projections.

The Special Events Department staff should have better knowledge of the ongoing finances of the department as compared to budget and prior year activity. There should be a unique departmental report capturing all revenues and expenses as compared to budget and prior year. In addition, the Special Events Department should return to completing the Event Profitability Excel (an in-house P&L) report that was developed a number of years ago. This report offers good insight into the profitability of each event and includes overhead staffing costs for housekeeping, security, facilities, etc.

The Special Events Department will benefit from improved office systems including an event management system to aid in venue management and scheduling, invoicing and coordination of resources. There are many packages available in the market and can range in cost from $1,300 to $10,000; plus annual

maintenance fees. Some of those available include but are not limited to:

- Event Management Systems – Dale Evans Associates – www.dea.com
- RESS Room & Events Scheduling Software – www.ress-by-ims.com
- Netsimplicity – www.netsimplicity.com

Facility marketability

In addition to improving the marketing collateral materials, website presence and information; the museum will need to focus their marketing message on the variety, flexibility, sizes and uniqueness of their rental venues. This, in addition to their free, ample parking and ease of access, make the museum a desirable destination.

The Special Events Department should organize, and co-host with the approved caterers, "sales receptions" for local event planners, corporate meeting planners and targeted customers to tour the museum facilities, see and taste the product and increase their familiarity with the museum. Costs of these events should be shared with local vendors donating product and services to raise awareness of their presence in the market and desire to service this venue in particular.

If seeking to expand the wedding market and opportunity at the museum, joining wedding websites like The Knot will help to provide exposure for the museum in the market. Also, if expanding the wedding market, it is most helpful to require wedding rental customers to hire an independent Wedding Planner to take the burden off the limited museum staff. A preferred list of planners could be established so they know the museum facilities, policies, capacities, etc.

High level donors, trustees and members
As discussed above, both these groups offer tremendous assistance to the museum with their financial support and time. There is no official guide to offering facility rental incentives to them, or how to make it fair and manageable. We have seen other institutions use a matrix of facility rental options that helps to address this issue. Figure 7 is an example and should be modified as appropriate to the situation.

In addition to facility rental incentives, certain food and beverage minimums should be put in place for each type of event to make sure that a prime space does not get taken off the market for only "coffee and cake". This is usually $10,000 to $20,000 in other similar institutions.

Museum Partner Level	Facility Rental Incentive	Definitions
Members	10% discount off "A" Venue 20% discount off "B" Venue	"A" Venues are defined as: I. Weekend / Holiday season rentals of any facility II. Courtyard – anytime
Trustees	40% discount off "A" Venue 50% discount off "B" Venue	
High Level Donors	50% discount off "A" Venue 1 free use of "B" Venue	"B" Venues are defined as:
		A. Monday – Thursday, non-holiday season rentals

Figure 7: Museum facility rental incentives

Birthday parties

Birthday parties are a popular attraction for many cultural institutions, especially family orientated institutions like the museum. It offers an opportunity to expand mission related programming and create an income source at the same time.

In recent years, the museum did not actively promote birthday parties. If the museum decides to actively pursue this market, the promotion needs to be designed and developed with resources and staffing in place. The following considerations need to be addressed.

Dedicated space is required. We believe that the Education classrooms could be used for this purpose. The space would need to be redecorated to be more "festive".

Dedicated staffing is required. Hire dedicated staff to supervise the parties. It is assumed that parties would be scheduled on weekends during the school year and every day during the summer. Parties can be scheduled every 2 hours with a 30-minute gap

between parties for cleaning. This schedule would allow up to 4 parties per day.

Hire dedicated part time staff (perhaps college students) to work these parties; and do not expect Special Events Department or Education staff to handle these events.

Pricing will vary, but we noted that the nearby children's museum charges from $460 to $700 for a 2-hour party rental (not including food which is a $250 minimum, or $12.50/person). Another local museum's price is $600 for members and $675 for non-members; which includes 20 kids and 10 adults, admission to museum, activities, 10% discount in store and is a competitive price in the local market.

The most successful birthday party programs make it easy to find and book. The birthday party venue should be featured on the front pages of the website with a direct link to check dates and prices. At the same time, we do not want to occupy the Special Events Department staff with fielding calls about these relatively straight forward rental events. We recommend adding a website program that ties into the museum website (with a link) and can help to manage the birthday party reservations. Some examples of this type of service include but are not limited to:

- Partywirks – www.partywirks.com/who
- Party Center Software: www.partycentersoftware.com/features.html

These systems work on parameters and rules, rates, dates that the museum will establish; the system does the rest, including collecting the fees! This is a must for a successful program as it will free up your staff to deal with more lucrative opportunities and it serves the birthday planning customer (mom) better by allowing off hours access to your information and booking.

Income potential can total $135,000 (3 events @ $600 each / day for 75 days per year). These revenues are included in future projections noted below.

Catering packages can be established and offered as options with the birthday room package. This typically includes pizza, hot dogs, ice cream and can be offered by one of the approved caterers or the in-house café operator. We recommend not allowing carry-in food (other than the birthday cake) by the host of the party.

Housekeeping will be an issue with the Birthday Party program. This would typically fall on the staff hired to supervise the parties and would require cleaning tables, organizing chairs, sweeping/

Museum Earned Income - Conservative Projections						
Function Rentals	Current	Year 1	Year 2	Year 3	Year 4	Year 5
Net Rental Income	$ 237,000	$ 282,506	$ 368,063	$ 469,609	$ 456,446	$ 481,065
Special Event Dept. O.H. Expenses	$ (122,000)	$ (169,500)	$ (201,480)	$ (209,719)	$ (218,108)	$ (226,832)
Catering Income / Commissions	$ -	$ 48,499	$ 60,904	$ 79,739	$ 78,480	$ 85,810
Total Earned Income	$ 115,000	$ 161,505	$ 227,486	$ 339,628	$ 316,818	$ 340,043

Museum Earned Income - Mid Range Projections						
Function Rentals	Current	Year 1	Year 2	Year 3	Year 4	Year 5
Net Rental Income	$ 237,000	$ 325,650	$ 418,763	$ 525,769	$ 521,479	$ 540,248
Special Event Dept. O.H. Expenses	$ (122,000)	$ (194,500)	$ (202,480)	$ (210,759)	$ (219,190)	$ (227,957)
Catering Income / Commissions	$ -	$ 52,549	$ 73,245	$ 93,166	$ 96,292	$ 103,702
Total Earned Income	$ 115,000	$ 183,699	$ 289,527	$ 408,175	$ 398,582	$ 415,992

Museum Earned Income - Optimistic Projections						
Function Rentals	Current	Year 1	Year 2	Year 3	Year 4	Year 5
Net Rental Income	$ 237,000	$ 409,159	$ 454,496	$ 548,779	$ 560,576	$ 563,258
Special Event Dept. O.H. Expenses	$ (122,000)	$ (219,500)	$ (226,480)	$ (235,719)	$ (245,148)	$ (254,954)
Catering Income / Commissions	$ -	$ 67,061	$ 82,248	$ 98,501	$ 105,660	$ 109,361
Total Earned Income	$ 115,000	$ 256,720	$ 310,264	$ 411,560	$ 421,088	$ 417,665

Figure 8: Museum earned income - conservative projections

vacuuming carpets and removing trash between each event. More thorough cleaning can be scheduled with the normal cleaning crew at night.

Earned income projections

With implementation of the above recommendations relative to staffing, pricing, advertising and promotions, we have prepared a range of revenue projections over a five year period with conservative, mid-range and optimistic assumptions (Figure 8). These projections are based on historical trends, new prices and number of facility rentals as detailed in the Financial Exhibit. This form can be used by the museum (in Excel) to adjust assumptions up or down as conditions change and can be used as a budget analysis tool.

Assumptions for the above projections

- Implement recommended pricing strategies by day of week, month of year. This includes 10% increase for Wednesday, Thursday and Saturdays and an additional 10% increase for these days in April, May and June.
- Add an additional dedicated"staffing position to allow for more sales development and event support with growth.

- Implement multiple approved caterer program.
- Assume additional income related to (see appendix for detailed data) Film Events – 5 to 8 per year; Proms – 5 to 8 per year; Birthday Parties – 50 to 75 per year.
- Commissions range from 12% for food to 20% for alcohol (equals current commission rates paid by the operator).

Visitor foodservice and operator evaluation

The operator and the museum relationship

All museum interviewees are very fond of the operator and respect its commitment to, and ongoing support of, the museum. The operator is passionate about the museum and really enjoys being there.

The museum does not know if the operator is a financially viable company. It has been said that the operator has a successful business and, therefore, the operator's motivation to be at the museum is not financial. As of the date of our on-site visit, the operator's 2010 payments to the museum were in arrears.

The operator would like to give up its off-premise catering business for full-time foodservice exclusively at the museum. The operator is meeting with their accountant to see what financial steps it must take to reach this goal.

The operator has limited industry knowledge of similar museum cafés and operations in the museum's geographic area that are more current, up to date and cutting edge. The operator asked for input from us as to which other museum cafés to visit in order to see the most current industry trends; and we provided several local suggestions.

The operator has expressed the desire to convert

the café to reusable ware (eliminate disposable ware), and to make changes/upgrades and improvements in the café. The operator also says that it is very committed to the environment and sustainable practices.

The operator who is also the caterer at the museum is very cooperative in providing museum internal catering services within the limited museum budget.

The operator is not perceived as a cutting-edge caterer in the museum's area; "good", but not one of the most creative, innovative or imaginative.

Museum department: The operator is not treated as a museum department, not fully integrated at the museum; and the operator is not treated as a museum department head would be treated.

Museum marketing: Historically there is very limited museum marketing support for café (and rentals). This includes a lack of signage in/around the museum parking lot and property.

Operator marketing/advertising: Very little is being done by the operator to advertise, market and promote its services at the museum. The museum website's information is very limited; there is no menu and the pictures are not attractive or inviting. There is nothing on the operator's website about the museum.

Contract and financial terms

The current operator contract is for exclusive café and non-exclusive catering services.

The dollar amount of catering buy-out for a facility rental customer to use their own food caterer is not material; and should not negatively impact the museum's ability to do increased facility rentals with rental customers using other caterers.

The current contract document is not detailed and far from consistent with industry standards for cultural institutions that outsource visitor foodservice and catering. The contract is not in the museum's and the operator's best mutual interest as written. Following are areas/examples of parts of the relationship with the museum and their operator that are not documented and/or areas that are not part of the current relationship that should be documented to fall within industry standards:

- No definition of Gross Revenue
- Not clear on when buy-out for catering applies
- Internal catering for staff meetings, etc.
- Off premise catering; reporting and commission payment
- Lacking definition of many terms
- Basis for pricing museum events

- Detailed reporting and POS requirements to museum (customer counts, average check, etc.)
- Seasonal menu changes in all areas
- Food safety/sanitation
- Customer/guest satisfaction (surveys, mystery shopping, etc.)
- Advertising, marketing and promotion of café and catering/rental business; normally % of sales commitment
- Normally % of sales commitment to Repair & Replacement fund for museum FF&E
- Pest control
- Capital investment
- Sustainability standards and expectations

Given the type of contract (non-exclusive catering and no capital investment) and current rate of gross revenue for café and all catering services currently running at about $1 million annual sales rate; the percentage of gross revenue (depending on how gross revenue is defined) is competitive and may be a little high as compared with what the museum could expect to get in the market. Based on the $1 million total sales with about two-thirds coming from catering, and with no operator capital investment; in today's

market you might see a café commission rate at 6%-8% and catering (external) commission rate about 12%-15% (blended, food and alcoholic beverages) based on other similar sized cultural institutions we are aware of in the museum's geographic area.

Café

The Café is over 20 years old. It opens to the public before the museum opens, and closes about 30-minutes after the museum closes. Café opens before the museum because café does get some general public patronage.

Unlike most museums, there is ample and almost unlimited café seating/dining space. Considering the potential for gaining additional seats by expanding the outside dining seating areas; the only limitation on the café volume is the café serving method.

The museum has talked about major renovation, including café redesign (to put kitchen where dining area is and dining area where kitchen is) as part of an overall museum renovation in about 5-6 years.

Refrigeration (freezer) storage is limited; and there is storage on the floor in these areas, due to lack of space; storage that is not health department approved.

Dry/catering storage is limited and inefficient as

currently handled in the loading area outside the back of the café, and in the back-of-house spaces inside the café.

Currently 100% disposable service ware is used in the café.

Café has never had any well-known or prominent identity/brand; just a reputation as an okay/good place to eat.

No details were available on estimated percentage participation from: visitors and museum staff/volunteers. Therefore, there is no way to quantify the impact of 50 museum staff moving away in 2-3 years, other than assuming it would have material negative impact on daily (Monday through Friday) café revenues.

The café look and atmosphere are old, tired and institutional.

Serving area equipment is old, dated and does not provide the operator ability to merchandise food/beverages based on up-to-date similar museum cafés/restaurants.

Method of café service (line and self-service), based on visitor demographic, is not current and up to date.

Menus do not change often enough, and menu items do not change seasonally, to meet needs of

staff, volunteers, zoo staff/volunteers, general public (not museum visitors) and museum members to encourage frequent repeat visits from these customers.

Some menu items posted on the café menu boards are not available. Menu boards are not updated frequently and not readily changeable due to permanent nature of signage.

Menu prices are competitive with similar cultural institutions in the museum's geographic area for like items.

The operator is missing or not taking full advantage of café opportunities for museum special events, evenings, Mother's Day, etc. by not knowing and understanding industry best practices; and not executing events in a way that will meet or exceed the customer's expectations.

Catering services

According to our interviewees, service is excellent.

Menus are old and tired, and not changed-up automatically. The operator is still using the same seven-year-old printed menu for daily lunch meetings.

The operator appears to offer new menu items only when prompted.

There is need for additional and more efficient storage space for catering related equipment currently in use, plus prospective equipment that can be added to save museum and rental customers on the cost of renting equipment.

The operator said it would consider doing table/chair set-up, etc.; including purchasing the additional equipment if there were somewhere to store it.

The operator has no sales staff, and makes little effort to sell museum rental spaces; unlike most operators in cultural institutions with similar contractual arrangements.

Proms: The operator does not service the prom (and/or grad night) market because the caterer has not developed a competitive prom menu and service program. Located o
at the museum, the operator should be able to compete successfully with any off premise caterer's pricing for like menu and services. Based on information collected from museum interviewees, in 2011 there will be approximately 7 events with an average 1,000 prom attendees, representing total gross sales of about $140,000. The caterer is not expected to capture any of this potential market because the caterer has not developed a competitive catering proposal for the prom market.

Off-premise catering: The operator does off-premise catering without event reporting or commission payment to the museum.

Recommendations

Contract and financial: If the business model does not change, café renovated in near future, etc.; a new Agreement based on industry standards and current financial terms should be prepared by the museum and presented to the operator, negotiated and signed.

Café services: Museum staff should visit some geographic-area museums and cultural institutions to see current and up-to-date menus and service styles.

Change to a quick/fast-casual service (where customer orders at the counter, receives their beverage and order number, takes their seat and their food is delivered to their table supplemented with grab-n-go menu items). Adjust price points with a new, daily/seasonal changing menu, use local, fresh and seasonal ingredients, make use of LCD monitors for menu signage (including advertising and promoting catering, special events, special exhibitions, etc.) and reusable plates, glassware and utensils. Changes should be concurrent with the proposed renovation below, if the renovation can/will take place in the next

12-24 months.

Plant a herb and vegetable garden near the loading area entrance on the public side of the wall and have herbs and fresh vegetables come from the garden on daily basis. This could help establish café signature item/items or enhance the café image within the area and community.

Café/storage renovation: Do not recommend flipping the kitchen and serving area. The cost estimate of $1.5 to $2.0 million minimum, for a better view from the dining area and no expectation of added return on investment, is cost prohibitive. The café will likely do no more sales by flipping the kitchen and dining areas than doing what is proposed below.

Spend 50% of the above referenced estimate amount, or less, to renovate café front of house serving and dining areas; and update kitchen equipment as needed (which is some cases will reduce energy costs).

The museum indicates that it is very unlikely that the dollar amount(s) mentioned above will be available during the next five years for café renovation; however, the museum might be able to come up with about $100,000 for café renovations/improvements to accomplish at least front-of-house improvements and

limited back-of-house changes/improvements.

Under normal circumstances with most operators, based on the current level of annual sales and prospective level of sales post-café renovation; it is likely that an operator would add a minimum of another $100,000, and possibly as much as $200,000 toward the funding of the café renovations. We do not know if the caterer is willing or capable of contributing to further enhance the café renovations.

Consider making the entire loading dock dry and refrigerated storage for events, catering and café. Deliveries can still drop off at the gates as the vendors do today. While this cannot be part of the museum's $100,000 budget, it would provide great added value for the café, catering and event rental business. Importantly it could add sufficient storage to enable the museum to have a complete inventory of tables, chairs, linens and other items normally rented; and possibly create a profit center as well if the museum can rent/provide these items to an event host more cost-effectively than can the rental companies.

If equipment inventory is purchased and storage space built, financial projections must be done to see the potential ROI over the years from profit center created with the museum's rental of these tables, chairs, linens and other items; as compared to costs

of that acquisition and construction.

Cover (shade) the outdoor area near the café to use for additional café and group tours dining. This would also create a new/enhanced covered rental space for various events.

Catering services: The operator should update menus seasonally for internal meetings/events four times per year. This would be consistent with industry standards; and issuing updated seasonal menus would likely stimulate increased use.

The operator should consider adding a sales person to help the museum with facility rental sales; which in turn helps the caterer achieve more sales. The caterer could also consider outsourcing sales to an event planner on a commission basis, which might be more cost-effective since a full-time sales person for museum sales only might not be a practical alternative.

The caterer should develop a lower priced catering program appropriate for proms. The caterer should be competitive and capture these prom sales if at all possible.

Off-premise catering: It is permissible for the caterer to book this type of business, and is common in the industry; but the caterer should be reporting these sales so the museum can evaluate the effect

(utilities, wear and tear, etc.) on overall museum cost structure. Normally when operators use the museum's facilities for off-premise catering, the museum receives a commission on these sales to offset museum costs.

The operator: How much can the operator really do on its own, regardless of its passion and desire? What creativity, innovation, finances, time and professional resources does it have at its disposal to take the museum café and catering services to the next level? All of this is unknown at this time.

Should the operator consider partnering with another operator, a restaurant operator who can work with it to re-concept and redesign the café (and catering services)? The goal would be to make services more appealing with hopes of making the café a destination dining location for park visitors, area residents, visitors and members.

If the museum is 100% committed to work with the operator going forward, then the museum should arrange for the operator to visit other museums with industry best café practices; this will enable the operator to see/learn more about operations than the operator would as a customer. The operator needs to learn more about the peculiarities of café operations and functions within a museum/cultural institution;

with seasonally changing menus, weekly/daily menu changes to optimize participation from museum staff and volunteers, and specific support of museum special programming to optimize the visitor/guest experience and optimize gross revenue for both the operator and the museum.

The museum should know the operator's financial condition, terms with vendors, etc. as part of good business practices in today's environment. Even if the operator is making little to no profit at the museum and the operator is running the museum business philanthropically, so to speak; museum management still needs this financial information. The museum should ask for, receive and review the operator's financial statements, tax returns, etc. The fact that the operator is in arrears in payments to the museum should be a major red flag that should be addressed as soon as possible to avoid embarrassment and/or any lapse of service (café closure) to the museum.

Today, as mentioned above, most museum café operators/caterers (including small companies like the operator) will make some level of buy-back protected capital investment in the institution's facilities over and above loose equipment, consumable inventory, etc. The museum needs this capital investment support if the museum would

like to see near-term café and improvement with the services. If this is the museum's intent, what is needed; and does the operator have the resources and willingness to participate in some type of buy-back protected capital investment?

The museum should embrace the operator (the caterer) and include her in the museum processes; as any other department head would be included. The operator staff should all go through the same museum orientation as museum staff and volunteers. There should be weekly meetings with the operator, including agenda, minutes and action items on both sides. The operator should receive attendance projections, special exhibition schedules, etc.

The museum needs to commit financial and human resources to advertise, market and support the café, catering and related services.

When the museum decides upon their direction, the operator should be provided much of the input and recommendations in this report; and, as the next step, be asked for a proposal covering all the elements, findings and recommendations for evaluation and consideration.

For the process to be most effective, it is necessary that the incumbent, the operator, know and understand its importance. The operator must

realize that if it does not take the process seriously, and is not very responsive in all regards, the museum will consider going to a request for proposal (RFP) process. Normally most operators, when made aware of the seriousness of the situation and assuming they want to stay at the museum, will make every effort to comply with the process. If the incumbent cannot be competitive, perhaps due to limited financial resources, personal time or motivation; it is best that the museum consider alternatives before taking time, effort and museum resources trying to work with the incumbent.

Knowing the current café and non-exclusive catering business model and the level of current sales will not likely pencil out for some museum restaurant/ food service operators consider asking some local operators (*depending on how the operator responds to the idea of partnering*) to see if there is interest for the Café foodservice only. These would have to be restaurant operators that also see the Museum Café as a destination restaurant with potential annual revenues from all prospective customer markets (general public, visitors, members, zoo staff/volunteers and attendees, etc.) of at least two times current levels.

An example of one U.S. museum that has a visitor café that fits well with mission, collection and the

museum is the Mitsitam Café and the National Museum of the American Indian.[1]

Other: We discovered that the operator does not have, nor has entertained, proposals from, Pepsi-Cola or Coca-Cola for exclusive pouring/serving rights at the museum. This is an area of potential added in-kind marketing/advertising support and maybe a little cash support that should be considered.

The museum mentioned that it has events during the year that involve specialty food vendors at fair/festival type events. This is a normal industry practice in cultural institutions and should not present any issue or conflict with the café operator; but the terms and conditions should be detailed in the café operator Agreement (contract).

Given the exclusive café and non-exclusive catering services and total annual visitor count and foodservice revenues; we do not believe that the current business model can be very, if at all, profitable for the operator.

Visitor foodservice, when viewed alone, normally loses money: even at higher attendance levels than those reported at the museum. Most visitor foodservice café operators at other cultural institutions have exclusive catering and much higher sales volume to enable profits from facility rental

catering sales to offset normal break-even or losses from visitor foodservice.

We have not reviewed the operator's profit and loss statements and have not done financial estimates/ projections based on the museum visitor foodservice/ catering services current business model. However, based on our experience and the current annual attendance, annual total foodservice sales and commission rates paid by the operator, we would assume the museum-only foodservice business model is currently losing money. (Reminder: we do not know how much off-premise catering is being done at the museum; since it is not reported or commissionable to the museum).

Going forward, we recommend this business model changes so that the museum knows that the foodservice business model is profitable for both the operator and the museum.

Next steps and timing: The timing of next steps is up to the museum. Following are recommended next steps:

1. Museum management/board internally determine and decide upon next steps, capital investment, café renovation, recommendations in the Facility Rental/ Catering Report section (as it relates to short-

list of approved caterers), renegotiate with the operator toward new Agreement or not, financial viability of the operator to continue in the current or new business model and related as detailed in our report.

2. Share specific, relevant excerpts of this report with the operator, assuming renegotiation is an option the museum wants to consider.

3. Depending on the museum's decision/direction, have several local restaurant operators look at the museum café to determine interest and test the market in this regard. Tell the operator you are doing this, of course.

4. If the museum proceeds with the operator as #1 option, ask the operator for a proposal. Or, the museum could ask the operator for a proposal along with other selected operators, to get all proposals in-hand at the same time.

5. Review and evaluate proposal(s) from the operator (and others).

6. If the operator-only proposal does not meet the museum's expectations/needs, an RFP should be considered; keeping in mind that the operator's viability and will/interest to continue may falter if the museum

proceeds with an RFP. In this scenario, while proceeding with an RFP, the museum would have a lame-duck operator and foodservices might deteriorate and/or cease. (Note that under those circumstances there should be little difficulty in contracting an operator for the current café on an interim basis at little cost to the museum if the operator were to leave.) The museum would also have to curtail the operator's booking of any future catering at the museum; allowing facility rental customers to bring in their own caterer or choose their caterer from a museum-created temporary list of approved operators.

NOTES

1 http://www.nmai.si.edu/subpage.cfm?subpage=visitor&second=dc&third=mitsitam

2

Bringing New Life to an Underperforming, Overpriced Café

The report on the following pages was prepared for a Botanic Garden attracting several hundred thousand visitors a year, mainly adults and families. The organization has a long-term contract with a national operator for its Garden café. The walk-up, self-service café is perceived by visitors, staff and guests as expensive. The Botanic Garden is not motivated to do a Request for Proposal (RFP) and instead wants to try to improve its relationship with the operator, enhance visitor experience and participation and provide more affordable offerings. The quality of food, beverages and services provided is not a major issue.

The same operator also provides the on-site catering for facility rental customers (mostly weddings, as with most botanic gardens). This is a popular wedding destination. The Garden is not looking to expand facility rentals as it is already close to capacity and does not want to do anything which will detract from the Garden's primary purpose and mission.

The resulting report examines:
- The café and visitor experience.
- Satellite food and beverage services.
- The catering service.
- The operator contract, which is due for

renewal in 18 months.
- The operator and Garden relationship.
- The food service contract.

Café, Catering, Facility Rentals and Operator Catering Services and Relationship Evaluation

This Botanic Garden has had a long-time relationship with the foodservice operator that operates the café and exclusive catering services at the Garden.

The Garden is generally pleased with its operator relationship, and we understand that it does not want to unnecessarily disrupt or change the relationship. The operator is in its eighth year of a ten-year contract that expires in the near future. The Garden has issues with the operator relationship including, but not limited to:

- the café menu variety (not changed frequently enough)
- pricing (high pricing)
- catering services (high pricing and possibly that the Garden's vision for the frequency and quantity of facility rentals/catering events – weddings in particular – is different than the operator's)
- and the turnover of catering management.

The Garden would like us to be objective and factual with this evaluation. It would like a review of the terms and conditions of the agreement (contract)

with the operator, to evaluate and compare with industry standards, and determine if the terms and conditions should be modified with a renewal.

On the client side, there are some issues and limitations that need to be considered. These include, but are not necessarily limited to:

- the fact that during the past year or so the Event Department has not been fully staffed, which resulted in a much lower number of weddings and rental events;
- the café has physical limitations, such as an old and failing septic system, the need to add a grease interceptor ($35,000 cost), and limited utilities, which inhibits significant changes to kitchen equipment.

Furthermore, subject to meeting capital campaign goals, the Garden is considering an expansion that would include major changes to the visitor center area, including the café facilities and back-of-house. While this expansion may be 5-10 years in the future, our recommendations at this time need to be sensitive to these facts and circumstances.

The Garden clearly indicated to us that its focus is on developing and building membership as a way to enhancing philanthropy from those members. An

important part of growing membership is for the members to have all aspects of their Garden visit, including visitor dining, to exceed expectations.

The Garden would like us to identify short-term improvements that can be made in all areas as well as long-term improvements, including renewal of the Operator Agreement based on mutually agreeable and, importantly, industry-competitive terms and conditions.

The Garden offers multiple indoor and outdoor facilities and spaces for special event rentals and catering. While facility rental income is an important part of the Garden's annual earned income, it has clearly indicated that the Garden and its collection, mission and vision come first; that the Garden is not an event center, and while some areas of facility rentals can grow (like rentals at indoor facilities), the Garden is not eager to increase the number of weddings much beyond an annual goal of 45-50 due to limited staff and the impact on the Garden property and facilities.

Café and visitor foodservice

The overall feeling, based on interviewee input and our observations, is that the operator has not developed a menu and a style of service specifically

Museum für Moderne Kunst, Frankfurt, Germany

for this Botanic Garden and its visitors. The operator is simply implementing similar café menu items and pricing as they are doing at their other museums and client locations without being sensitive to the Garden's visitor demographic, tastes and preferences. Café service appears to be an "Operator program at the Botanic Gardens", not a "Botanic Gardens program". The operator does not have any client locations like the Gardens, their people do not have Botanic Gardens experience, and, given this lack of experience and knowledge, they are not researching industry best practices at similar locations in the U.S. or in the Garden's immediate area.

Per capita spending and participation: Before the economic downturn, café spending was about $2.15 per visitor. Given the location and convenience of the café, this should be at least $.50 to $1.00 higher based on our experience with similar gardens and other cultural institutions around the country. Current high menu pricing and lack of frequent change of the menu items (given the high frequency of repeat visitors) are likely driving down visitor participation at the café. Current *per capita* spending is down at about $1.80. Assuming an $11 average check (which the operator reported), this represents about 30,000 annual lunches (not including morning or afternoon

beverages or snack sales, which would make this 30,000 lunch figure lower) or about an overall 15% lunchtime participation rate by the several hundred thousand annual visitors (about half paid attendance and half member attendance). Given the location of the café in the visitor center area where every visitor walks past the café twice (on their way in and on their way out), we would expect participation would be at least 25% based on similar cultural institutions with their cafés in a similar great location. With the appropriate café menu, service delivery style, price points, speed of service, and ability to serve visitors on high attendance days, the café should have the potential of doing at least 10% more annual lunches per year based on its current size and location. If the *per capita* spending increased by $.50, that would add significant per year sales based on the annual visitor count, which would materially increase profitability for the operator and the commission income for the Garden.

Café service style: Currently the customer walks-up, pays and takes the food/beverage. This type of service style is very basic, like a *Burger King* or similar quick-service restaurant, not the style of service customarily found in a venue like a Botanic Garden. The current service style is not consistent

with, or similar to, cultural institutions with similar visitor demographics. The more common service style at gardens and museums with similar visitor demographics is the customer walking up to the counter, ordering, being given a number and taking their beverage with them, being seated, and having café staff deliver the primary menu item to the table. This style of service is often supplemented by a self-service, *grab-n-go* refrigerated case with a selection of salads, sandwiches, beverages and the like. Commercial examples include the *Corner Bakery* and *Panera Bread*, among others. This type of service style can be done using disposable ware, permanent ware (plates, glassware and stainless steel utensils) or a combination thereof (permanent ware would require the Garden to install the grease interceptor as mentioned above). What is most important to consider here is which style of service will provide the visitor with the best, most desirable and memorable service and experience.

Knowing and understanding the customer: Based on the menu variety and price points ($3.00 for a cookie, $5.00 for a cup of soup and $2.25 for a small dispenser soda with no refills, for example), it is our opinion that the operator does not really know and understand the customer and the demographic – who

they are, where they come from, where they casually dine, their tastes and price tolerances – and what is needed to optimize participation and satisfaction.

The Garden's website: The café is not listed under *Visit* on the website; it is listed as *Energize*. No menu, pricing or photos of menu items are provided. The operator indicates that all the information about the café is located on the operator's website. However, visitors to the Gardens do not research or plan their visit at the operator's website. The Garden should provide a link to the café details and description on the Garden's own website using the operator's content (assuming it is appropriate, up-to-date and accurate). It is industry standard for the café operator to build the café website and provide and regularly update it for the institution's use.

Satellite location: The food is good (we patronized twice this past season), but service style and set-up is awkward and not customer-friendly. We highly recommend that the operator rethink the physical set-up and style of service, including wait staff to deliver food and take beverage orders to elevate the overall dining experience.

Kitchen and storage: Based on our observations, the kitchen size is more than adequate given the number and potential number of visitors served on

average busy days. In addition, that kitchen space is supplemented by sufficient additional storage and refrigeration. Some of the kitchen equipment can and should be updated if the operator changes the concept, menu or style of service. However, the way the operator is storing in the storage shed is not legal, i.e., everything is *not* a minimum of six inches off the floor.

High-attendance days: Interviewees expressed concern about the operator's ability to operate the café and additional points-of-sale during high-attendance days in such a way as to optimize the visitor experience and customer counts. A high-attendance day is defined as several thousand person-days on predictable high-volume weekends and seasonally (in the Spring). Secondary points of sale are established but, based on interviewee input, still have queues and congestion, and the café has a +/- 30 minute wait to get food and frequent run-outs. Given how long the operator has been at the Garden, the operator should have excellent data available, which is defined as visitor counts, customer counts and weather, which historically is the basis of making adjustments so that next time or next year all is better and improved. Typically, during high-attendance days, the number of lunches as a percentage of visitors will drop

because of capacity issues. If secondary points of sale, in addition to the café window, can be established, be well-signposted and communicated to visitors (via the website, ticket sales windows and volunteers), and the secondary points-of-sale are truly nice and comfortable lunch options, then the percentage of visitors purchasing lunch should be higher. All that being said, if the total annual lunch customer count is running at an average of only some 15% based on the calculations above, then it would seem that the participation percentage on a high-attendance day might be less than 15%, which would not be good. It would seem that there are great opportunities to increase customer counts and visitor satisfaction on high-attendance days through cooperative and collaborative programming between the Garden and the operator, with sufficient advance advertising and promotion to the members and general admission.

Visitor research: The Garden has never undertaken research to learn café expectations and needs from its visitors, members – and board members. Most institutions routinely do a little of this as part of annual research with visitors and members. We recommend that it would be in the Garden's and the operator's mutual best interest to do foodservice-specific research to learn preferences about what

specific type of daily foodservice would best meet their needs and encourage more frequent participation, services, menu variety, hours of operation, price points, sustainability practices and style of service. You can also test locally-known restaurants and use this research to rule out or rule in members' preference for a local high quality restaurant operating the Café versus the current operator.

Comment cards: Currently these are hidden in a basket on the café condiment table. These should be in holders on all dining tables and include scoring for the purpose of establishing metrics to measure performance. These should also be postage-paid to help encourage return.

Menu pricing: Soup, salad and a relatively small soda in a paper cup purchased by us for lunch totaled $18. When you compare the café pricing to other local family attractions and cafés, some of the operator's pricing is too high and not sensitive to who the customer is or to the local market. Soup and sodas are one size. There is no free refill for sodas (it is not practical to have free refills because of the current service style). There are also no soup/salad and half-sandwich combinations. Soup is $5; a small-sized soda is $2.25. Offer at least two sizes of soda/cold

beverages and small and large bowls of soup and you will likely sell more of both. Sandwiches with protein are about $10 and a jumbo beef hot dog is only $3.75. On day two of our on-site visit a soup and sandwich combination was offered at $6.50. It was half of a roast beef sandwich and a 12 oz. size bowl of soup. The customer could only have roast beef, with no substitution for turkey, tuna or a vegetarian option. This price is probably too low in relationship to other *a la carte* pricing. It seems like the operator does not have a formal and thoughtful pricing philosophy or guidelines for its on-site manager.

Food quality: Overall, the food tasted was good. Cookies were not labeled to tell customers what they are (for those concerned with nut allergies). Many interviewees commented about inconsistent quality and not always having fresh food (yesterday's food today). It does not appear that the operator is using year-over-year historical attendance, sales, customer counts, weather, special exhibitions, etc., as mentioned above, to plan daily food production.

Grilled chicken & apple salad: This was not what was advertised on the menu board. The menu description implied it was chicken breast on a bed of arugula with grapes, apples, walnuts and lemon aioli. What we got was mayonnaise-based chicken salad on a bed

of arugula with apples and grapes and no walnuts. This was corrected on day two during the visit after mentioning this to the operator during the interview on day one.

Edible garden: It was wonderful to see the use of fresh vegetables from the Botanic Garden as ingredients in café menu items. This is a strong message to communicate to café customers, members and visitors as a signature of the Botanic Garden café. However, little or nothing is done to promote and advertise this fact. Of minor note is that menu ingredients from the garden are provided at no cost to the operator, which to some degree lowers their overall cost of goods sold (food cost) at the café.

Cleaning and maintenance: There is concern that the operator is not being diligent in cleaning and owning responsibility for dining, kitchen and loading/storage areas. It is not so much that the operator is not doing any cleaning, but it appears that there are no clear and distinct written contractual responsibilities for the operator and the Garden, which, in turn, means at times some areas are not getting the necessary detailed attention. Contract responsibilities need to be clearer in this regard.

Septic tank: The septic system is old, failing and the café's use of the dishwashing machine places

a strain on it. Installation of a grease interceptor (estimated at about $35,000) would extend the life of the septic tank until the major renovation of the visitor center is completed 5-10 years from now. Based on comments received and our observations, the Garden should consider making the investment in the grease interceptor now. A side benefit might be, depending on what changes the operator does or does not make to the café service model, the ability to reuse plates for café service, which is a more sustainable approach and would reduce the trash generated by the café, which we understand is very substantial. Reusable plates would greatly enhance the café service, presentation and image as well. (Currently the operator uses the dishwasher to wash service ware from catering events. The operator and the Garden should research water consumption as well as impact on the septic system when considering partial or full use of reusable plates, silverware, etc. in the café. It is possible that partial or full use of reusable ware in the café will have minimal impact, but this needs to be carefully researched by both parties to be certain.)

Sustainable practices: Some sustainable practices are in place and some are noticeably not in place. Most disposable ware that is being used appears to be sustainable/compostable. This is not the case with

soda cups or the plastic-coated soup cups. The Garden should clearly set forth to the operator sustainable and green standards and the operator should fully follow these.

Opportunities

Among the prospective opportunities to do increased customer counts and sales are the following:

Morning business: If the operator knew the daily/ morning gate counts (especially morning), they could then try to capture these visitors at the café for coffee or breakfast like *Starbucks* does. This would require not just signage, but also asking the Garden to hand out complimentary certificates or tokens for coffee, croissant, bagel or the like periodically so visitors know the café is open and have the incentive to try it. Advertising and marketing could be done through Garden mailings and email blasts. Pricing, portion sizes and quality is equal to or lower than local *Starbucks* and competing coffee shops. However, the operator could consider having *We proudly serve Starbucks* signage, or, if applicable, reach out to a local coffee shop and buy and grind their coffee and offer that local brand. On chilly mornings they could consider using the space heaters that are in the loading area behind the café and, if available, opening

one of the meeting rooms. They could also consider having a selection of local or national newspapers for customer reading.

Signature menu and menu items: This is a great opportunity to have the café known for the fresh vegetables from the Garden as a reason to try the salads, soups, sandwiches, etc. that are made with these ingredients. The operator could possibly serve freshly baked zucchini or carrot muffins made with vegetables from the Garden.

Member marketing: Café services can be marketed to members during slower times, with special incentives for morning and afternoon use, and use during slower times of the year. The operator staffs the café all day, every day, so why not increase traffic during the slower day-parts? This is good for the Garden, too, because it increases the value of the membership.

Café marketing and PR: Most operators dedicate 1%-2% of sales to advertising, marketing and PR. How it is used is normally collaboratively determined between the Garden and the operator, with the Garden providing support, where possible, through its publications, mailings, email blasts and on-site signage.

Tour groups: The operator is only capturing a

fraction of the tour group business. They do not have any ongoing contact or relationships with tour group operators. The operator should be communicating with Garden representatives and tour operators to be sure the café offers tour group menus and pricing that meets the needs of the various types of groups that come to the Garden (i.e., seniors, low-income, etc. and wherever they come from).

Food and beverage programming to increase visitor attendance: Most cultural institution operators have unlimited ideas and support from their own marketing departments to help the institution develop daytime and evening programming that includes dining, food and beverages. Normally these are *institutional* programs, not *operator* programs, and are institutionally mission-related, educational or the like.

Café potential: There is no reason why the café cannot, or should not, become a true destination for both visitors and local area residents as a great location for breakfast, coffee, lunch or afternoon tea. Currently it comes across more as just "a place to eat."

Catering and facility rental sales

Ability to grow business: The Garden and its mission come first. The Garden is not an event venue. The annual number of weddings should be reasonably limited. Growth opportunities exist with non-wedding rentals in indoor venues that include food or beverage-related services and/or programming during slower seasons and times.

Exclusive versus non-exclusive catering: Exclusive catering is best for the Garden due to limited staff resources to manage and oversee catering in addition to rental and wedding customers. However, based on our interviews and based on what most other cultural institutions do, even with an exclusive caterer, there need to be exceptions to exclusivity in order to accommodate budget and special needs for both internal (Garden-related) and external (rental and wedding) events.

The operator is perceived by most in the area as a high-end caterer. *High-end* includes high pricing. The operator says it makes an effort to adjust menus and services to meet all external client needs. Unfortunately, however, if a prospective client does not know this upfront, they might go elsewhere simply because of the perception, not because of the reality, of the situation.

Following is a summary of terms and conditions often found in exclusive catering contracts, like the relationship between the Garden and its operator:

- Exception policy (food catering only) for any event up to 2-3 times per contract year.
- Buy-out option (food catering only).
- No use of the café kitchen under the above.
- Ability to receive donated wines and/or other food/beverages with nominal (at cost + small mark-up) set-up/service charge by exclusive operator.
- Exemption for staff events so you can get food/beverages from *Costco* or similar source.
- Exemption for any internal catering event where the exclusive operator cannot reasonably meet the client budget for that event, or the operator does not want to do the catering because they cannot do it profitably based on client's price point.
- Kosher, Indian and similar ethnic (food only) catering is exempted.

Non-exclusive catering might result in more rental business for the Garden. However, given the limit on increasing the wedding business much beyond 45-50 a year and the Garden's limited staff resources,

exclusive catering is the best way to continue – assuming the exclusive catering terms and conditions (listed above) between Garden and operator can overcome the areas of current concern and criticism. Furthermore, given that total foodservice revenues (catering plus café) are about $1 million or less, in order to maintain the café without subsidy from the Botanic Garden, having one company do all the catering is the most financially viable way to go to realistically ensure an unsubsidized café.

If visitor research indicated a strong preference for a local restaurant opertor, or if local restaurant operators expressed interest in operating the café without subsidy, and the café could be successful on a stand-alone basis without exclusive catering, then the Garden could continue exclusive catering with the operator or any other exclusive caterer under a separate contractual arrangement. It is likely, if not probable, that the café currently loses money for the operator and is being subsidized by the operator's catering profits at the Garden. If the café could become a destination, optimize sales, and gain a following from the local community with $500,000 to $600,000 annual sales compared to the current $350,000, at those sales levels it likely could be stand-alone profitable.

Development support: The operator's catering is generally too expensive, its quality is inconsistent and it is not flexible enough to meet the day-to-day needs of the development department for donor cultivation and related activities. For this reason, some of the recommendations in the previous section should be implemented.

Survey rental and wedding customers: We recommend implementing an online survey for all events at the Garden as a way to measure service quality and performance and to establish metrics to measure the quality and consistency of the operator's services.

Member and board facility rentals: The Garden has no corporate member program and does not offer special rates or discounts for board members to hold events. Many cultural institutions have corporate member programs, and part of such programs includes the ability to have one or more events at the institution at low, or no, cost as part of that membership.

Special Event Department staffing and Operator Catering Manager: The Garden had staffing deficiencies in its special events office during the past couple of years that resulted in a decrease in weddings booked. Currently, the special event department staffing is where it should be, and the bookings are very good.

The operator has been without a full-time, dedicated on-site catering manager at the Garden for most of the year but will have this person in place toward the end of the year. This person will be housed in the same office as the Garden special event staff, which is good.

Facility rental rates: The Garden does not annually benchmark its rental rates against competing venues. It sets its pricing purposely a little higher than the competition to discourage low-end rentals not consistent with the Garden's image and mission.

Operator training: The operator appears not to have a formal and strict training program for its truck drivers and party staff based on interviewee input (hence damage to Garden property, dumpster fire, etc.).

Operator trucks on property: The Garden has strict guidelines on the size of trucks allowed on its property (beyond the parking lot). However, it appears that the operator does not closely follow these guidelines at all times.

Catering pricing: It appears that the operator is using a standard wedding package at all of its cultural venues, rather than tailoring the package to the venue, local competition and client demographics. We recommend that the operator shop the competition

at other cultural institutions and both indoor and outdoor unique venues in the community and update its menus and pricing in all regards to better reflect the community rather than other operator venues.

The operator relationship

Cultural institutions: The operator indicated that they really want to be at the Garden. They also indicated they are committed to growing and expanding their cultural institution business.

Garden staff and board members: There was mixed input on the level of satisfaction and interest in considering alternatives to the current operator. All seemed to be all right with staying with the present operator if current issues and concerns can be overcome and resolved. The only way the negative operator comments will go away is if the operator, in fact, does what they need to do in all regards and all ways.

Operator resources and commitment: We are not sure that the operator has the resources within their organization, or if they will find and commit the resources needed (both human and financial), to know and understand what needs to be done at the Garden. It appears that the management (COO and vice president of operations) which has operational responsibility for the Garden principally only knows what the operator is doing at other operator performing arts center and art museum clients. As a result, if the Garden proceeds with the operator as recommended later in this report, the Garden may

see continued ups and downs during the learning curve even if they try to make significant changes and improvements. If the operator's COO and vice president of operations can commit the resources and gain the relevant knowledge before new programs and services are started at the Garden based on industry best-practices, then it is likely that all will go very smoothly.

Operator operational management and brand: While seeming well-meaning and -intentioned, we do not believe the operator's on-site general manager understands that to be successful in today's cultural institution it is "all about the institution," not about the operator or the operator's brand. Most cultural institutions today want the institution brand, culture, mission and image out front. If the operator is a brand, that is fine, but it is very small print and only used, promoted and advertised by the institution if the institution sees institutional value in doing so.

Operator on-site manager and staff: Garden staff really like the on-site operator manager and staff and feel they do not get support from above. The operator's on-site general manager said on our second day, "Thank you for saying prices are too high, I have been saying that for a long time and agree."

Garden foodservice department: Operator

management and staff do not seem to be functioning as an integrated Botanic Gardens department. Normally, the operator on-site manager is treated and acts like a Botanic Gardens department head and attends senior staff meetings. In addition, all foodservice staff received Garden orientation, the same as volunteers or staff would receive. The best foodservice operator/institution relationships are when the two entities function as one department of the institution, and the only noticeable difference is the name the paycheck comes from for the different parties.

Industry best practices: Senior operator management has not pro-actively gone out to learn and see industry best practices which they might apply at the Garden. The operator's vice president of operations did go to another local museum with a similar visitor count and similarly sized café and seemed to be impressed. Normally, operations management and their on-site general manager frequently get out to see industry best practices in order to help them develop relevant and competitive programs for their clients.

Operator contract findings

There are terms and conditions not in the current contract that we have found in most client-operator cultural contracts over the past 10-plus years. Examples of this, as well as comments about the current commission rate, are as follows:

- No liquor license transfer terms.
- No Garden approval of on-site manager and/ or key management (catering manager and chef).
- No removal of staff upon Garden request.
- Staff orientation of Garden.
- Catering pricing is not based on competing venues in the local area; it is based on other operator venues that are not relevant.
- No detailed and strict food safety or sanitation section, including penalty for underperforming in this very important area.
- The current commission rate(s) given sales volume averaging about 11% of sales is competitive to a little high. In the current market, it is likely the Garden would get zero commission on the café sales based on current café sales levels.
- No funds set aside for café or kitchen refurbishment, furniture, fixtures and

> equipment (Garden-owned) replacement; or advertising and marketing of all services.
> - Truck size limitation for trucks on Garden property and training truck drivers and other operator staff.
> - No detailed written respective responsibilities for the Garden and the operator for cleaning, maintenance and the like.

Short-term contract recommendations

Amend the contract with important new, or more detailed, terms and conditions that are important for the Garden now, such as some of the above. Do not wait until drafting a new contract because documenting now what is missing will help quiet some of the criticism and complaints.

Request that the operator underwrite a cost, not to exceed $2,500, to enable Garden staff to work with operator input, and implement as soon as possible an online member (and board) survey totally focused on the café and all visitor foodservice at the Garden. This will provide the operator with great input and help them prepare a proposal based on users' expectations along with the operator's research on industry best-practices.

Operator to correct deficiencies noted in this

report regarding storage being off-the-floor.

Long-term contract recommendations

There should be a new, more industry-standard form of Agreement if the contract is extended.

If the operator can make necessary changes and show consistency in the short-term, then we recommend doing a new five-year contract with mutual option to renew for up to five years.

Capital investment

Based on interviewee input, the Garden can likely find a small, five-figure capital investment for short-term improvements in the café kitchen provided value is there. Value was defined as improved service, visitor experience, improved member benefit and participation, etc.

We recommend the Garden consider investing in the grease interceptor, assuming the operator's overall café improvement proposal warrants this investment, and taking into consideration the value criteria that is used by the Board's finance committee in this regard. In addition, the Garden should consider a small investment, matched by the operator, for whatever kitchen changes might be needed to improve services and operations.

Next steps and timing

Short-term plan

1. Local Restaurant Operator:[1] Consider inviting at least one local restaurant operator to come by, confidentially, after-hours and look at the café to get an outside, third-party perspective and include their comments in this report. We need to know as soon as possible if the Garden wants to do this so we can make the call and get it scheduled.

2. Draft the report to the Botanic Garden.

3. Include with this report a draft letter (Figure 1) to go to the operator asking for their proposal to address all the issues and concerns detailed in this report. Also to be included is a metric reporting system that will be used to measure performance next spring and summer. (See Figure 2 for sample of weekly metric reporting developed by us. This reporting document is used by the operator to provide weekly metric reporting to the client.) The essence of this letter will ask them to totally reinvent the café operation and to provide a second level of catering services, or rebrand catering services, in such a way that the perception of quality is not reduced, but the catering becomes more

affordable. The Garden should either send the letter or have us send the letter on receipt of our draft report.

4. Review our draft report with the Garden and get edits and comments on both Garden and operator versions of the reports.

5. The Garden drafts a two-page Board Executive Summary based on our report and sends it to us for review and comment.

6. We finalize the Garden and operator reports and distribute.

7. Ask the operator to update their reporting using our Excel document to also include average check and customer counts and a better department breakdown starting in January next year.

8. Within 30 days after receipt of the letter, the operator meets with the Garden (and ourselves at the Garden's option) to discuss and clarify the Garden's goals and objectives and then submits a proposal for short-term changes, capital investment needs, etc. addressing all the points in the letter and our report. Implementation (once approved by the Garden before the end of the year), early next year with full implementation by March.

9. Operator management (including the operator's

on-site general manager) visits other cultural institutions to learn about industry best practices as needed.

10. Metrics (minimum scoring expectations) are discussed and agreed upon between the Garden and the operator. The operator, using the Figure 2 metrics reporting document, develops a similar weekly reporting tool for the Garden (and ourselves) to review and comment. The Garden metric document is used to set goals for café, catering (internal and external separately) and other regular, recurring points-of-sale (like satellite locations, cart services, etc.). This reporting tool will commence the first week when new services are implemented and will be provided to the Garden by Tuesday morning every week for the prior week's services. Note that the customer (visitor foodservice, all points of sale) and client (internal and external catering) will have to have updated survey forms and methods of distribution implemented to encourage optimum return in order for the metrics to be meaningful.

11. New services are implemented by March of next year, comment cards and catering surveys are fully implemented, and metrics tracking (by the

operator) is in place with weekly reporting to the Garden (and ourselves at the Garden's option).

12. Garden and operator management (and ourselves at the Garden's option as needed) meet monthly, starting in March of next year, to review results and services and proactively adjust the program as needed.

Long-term plan

1. Parties meet in August of next year to review and evaluate monthly reporting, metrics, services and input from staff and trustees.

2. The Garden determines if the updated programming and services are successful and both parties want to extend the contract for five additional years based on terms and conditions to be mutually agreed upon the following year.

3. If the parties agree to an extension, then the operator should provide a financial proposal including commissions and capital investment and related terms and conditions for the Garden's consideration.

4. The Garden should evaluate the operator proposal (with optional input from us), be sure that proposed terms are industry-competitive, and then prepare a new industry-standard form

of Agreement to present to the operator.

5. However long it takes to complete the new Agreement is the basis for the start date of the new Agreement.

NOTES

1 If this turns out to be a viable opportunity to operate the café as a stand-alone, with a separate exclusive catering contract, then this should be discussed with the operator to see what their interest would be in continuing as "caterer only" and, if interested, having to work as an off-premise caterer (not able to use the café kitchen, but could have some dedicated storage). If they are interested, it would need to be determined how this would affect their catering pricing, if at all.

ARTHUR M. MANASK & ASSOCIATES

Management Consultants To The Foodservice Industry

Mr. John Smith
Operator
XXXXXXXX
XXXXXXX
XXXXXXXX

Dear John,

RE: Botanic Gardens Café and Catering Services

The Garden would like to receive a proposal from you within 30 days of receipt of this letter to substantially reinvent the café and visitor foodservices and present more affordable catering service alternatives.

To help you gather input for the above request, you are encouraged to reach out to the Garden to meet with key management/board representatives as soon as possible after review of the Consultant report and this letter.

Furthermore, the Garden encourages you, and your Garden management team to tour and visit other family-oriented cultural attractions in the local area (and outside the local area if you can) as well as local casual cafés to enable you to see and taste *local* best practices, menus, pricing, portions, style of service, etc. to help you match the Garden's café to the Garden member and visitor demographic.

Following is what the Garden would like to receive in your proposal (formatted and contents as follows: three-ring binder, printed on two sides and tabbed accordingly; three (3) originals to the Garden and one (1) directly to the undersigned):

A. Café

1. Description of rebranding, including name/identity.
2. Concept and style of service.
3. Menu, price points, portions (where applicable) and frequency of menu item changes.
4. Signature menu items.
5. Staffing.
6. How the café will become part of the Gardens and, if it can, become a destination in and of itself for the community.
7. Sustainability practices.
8. Signage that allows maximum flexibility for change.

MANASK & ASSOCIATES
209 W. ALAMEDA AVENUE, SUITE 103, BURBANK, CA 91502
TELEPHONE: (818) 557-0635 FACSIMILE: (818) 563-3562 E-MAIL: artm@manask.com WEB SITE: WWW.MANASK.COM

Figure 1a: Letter to operator

Mr. John Smith Proprietary & Confidential
Page 2

9. Advertising, marketing and promotion, loyalty programs; what you will be doing and what is expected or needed from the Garden.
10. Garden website support.
11. Physical equipment or other changes, including your capital investment as needed.
12. What is expected of the Garden (specifically) to support you and make the above happen?

B. Tour Groups

1. Menus, portions (where applicable) and price points.
2. Branding.
3. Advertising, promotion and marketing.
4. What is expected of the Garden (specifically) to support you and make the above happen?

C. Catering Services

1. Rebranding or offering two brands.
2. Wedding packages with competitive (in the local area) menus, services and price points.
3. Exclusivity (willingness to include Consultant input from Section III. A-2 at the Garden and if yes, proposed terms and conditions for each of the points listed in this Section of the Consultant report).
4. Garden website support.
5. What is expected of the Garden (specifically) to support you and make the above happen?

D. Other Services & Amendment to Current Contract

1. Garden Programming: Please address and propose your approach, including menus, pricing, advertising, marketing and promotion by the Garden and by you for 2011 program-related special events including, but not limited to, Satellite Services, Carts, Holiday Events, etc.
2. Your Proposed Events/Programming: What food/beverage events/services do you propose to do in 2011, including as much detail about each: date/timing; purpose; advertising, marketing and PR and by who; menus; pricing; where located; and how you see the Garden benefiting from each. All of these, of course, are subject to the Garden review and approval as to implementation.
3. Contract Amendment: Excerpting from Consultant's report and anything you would like to add, provide a draft Amendment to the current contract that will include items missing from the current contract, like truck-size, your training, cleaning/janitorial responsibilities, etc., so going forward items that are not clear on either side can be clarified in writing for the balance of the term of the existing contract

Figure 1b: Letter to operator

Mr. John Smith
Page 3

Regarding timing, following is what the Garden would like you to consider:

Date/Timing	Activities
December	1. Your proposal to Garden 2. Meeting, presentation and tasting with Garden representatives 3. Garden approval to proceed
January/February	You start planning and implementation of mutually agreed upon changes to café, catering and related services and activities
March/April	Implementation of Garden-approved new programs and services Appropriate advertising, promotion and marketing by Garden and your company
April through July	Metrics reporting by you to Garden
August	You and the Garden formally meet to review metrics, services, overall performance and mutual support
September	Garden indicates its intentions about your contract renewal/ extension

Please feel free to contact me if you have any questions.

Sincerely,

Arthur M. Manask
President

Figure 1c: Letter to operator

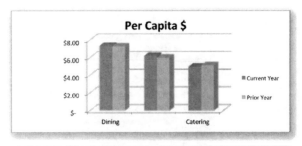

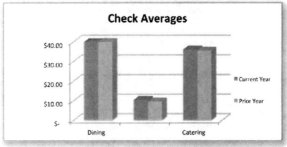

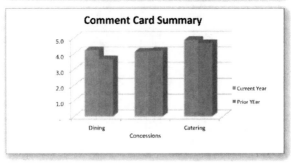

Figure 2: Sample weekly metric reports

3

Success Planning for a Historic Home's Visitor Center

The following report was prepared for a Historic House which attracts several hundred thousand visitors a year. There is currently a small café in one of the separate buildings on the property (see plan on following page).

However, the organization has had a long-term vision to be able to provide lunch service to its visitors. It has experimented over the years, providing various forms of lunch service at the property with support from local caterers.

Lunch would be viewed more as a visitor amenity than as a potential profit center, but the organization does not want to offer it unless it can be financially self-sustaining.

The organization wants to examine the feasibility of building a visitor center to house ticketing, café, gift shop and restrooms in order to enhance the visitor experience and asked us to provide input on sizing for the café and gift shop.

Based on our recommendations, the House engaged an architect to take this basic sizing information and see what that converted to with an actual structure – taking into account local codes and ordinances.

The resulting report examines:

· The issues to consider in building a new

visitor center to house a café and shop, and
possibly also ticketing and meeting facilities.
- How large the new visitor center should be.
- Where on the property should it be located.

Site plan

Visitor Center Foodservice Study and Evaluation

The Historic House is considering building a permanent visitor center at its property to replace current ticketing and seasonal temporary (and tented) café locations which are located near the entrance to the property.

The House has asked us to provide input for the total square footage required for visitor foodservice and related services at five potential locations for the new visitor center:

- Current ticket location near the main entrance.
- North West location.
- North East location.
- South West #1 location.
- South West #2 location.

To assist us, the House has provided historical visitor and lunch counts.

The House is open early in the season from 9am to 5pm (last tour) or from 9am to 6pm (last tour) depending on the time of year.

In reviewing visitor counts for several months, we have made an estimate of what the average busy day is each month as follows:

- Month 1: 1,200
- Month 2: 1,300
- Month 3: 1,700
- Month 4: 2,000

We have estimated the average busy day because planning and programming should be based on the average busy day, assuming the physical space for dining and capital for build-out is available. If the average busy day is used, then the café is right-sized to service the majority of days that month. For the days the visitor counts exceed the average busy day number used, then most café operations can stretch to accommodate larger numbers on the few days per month the total visitor count exceeds the average busy day.

If the House agrees with the assumptions for monthly average busy days, and assuming you want to take a conservative approach (as it relates to total café size and capital cost to build-out), we recommend basing programming on 1,500 average daily visitors for inside, climate-controlled dining areas and supporting higher visitor counts with outside, adjacent patio dining – acknowledging that there is no guarantee that patio dining seats can be used every day if it's not at least in the covered patio.

In reviewing data provided, it appears that historical lunch versus visitor attendance participation at the current café is running at 10% to 15%. Given the physical location of the current café and its size and seating (not including what the House is or is not doing with advertising, promotion and marketing) this percentage participation seems consistent with industry standards and provides us with some basis to look at prospective participation for the new café.

Based on the House's criteria, food and beverages for the café are defined as follows:

- 100% pre-packaged sandwiches, salads, snacks, cold beverages, desserts and bakery items prepared at an off-site kitchen.
- The only on-site prepared menu item would be brewed coffee, possibly, optionally, including an espresso machine.

Recommendations

The café concept: The style of operation is defined as follows:

- 100% customer self-service at a walk-up counter and customer self-serve refrigerated and dry cases in straight-line configuration.
- Primarily for in-season lunch service (about 11.30am to 2.30pm); however, could be open 1-hour after the House opens to 1-hour before the last visitors leave in-season to provide a place for visitors to sit down and have a beverage or snack.
- Efficient queuing system.
- Sufficient POS (point-of-sale) stations to optimize speed of service; POS station(s) at end of counter and possibly at a second location away from counter for peak hours.
- Both inside seating and outside seating can be considered; however, for our study purposes, inside climate-controlled seating should be sized to handle the average busy in-season day not dependent on outside seating that may or may not be suitable to use (due to heat, rain, etc.) everyday.
- Sustainable/green as it relates to disposable ware and recycling containers.

- The café dining and seating area should be such that it can be multi-purpose and used for meetings when not in use for seasonal lunch service.

Café menu: Pre-packaged (prepared off-site at the caterer's kitchen and delivered once each day, including third-party vendor-provided items such as napkins, coffee cups, lids and sleeves, individually packaged condiments, coffee creamer, etc.):
- Sandwiches
- Salads
- Bakery items
- Snacks
- Beverages (only brewing coffee and espresso)

The above includes healthy, vegetarian and vegan options.

Café infrastructure (back-of-house, storage, sizing and the like): Should include but not be limited to:
- Inside dining/seating area principally with tables for two and four guests, with the assumption that the tables and chairs will be multi-purpose and will be able to be used for after-hours and off-season meetings and

functions.

- Outside covered or shaded dining and seating area that is 50% of the size of the inside dining and seating area (the purpose of the patio dining is to enable the café seating to accommodate the busy days).

- Table and chair storage to store up to 50% of the dining tables and chairs when the dining area is used for meetings or receptions.

- Seating should have space to handle strollers and high chairs.

- Condiment stand on wheels that can be moved out of the dining room, or to a different location within the dining room, for after-hours use.

- Self-bussing trash/recycling containers in the dining room and patio.

- Microwave oven behind the serving counter may be used to heat-up customer bakery items upon request (like a muffin).

- Sufficient on-site refrigeration to handle one day's customer counts, to minimize the need for the supplier of prepared food (and beverages) to have to make multiple same-day deliveries to the café.

- Sufficient on-site dry storage for non-

perishable food and non-consumable supplies for three to four daily turnovers of the inside dining seats.

- Public restroom(s) based on local code (and confirmation that this suffices for foodservice staff).
- Enclosed (out of public view) trash storage (where back-of-house delivery door is located) to accommodate recycling needs based on local codes and ordinances and the House's preferences.
- No office or desk space is needed for the café manager or staff person (drop safe required; money counted and reconciled where the House handles tickets and gift shop operations).

Shop component: We recommend considering including a small retail/gift shop component strategically located as part of this new structure, highly visible to café customers going into and from the café space. Total square footage including storage space of +/- 500 sq.ft.

Café sizing: The House has asked our opinion and recommendations as it relates to locating the café and related activities at five alternative locations:

- Current ticket location near the main entrance to the property (highest potential participation).
- North West location (isolated and likely low participation).
- North East location (visible to visitors exiting House).
- South West location #1 (isolated and likely low participation).
- South West location #2 (possibly more visible from the House but isolated).

The House has expressed concern about which location to use due to limited parking at the nearby parking lot. Having an on-site lunch location will slow the turnover of cars in the parking lot. So, while the café amenity is desirable for the visitor experience, not having the café located where it will optimize visitor participation might be the best way to go, subject to further study of parking, ticketing and related issues.

Based on industry standards and our experience, the closer the café is to the entrance to the House and the more visible it is, the higher the visitor participation. (Not including how much or how little advertising, marketing, promotion and on-site

signage is undertaken, which can also dramatically impact participation, regardless of the location.)

Of the five possible locations, following are the locations we recommend the House should consider with estimated daily visitor lunch participation (lunch purchases only, not including beverages or snacks during morning or afternoon hours). The recommendations are provided from a visitor service standpoint, with the aim of getting optimum visitor participation, whilst appreciating that the House may not be able to do this due to parking limitations.

Estimated visitor participation percentages are based on the following assumptions:

- Some House visitors might have already had lunch at a nearby location.
- The House is advertising and promoting the café on its website and printed material and has appropriate directional and informational signage on-site.
- Location of the café (i.e., visibility to visitors, closeness to entrance/exit to the property).
- Café size, seating, etc. based on our recommendations.
- Industry experience, which indicates there is the potential for a minimum of 25%-30% daily visitor lunch participation if the most

visible and high-traffic location is selected with optimum signage, advertising and promotion.

Café location	Estimated % of visitor lunch participation
1. Current ticket location near entrance	25%
2. North East location	20%
3. South West location	15%
4. North West location	10-12%

Translating these estimated participation levels into estimated daily lunch customer counts, we would look at the House's average busy visitor count days (below) and determine what number the House wants to use for planning the space requirements:

- Month 1: 1,200
- Month 2: 1,300
- Month 3: 1,700
- Month 4: 2,000

We recommend using 1,500 as the average busy day, noting that:

- The proposed programming can easily be adjusted up or down based on the House's preferences, physical and capital limitations.
- The proposed programming at 1,500 average

busy day visitors is programming for inside, climate-controlled dining space only (additional patio seating would enhance capacity), serving line, POS, queuing, and back-of-house storage/support.

- We assume the House would like to be conservative in relation to café size (footprint) and total capital cost to build-out.

Assuming that lunch purchases will happen primarily during a three-hour period (which approximately matches-up with the peak serving period at the current café), following are the criteria we would use to estimate inside seating requirements using the North East café location in the table above for illustration:

- 20% x 1,500 visitors = 300 lunch customers.
- Assuming seats will turnover within 45 minutes, that means the inside dining room can turnover four times during a 3-hour period.
- Normally the total number of seats are only about 85% occupied, depending on the type and sizes of the tables (2-tops, 4-tops, etc.)
- 300 lunch customers with four turnovers would mean about 75 lunch customers per turnover.

- With about 85% seat occupancy we would need about 90 inside seats to comfortably accommodate 75 lunch customers at one seating.

As recommended above, we recommend adjacent covered patio seating, thus adding 50% to the inside seating which, based on the above illustration would add 45 outside seats, which we would recommend be primarily tables of four seats.

Café location: Our recommendation as to the best location for the café is affected by client variables, issues and concerns including but not limited to parking availability and wanting cars to turnover as quickly as possible in the parking lot, for example. Optimizing the percentage of visitors that use the café will likely increase the amount of time the average car is in the parking lot.

Most cultural institutions provide visitor foodservice to enhance the visitor experience and increase the length of the visit. The best location to accomplish this would likely be Location 1 followed by Location #2 and then Location #3 as detailed above.

The House needs to weigh the pros and cons of each location based on prospective utilization and related issues and concerns.

Café programming: Following is our recommendation of space requirements for the café based on the #2 and #4 locations above and including the criteria proposed in this report:

- Café with inside and outside seating.
- Back-of-house and infrastructure to support the concept and style of service detailed above.
- Ability to convert inside seating/dining area for multi-purpose meeting space for evenings and off-season including table storage and audio-visual needs.
- Small gift/shop retail component.
- Restroom(s) to meet local code for public and employee use.

Based on the estimated square footage required to build-out #2 (North East location) detailed below (around 4,400 square foot building, plus around 1,530 square feet developed exterior space), an idea of the total space required for the other three locations may be calculated as follows:

- Add approximately 18% to the building and 25% to developed exterior space to the total #2 square footage for location #1.
- Reduce the #2 total square footage by

approximately 18% for the building and 33% to developed exterior space for location #3.

- And for location #4 reduce the #2 total square footage in the range of 28%-35% for the building, and reduce 40%-50% for exterior space.

Program building location #2 (sq.ft.)

Interior

Dining: 90 seats @ 16 sf	1,440
Servery and circulation: 90 @ 9 sf	810
Pantry/storage: 90 @ 2.5 sf	225
Retail/storage	500
Toilets/janitorial (est.)	500
MEP [1] (est.) @ 10%	350
Subtotal	3,825
Planning factor @15% (est.)	575
Total	4,400

Exterior

Patio: 45 seats @ 30 sf	1,350
Service yard: 90 @ 2 sf	180
Total	1,530

1. Mechanical and Engineering Plans

Program building location #4 (sq.ft. range)

Interior

Dining: 45-54 seats @ 16 sf	720 - 865
Servery and circulation: @ 9 sf	410 - 485
Pantry/storage: @ 2.5 sf	120 - 135
Retail/storage	500 - 500
Toilets/janitorial (est.)	500 - 500
MEP (est.) @ 10%	230 - 250
Subtotal	2480-2735
Planning factor @15% (est.)	370 - 415
Total	2850-3150

Exterior

Patio: 25 seats @ 30 sf	750 - 750
Service yard: 50 @ 2 sf	100 - 100
Total	850-850

Café location	Estimated building sq ft
1. Current ticket location near entrance	+/- 5,200
2. North East location	+/- 4,400
3. South West location	+/- 3,600
4. North West location	+/- 2,800 - 3,160

4

Updating Rentals and Contracts
After a Museum Renovation

The report which follows was prepared for a fine art museum which attracts several hundred thousand visitors a year. Due to its urban setting, its visitation is not dramatically affected by seasonality. Current provision consists of a self-service café, a courtyard coffee cart, and catering services.

The organization has a long-term contract with a national operator for its visitor food services and catering. The Museum has been going through a long renovation and expansion and will be re-opening to the public in 18 months, and wants to evaluate the current café, coffee cart and catering operations as well as its own organizational staffing to support facility rental programs.

The current operator contract is a subsidized management fee agreement, due to the long-term renovation and reduced visitor counts during this period. The Museum wants advice on the contract options, financial implications and renegotiation strategy for a new contract with their operator once the Museum re-opens to the public.

The resulting report examines:

- Facility rental pricing and policies.
- Benchmarking local market pricing for facility rentals.
- Recommended facility rental policy and prices.

The Field Museum, Chicago, Illinois, USA © Botanicals

Facility rental, special events and foodservice operations study

Museum organization

The Museum's existing organizational structure is similar to many cultural institutions across the country. However, in practice, the functions and responsibilities as they relate to foodservice, facility rentals and special events is split across the organization, creating inefficient communications, and sometimes conflicts of goals and execution.

Currently, the Director of Events and Food Service Operations oversees the foodservice operator and reports to the Vice President and Chief Financial Officer (CFO). The Director of Events and Food Service Operations is a conduit of information related to the foodservice operations, including sales and statistical information. Much of this information is very thorough and provides some of the best-detailed information we have observed at any institution. However, it appears that this position is not regarded by all as the "point person" for all foodservice related issues, and multiple channels of communication have developed. This can lead to conflicts of direction and has been known to create confusion for the operator before and during events, leading to compromised

guest service. Furthermore, it appears that non-catering issues and daily foodservice operations are directed to the CFO and bypass the Director of Events and Food Service Operations.

Why does this matter? Without the recognized point person for these issues, it has been known to cause conflict between departments and scheduling resources, resulting in less efficient service to the customer. It is not uncommon for potential customers inquiring about a facility rental, catering, Museum tour, or parking to have to make multiple phone calls to arrange these various services independently. There have been several examples of important, sensitive events (i.e. Chairman of the Board of Directors dinner event) that were booked by one department and not known to Special Events or the catering providers until the day before (fortunately, this group is resourceful and was able to provide the service flawlessly even with this lack of efficient communication).

Marketing efforts have been coordinated between the foodservice operator and the Vice President of Marketing and through this collaborative effort they have developed some excellent marketing materials. However, this marketing support has been inconsistent and is not supported by a formal

budget for the foodservice department. This creates a missed opportunity to consistently and methodically include foodservice and facility rental advertising in the public domain.

The development staff have an active relationship with foodservice and the special events group. As is typical, many events that are planned annually focus on fundraising and corporate partners. Included in the development staff is an Events Officer who works directly with the operator to plan and organize these events. This position includes the event logistics, menu planning, invitations and tracking RSVPs, design, client packages, mailings, etc., covering the requirements outside the normal scope of services provided by the Special Events Group and the operator. There have been occasions when the catering delivery at these events has not been up to the expected standard or there have been errors and overbilling for the services provided. This reinforces the previously noted finding regarding too many levels of communication with the Special Events and Catering group. There is a need to establish a clear chain of communication, roles and responsibilities.

Development has obtained unique support with some corporate partners that include, among other things, free lunches for school groups. This seems

to be a win–win: the corporate partner supports the community, the school kids enjoy a day at the Museum, and foodservice sells a pizza lunch.

Development also has printed a brochure listing the various levels of membership benefits. As is typical, the higher the level of membership, the more benefits that accrues. This includes a *Waived Facility Use Fee*, but does not define which venues or when. This has created an environment of continuous negotiation for fee reductions between Development, the Administration, and Foodservice. For example, it does not make sense to waive a $10,000 rental fee to a $5,000 donor. It is not clear from our interviews or from printed materials what the Corporate Member can expect in this regard.

Facility rentals and catering operations

Activity and pricing: Facility rentals and catering have been fairly active despite the ongoing construction project. Activities are tracked in three categories: External, Internal and Auxiliary Services. We reviewed the statistical and financial summaries for each of these groups for the recent fiscal years and the current year-to-date. The following charts summarize this activity for each group (it should be noted that during the current fiscal year, the Museum was

Museum - External Clients			
	Year 1	Year 2	Current
Events	75	66	48
Guests	9,619	6,701	5,157
Invoice Total	$780,601	$678,964	$585,787
Average / Guest	$ 81.15	$ 101.32	$ 113.59
Food & Beverage	$ 37.74	$ 41.42	$ 51.30
Liquor	$ 8.84	$ 14.11	$ 19.80
Gratuities	$ 7.75	$ 9.04	$ 11.54
Set Up/Tear Down	$ 3.36	$ 2.35	$ 4.17
Room Rentals	$ 7.21	$ 16.38	$ 17.15
Security	$ 3.06	$ 4.36	$ 3.64
Equipment	$ 2.56	$ 1.49	$ 0.95
Other	$ 10.64	$ 12.17	$ 5.06
Total	$ 81.15	$ 101.32	$ 113.59

Museum - Internal Clients			
	Year 1	Year 2	Current
Events	126	126	43
Guests	6,813	6,553	2,898
Invoice Total	$191,577	$189,588	$50,772
Average / Guest	$ 28.12	$ 28.93	$ 17.52
Food & Beverage	$ 18.71	$ 16.98	$ 12.83
Liquor	$ 1.75	$ 2.01	$ 0.48
Gratuities	$ 3.52	$ 3.25	$ 1.83
Set Up/Tear Down	$ 4.14	$ 4.03	$ 0.97
Room Rentals	$ -	$ -	$ -
Security	$ -	$ 0.54	$ 0.82
Equipment	$ -	$ 1.72	$ 0.27
Other	$ -	$ 0.40	$ 0.32
Total	$ 28.12	$ 28.93	$ 17.52

Museum - Auxiliary Clients			
	Year 1	Year 2	Current
Events	82	85	41
Guests	4,729	5,023	1,821
Invoice Total	$192,840	$287,294	$51,118
Average / Guest	$ 40.78	$ 57.20	$ 28.07
Food & Beverage	$ 29.75	$ 27.91	$ 17.77
Liquor	$ 4.00	$ 4.39	$ 3.10
Gratuities	$ 5.03	$ 4.84	$ 3.43
Set Up/Tear Down	$ 1.73	$ 8.33	$ 1.51
Room Rentals	$ -	$ -	$ -
Security	$ -	$ 1.90	$ 1.82
Equipment	$ -	$ 7.41	$ 0.20
Other	$ 0.26	$ 2.41	$ 0.24
Total	$ 40.78	$ 57.20	$ 28.07

Figure 1: Facility rental and catering pricing

entirely closed for five weeks due to construction).

These summaries demonstrate the different rental policies and discounts available to each group. It is noted that External costs per guest have steadily increased each year, in most categories. The overall billings have increased 139%, and liquor sales increased 224% since 2004. This supports the public perception that the Museum is an expensive venue to host an event.

Customer and client surveys: To help understand the public perception of the Museum, we conducted a phone survey of *current* customers and clients (that have used the Museum's catering within the past year), *former* customers and clients (that have not used the Museum for at least one year) and *lost* customers and clients (that inquired about the Museum's catering but went elsewhere). We called 38 customers and clients and were able to survey six current, three former and one lost customer or client. Following is a synopsis of their comments:

1. *Current customers/clients*: Most of these clients oversee multiple events like the ones held at the Museum. They use the Museum for its unique environment. Most events were tied to the Museum's program (special art exhibit, tours, etc.) The most common competitor named is The ABC History

Museum. Other cultural venues in the Museum's area were not considered viable options for the type of events they were hosting. Five of the six clients were *Completely Satisfied* and the one was *Satisfied*. Comments included:

- Our guests all raved about the event.
- Fabulous event.
- Wonderful job.
- Courtyard is a great option.
- Location is great.
- Fantastic staff to work with.

Two clients raised the cost issue:

- Prices are high – surprises on our bill. Not aware of all the add-on costs.
- Cost is an issue at the Museum – parking and add-ons add up.
- Need to create menus for different budgets.
- Started the event thinking $50/person, ended up at $150!
- There should be a choice of caterers.

2. *Former customers/clients*: Three clients were interviewed. Each hosted one event. The most common competitor named is The ABC History Museum. All deliberately alternate their event at different venues

each year. This is not an issue with the Museum.

All three were *Satisfied*, but not *Completely Satisfied*. Comments included:

- Replenishment of food stations too slow.
- Only one bartender for 80 people; too slow.
- Sound system was not right for the room.
- Not enough time to view the collection after dinner.
- I've been to better events at the Museum.

3. Lost customers/clients: Reached one client. Planning a dinner for 75. Chose another location because it was closer to where their employees and guests are located. The Museum is pretty expensive: "A cost for everything… even a cost to hang your coat."

We noted that six *Below Expectation* comments are related to pricing, another six are related to service, and two are related to the billing process (Figure 2).

We also observed the set-up and planning for a catering event during the on-site visit. The details of the planning, menu execution and service appeared high quality and consistent with other high quality catering services in similar fine art museums. The comments noted during the survey related to larger events and were influenced by the construction and facility challenges at the time.

Factor: Overall summary	Exceeded Expectation	Met Expectation	Fell Below Expectation
Selection of items/ menu variety	5	5	
Selection at price point you wanted		7	3
Pre-event coordination (Museum staff)	4	6	
Availability of Museum staff when needed	3	7	
Flexibility with any changes	3	7	
Operator catering communications	5	3	2

At Event Factors	Exceeded Expectation	Met Expectation	Fell Below Expectation
Food quality/ temperature/taste	3	7	
Speed of service	2	5	3
Operator catering staff attentiveness	3	6	1
Atmosphere/décor	4	6	
Presentation/ appearance	2	8	
Value for price	1	6	3
Portion size	1	7	
Post event follow-up billing (Museum)		8	2
Post event follow-up billing (Operator)		8	2
TOTAL	24%	65%	11%

Figure 2: Customer and client feedback

Catering policies: The pricing/cost issues and invoice issues are related. Current practice is to charge for multiple costs incurred including:

- Food and beverage (per person charge).
- 18% gratuity – collected but not distributed to employees. Operator employees are paid competitive rates and do not rely on gratuities as part of their pay. This essentially becomes a contribution to overall catering profits. (The industry standard is to charge a Service Charge when the amount is retained by the caterer and not paid to staff; if called a Gratuity it leads the customer to believe that these dollars go to the staff when, in fact, it is just a higher price in disguise.)
- Alcohol (consumption).
- Room rental fee.
- AV services (if used).
- Parking (if wanted).
- Set up and tear down – charges (mandatory).
- Security (actual hours used for each guard).
- Bartender and carvers (if used).
- Visitor services (actual hours used).
- Building maintenance (actual hours used).
- Administrative fees.

These are usually detailed in an advance quote, but it can often take weeks after the event to capture all the actual costs for security guards, building maintenance, etc. The invoice can become overwhelming with so many line items detailed. This all contributes to the public perception of the Museum being too costly.

We noted that the operator has charged for client tastings, contrary to industry norms. Most caterers, in similar fine art museums, will provide tastings at no charge, or if there is a charge it is waived if the group books the event.

Local market benchmarks: We compared other local rental venues to the popular Museum venues (Figure 3). This clearly demonstrates that the Museum is at the top of the local market, even before many of the added charges for security, administration, etc. The Museum is unique, and this has been the primary driver for events held there. The question is, will the Museum's uniqueness continue to support the rental rates and additional add-ons into the future?

Facility rentals: In the last fiscal year the Museum collected $109,750 in room rental fees. This is compared to potential income of $2.6 million for this space if fully rented at current rates (see Figure 10 for Space Inventory Analysis).

Location	Venue	Reception	Seated	Price	$ / person
Museum	Grand Hall	500	300	$ 10,000	$ 20.00
Museum	Artist Court	300	200	$ 5,000	$ 16.67
Museum	Courtyard	200	150	$ 2,500	$ 12.50
Symphony	Music Hall	750	320	$ 3,000	$ 4.00
Symphony	Atrium	450	200	$ 750	$ 1.67
City History Museum	City Streets	500	200	$ 2,500	$ 5.00
ABC History [1]	Ballroom	600	350	$ 2,000	$ 3.33
ABC History [1]	Tavern	-	180	$ 400	$ 2.22
ABC History [1]	Café	-	130	$ 400	$ 3.08
ABC History [1]	Museum Floor	1,500	700	$10-$15 / pp	$10-$15

1. ABC History pricing subject to food & beverage minimums

Figure 3: Local market catering venue pricing comparisons

This would suggest that the space is generating 4% of its potential assuming 100% utilization. Of course, it is not feasible to think that all space would be rented at every opportunity, but it does demonstrate the upside potential if these spaces were viewed as perishable products that expire every day that they go unused. (This is a similar concept to how hotels view their occupancy rate.)

Many museum clients will manage their inventory of facility venues by first reserving the dates and spaces needed for internal events and key donors or Corporate Partners. After these dates are reserved, the remaining inventory is released and available for rental.

This leads us to the break-even analysis relative to rental pricing and policies. If the Museum were to forfeit certain add-on charges and/or lower the rental rates, how many more rentals would be required to break-even with last year's income?

Figure 4 indicates that the Museum would need to average one more rental per week to cover the income lost if these add-ons were discontinued. The average event would cost the customer $1,746 less on their invoice, or $17.20 per person savings.

Catering prices: local benchmarks: Finally, we used a mystery shopper to conduct a market comparison

Add-On $	F/Y 1	Average Rental	# Rentals To Break Even
Set Up/Tear Down	$ 15,755	$ 2,214	7.1
Security	$ 29,239	$ 2,214	13.2
Administration	$ 5,412	$ 2,214	2.4
Visitor Services	$ 4,233	$ 2,214	1.9
Gratuities	$ 60,604	$ 2,214	27.4
Total	$115,243	$ 2,214	52.1

Figure 4: Rentals required to break-even

for two fictitious events by calling six area catering venues to compare responsiveness, pricing and overall charges.

Each was told that we were interested in a reception for 250, strolling dinner and a separate event that would be a seated dinner for 50. Surprisingly, our shopper found it very difficult to get professional responses or eager assistance from most venues, except for the Museum. She was most impressed with the response, follow-up and information provided by the Museum team. However, she did need to make two calls, one to check for room availability and one to get catering information.

The reality of this market comparison (Figures 5-6) indicates that the Museum falls into the middle of the market compared to other unique cultural destinations in the area. Certainly, less expensive options exist with hotels, banquet halls and restaurants, but it would not be practical or expected

50 Guest Seated Dinner	Museum	Symphony	ABC Historic Estate	ABC History-Tavern
Rental	$ 2,500	$ 1,200	$ 325	$ 400
Set Up	$ 300	$ 1,300		
Security	$ 600	$ 750		
Visitor Services	$ 75			$ 50
Maintenance	$ 75			
A/V	$ 200			
Admin Fee	$ 50			
Valet	$ 20	$ 315		
Other		$ 302		
Non Food Total	$ 3,820	$ 3,867	$ 325	$ 450
Reception	$ 750			
Dinner	$ 2,375	$ 2,450	$ 3,300	$ 3,275
Beverages	$ 975	$ 1,060	$ 1,624	$ 3,900
Bartender	$ 150		$ 100	
Staffing		$ 1,029		
Other		$ 130		
Tax	$ 246	$ 512	$ 321	$ 457
Gratuity	$ 738	$ 1,622	$ 1,016	$ 1,449
Food Total	$ 5,234	$ 6,803	$ 6,361	$ 9,081
Grand Total	$ 9,054	$10,670	$ 6,686	$ 9,531
$ / Person	$181.08	$213.40	$133.72	$ 190.62

Figure 5: Market comparison for 50-guest dinner

to try and compete with these on a price basis.

One difference that does stand out regarding the Museum estimates is the number of add-on charges, helping to create the perception that there is a "charge for everything". While these comparisons are not necessarily statistically significant, they did highlight a few advantages for the Museum:

- The responsiveness of the Museum staff

250 Guest Strolling Dinner	Museum	Science Museum	ABC Historic Estate	ABC History-Museum
Rental	$ 5,000	$ 5,000	$ 500	$ 2,500
Set Up	$ 500			
Security	$ 800			
Visitor Services	$ 150			
Maintenance	$ 150			
A/V	$ 400			
Admin Fee	$ 250			
Valet	$ 1,000	$ 1,045		
Other				
Non Food Total	$ 8,250	$ 6,045	$ 500	$ 2,500
Reception				
Dinner	$ 10,000	$ 10,000	$ 20,250	$ 20,000
Beverages	$ 5,000	$ 2,425	$ 1,313	$ 1,451
Bartender	$ 300	$ 800	$ 400	$ 400
Staffing	$ 200	$ 3,000	$ 250	
Other		$ 6,250		
Tax	$ 900	$ 1,112	$ 1,593	$ 1,449
Gratuity	$ 2,700	$ 3,521	$ 4,097	$ 4,590
Food Total	$ 19,100	$ 27,108	$ 27,903	$ 27,890
Grand Total	$ 27,350	$ 33,153	$ 28,403	$ 30,390
$ / Person	$ 109.40	$ 132.61	$ 113.61	$ 121.56

Figure 6: Market comparison for 250-guest dinner

was far superior to the other venues. Others contacted either did not call back, or told our shopper to go online and look at their website. Very few were willing to give quotes or send materials. This is surprising considering the condition of the economy. We would think that these caterers would jump at the chance to book these types of events.

- The Museum is not necessarily more expensive than the others.

Catering support facilities: The operator and the Museum staff have had to be very resourceful during the construction period at the Museum. While the catering kitchen is very well equipped, it is in the basement and must rely on the one and only operating elevator to transport the food up to the first or second floors where the events are held. This elevator is also shared by the guests, creating long wait periods. This will be resolved with additional elevators in the building once construction is completed, but for now, it has been an issue impacting the operator's ability to quickly respond to catering demands.

In addition, there are no formal catering support spaces, either now or planned after construction, to support the Grand Hall or Artist Court venues. The operator has been designated certain locations in hallways or galleries to set up support space, but is always temporary and lacks the desired infrastructure of running water, ice, staging space, etc. While this is often common, especially in older museums, and caterers know how to work around these issues, it is unfortunate that the opportunity to remedy this during the renovation of the building was not considered.

The operator

Financial results: The operator has been the contracted foodservice operator for 13 years. They provide the service for the visitor foodservice, *Café Museum*, *Courtyard*, and all on-site catering services on an exclusive basis. They operate under a management fee/full subsidy contract requiring the Museum to reimburse all operating losses plus a management fee.

The Café Museum is a new facility opened last year. Prior to the Café Museum, all visitor foodservice was located in the Courtyard. Currently, the Courtyard is used for the Museum staff breakfast service and to serve coffee and light snacks for visitors throughout the day.

The past few years have not been good years to compare financial results as the construction has closed two-thirds of the Museum; it has also been closed for five weeks in the current year creating an inconsistent visitor flow. The table at Figure 7 compares the operator's results of the last two years.

More recent financial statements indicate an improving trend for the net subsidy with the latest year-to-date results showing a $94,000 (19%) subsidy versus $157,000 (35%) for the same period in the previous year.

Operator Operating Results		
	Year 2	Year 1
Café	$ 440,748	$ 441,089
Cart	$ 34,473	$ 14,697
Catering	$ 506,121	$ 558,014
Other [1]	$ 113,166	$ 122,944
Total Sales	$1,094,508	$1,136,744
Food Costs	$ 385,979	$ 391,839
	35.3%	34.5%
Labor Costs	$ 732,501	$ 756,482
	66.9%	66.5%
Other Costs	$ 205,664	$ 186,667
	18.8%	16.4%
Mgmt Fee	$ 59,139	$ 60,991
	5.4%	5.4%
Subsidy	$ (288,775)	$ (259,235)
	-26.4%	-22.8%

1. Other Revenues include catering add-ons and the Museum discounts

Figure 7: Operator financial results

The operator did not provide a detailed operating statement for the various elements of their business until the current year. Prior to that, all business (Café Museum, Coffee Cart, and catering) was accounted for on one statement, making it difficult to monitor the profits or losses from each operation. The operator now provides separate statements for Café Operations and Catering.

We reviewed these financial statements and offer the following comments:

- Sales include the discounted value for members (10%) and Museum staff (25%). This is allowed per the contract and gives the operator a larger revenue base to calculate their Management Fee (about $3,000 impact per year). It can be argued that this is part of the "Managed Volume" by the operator, but it is somewhat unusual practice in the business.
- Food costs are in line with industry averages. We noted that the contract allows the operator to keep all rebates from supply vendors at their corporate office. This is typical in the industry, but can be a significant value.
- Labor costs are a heavy burden for this operation at 66% and they continue to be in the current year, with labor now at 74% year- to-date. We would point to the multiple managers as the prime cause, representing approximately 33% of labor costs. Currently there are four managers assigned to the Museum operation as follows: General Manager, Café Museum/Operations Manager, Executive Chef and Catering Manager.
- Labor staffing for the Café Museum and Courtyard are also heavy for the current business levels. However, we acknowledges

the challenge of staffing the Café's various stations which will be improved once the attendance returns to normal after the re-opening of the Museum. Benchmarks to monitor are: Customers/Clients/Labor Hour 2.7 versus industry standard 10-15; and Sales/Labor Hour $20.93 versus industry standard $30.00.

- Other costs are in line with industry averages.
- Management fee is 6% of revenues and is consistent with industry practices. However, among cultural institutions, management fee, subsidy contracts are becoming very rare. (Note – the Museum has acknowledged this and intends to implement a new contract with the operator after the re-opening of the Museum.)

Café Museum operations: We observed the Café Museum operations over a three-day period and found the operations to be generally very good with a wide variety, nice presentation, and friendly service. Following are comments regarding these observations:

- Café is bright, clean, and inviting.
- "Scatter System" or various food stations

confused some customers as they entered: not clear where to go.

- Signage and menu presentation not clear; need to simplify.
- Speed of service very slow for the daily specials/demonstration entrées. Stir-fry took over 15 minutes in-line. Server could have been more efficient with the three burners, but was only working one order at a time. Management should have noticed and stepped in or provided additional servers. This dish was disappointing, not much seasoned flavor.
- Grill items also very slow. Grilled salmon took ten minutes. This creates a dilemma and conflict of providing fresh-to-order food and wait time. The dish was very good once served.
- The Café advertises *To Go* for any item, but does not offer pre-made *Grab and Go* items. We have observed other operations with excellent *Grab and Go* menu items, merchandised and displayed very successfully. A few pre-made sandwiches were displayed in the deli cooler, but are not self-serve and are not merchandised in a way that makes you want

to buy them.

- The Pizza Station was closed on Thursday and Friday. Our experience is that pizza is a very popular item and inexpensive to produce. In addition to pizza, additional items can be made using the impinger oven like stromboli, calzone, and individual casseroles. The operator management's response was that business is slow and they only open the station when they know school groups are scheduled. We believe there is a missed opportunity at this station with a more creative menu.

- The Grill Station offered a wide variety: from the traditional burgers to steaks, salmon, and chicken breasts. We were surprised to see frozen hamburger patties versus fresh ground, hand-pattied burgers.

- Deli Station/*Jazz Salads* offered a nice variety of traditional delis, wraps and made-to-order salads. We noted that the breads were rather ordinary and croissants were frozen, without much taste.

- The Café Museum offers a wide variety of healthy options, although comments during interviews and customer comments would lead you to believe otherwise. Healthy options

 include: Salad Bar, Wraps & Delis, *Jazz Salads* made-to-order, a daily *Healthy Special* that is a combined package (not clearly advertised and hard to find), Grilled Chicken Breasts, Grilled Salmon.

- The dining room is nicely appointed, although a bit crowded at times. We noted that there are many missing chairs (we counted 40) that would help on busy days.
- The dining room is fully bussed by an operator employee. He was quick and courteous. Some customers (like me) did not know that they can leave their trays and were observed wandering the dining room looking for the tray return.

Who uses the Café Museum? We noted that it is mostly a staff dining room (Figure 8). Members and visitors together represent about 18% participation by all visitors attending the Museum. This is low compared to similar-sized institutions, in similar locations, and with similar admission policies, where there is 25%–35% participation.

Check average at the Café Museum is $5.57 and is lower than industry averages. Prices for café items were found to be competitive to similar institutions.

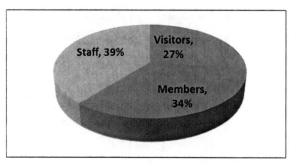

Figure 8: Café Museum customers

Courtyard: We also observed the Coffee Cart operation in the Courtyard. This is a beautiful area and invokes the feeling of a street café in Europe. Initially, this was not opened as a food venue after the Café Museum opened, but customer feedback was so strong that it was decided to offer the coffee cart and limited snacks. Following are our observations for this operation:

- The coffee cart is set up for staff breakfast and offers cereals, Danish and hot breakfast sandwiches.
- We noted it to be somewhat busy in the morning hours, with around ten customers, mostly drinking coffee or with a Danish pastry.
- The cereal and breakfast items were left out during the lunch period cheapening the

overall appearance of the space.

- Espresso-based drinks are offered, but very few were observed to be sold during this period.
- *Starbucks* coffee is offered in air-pots. Our coffee was luke-warm indicating the coffee had been sitting too long.
- The table and chairs are incongruous with the overall atmosphere.
- Average customer count is approximately 60 per day with sales of $140. Current operations are definitely a financial loss for the overall operations. We estimate the loss to be $7,000 to $10,000 per year depending on how much labor is assigned here.
- Generally speaking, we found no compelling reason to use this space except for the atmosphere.

Production/catering kitchen: We observed the kitchen operations from early morning through the lunch period. Following are comments relative to these observations:

- No formal production controls are in use, relying on *instinct* based on experience rather than *method* or documented records.

- There was no documented menu cycle in use. The current menu is loosely based on the operator's quarterly menu cycle, but not formally documented. Normally, we would expect to find a complete menu cycle for three, four to six weeks written out to ensure a good balance of recipes, colors, popular local items, etc. These menus would also capture sales data to identify popularity and quantities to aid in future production planning.

- Consequently, the operator is not measuring his actual food cost to "ideal" food costs. We acknowledge that the current food cost of 35% is good by most standards, but how do we know that it shouldn't be 31% or 29%? Given the high catering sales mix (50%), catering food cost is typically much lower than café food costs and the combined mix is keeping food costs low. But, ideal food cost is calculated by knowing what each and every recipe costs to produce, the actual number of items sold resulting in "ideal" or the "perfect food cost" assuming no waste. We know that the ideal food cost is never actually attained, but the margin between actual and ideal is

the gap that can be managed to smaller and smaller variances.

- Figure 9 provides an example of how Ideal Food Cost can lead to interesting management conclusions. In this case, the 38% food cost was actually "mis-managed" more than the 42% food cost. Keep in mind that these are the same products, costs, and selling prices in both examples. Just a different sales mix can create very different answers.

- Sanitation in the kitchen was not up to expected standards. Not terrible, but the details of corners, shelves, drawers, drains, carts, dusty air vents, etc. all showed need of a thorough cleaning.

- Stock was not dated when delivered. This was noted in the coolers (dressings, chicken, cheese, etc.) and dry storage. Without dating product as received, it is possible to have products that could exceed the proper shelf life if not rotated and put into production in a timely fashion.

- A safety issue was noted with a radio plugged into an extension cord sitting on a shelf above the pot and pan sink; this was immediately corrected by the chef.

Ideal Food Cost Example								
				Week I			Week II	
Item	Cost	Selling Price	# sold	Sales	Cost	# sold	Sales	Cost
20 oz Pepsi	$ 0.24	$ 1.19	20	$ 23.80	$ 4.80	15	$ 17.85	$ 3.60
20 oz Starbucks	$ 0.37	$ 1.65	15	$ 24.75	$ 5.55	15	$ 24.75	$ 5.55
1/4 cheesburger	$ 1.35	$ 2.39	5	$ 11.95	$ 6.75	20	$ 47.80	$ 27.00
Pizza Slice	$ 1.14	$ 2.99	9	$ 26.91	$ 10.26	10	$ 29.90	$ 11.40
Tuna Salad Sandwic	$ 1.27	$ 3.39	3	$ 10.17	$ 3.81	3	$ 10.17	$ 3.81
Total				$ 97.58	$ 31.17		$ 130.47	$ 51.36
Ideal Food Cost					31.9%			39.4%
Actual Food Cost					38.0%			42.0%
Unexplained Variance					6.1%			2.6%

Figure 9: Ideal food cost example

- The pot and pan sink sanitizer was not working. The chef was to follow up on this issue.

- An old wood-block table was in the kitchen. These are very hard to clean properly and can accumulate bacteria in the many cracks and grooves. The chef says the table is not used for food production, but it is a concern to have in the kitchen and must be cleaned with a stiff brush and proper chemicals (not bleach).

Operator Contract: The Museum desires to convert the existing management fee/ full subsidy operating contract to one that assigns more risk to the operator and reduces or eliminates the subsidy currently required. The operator is in principle in agreement. The Museum shared with us a preliminary draft of a contract document that attempts to accomplish this goal but, in our opinion, it would fall short and create

a complicated operating and accounting environment and possibly lead to operator issues due to financial problems.

The draft contract presented created the following basic conditions:

- The operator would operate the Café Museum on a full risk, profit and loss basis, with no subsidy.
- The operator would operate the catering services on a management fee, receiving only a 6% fee.

This is contrary to what is normally found in these types of contracts. Typically, a profit and loss contract with an operator is usually 100% P&L or, if there is a split contract, the catering portion of the business is the P&L segment, not the café.

The operator acknowledged that they are interested in this conversation, but have issues with the contract as presented and would want to discuss the terms in more detail before implementing this type of contract.

Recommendations

Organization

The Museum may want to consider consolidating the functions that touch the visitor under one position. This would help to streamline the communication and execution required to serve all the needs that arise related to visitors. We have noted some institutions defining this type of position as Director of Visitor Experience. This position would oversee the following type functions:

Service-related

- Food service and catering
- Facility sales and rentals
- Group sales
- Film theater operations
- Admissions

Technical

- Housekeeping
- Security
- Maintenance

A clear chain of communication within the Museum and Special Events Group needs to be established and reinforced to ensure that all clients (internal and external) are treated in a similar manner and that

the caterer (operator) is not responding to multiple bosses. Simply put, any event should go through the same process where the dates, menus, staffing, rental needs, set up, design, etc., are discussed, costed, quoted, and documented in advance, then left for the Special Events Group and operator to deliver. By clearly defining the roles and responsibilities of the Special Events Group, Caterer, Events Officer, etc., there should be no conflict in who does what and when.

The Museum may consider outsourcing the Facility Sales function. We note that some institutions are using their contracted foodservice operator to manage the Facility Sales function and more are looking at converting in this regard. The foodservice operator has the incentive and it streamlines communication. This can be covered in the master agreement and usually includes a percentage of sales (facility rental fees) booked as their compensation. The current operator has done this successfully at several of their other clients around the country.

Development should clearly define the benefits of various levels of corporate partners, especially as it relates to facility use and rentals. We have seen this successfully done by defining the rental venues as an A, B, C, D, etc. space. For example: A – Grand Hall

(Weekends); B – Grand Hall (Weekdays); C – Artist Court (Weekends); D – Artist Court (Weekdays); E – Courtyard (Weekends) ; F – Courtyard (Weekdays).

The facility use benefit could easily be defined for each level as *one free C Facility Rental* or whatever the appropriate benefit would be for that level. This would take (or reduce) the negotiation factor out of the facility rentals currently observed.

Marketing should be given a specific budget for the purpose of advertising and promoting facility rentals and foodservice activities. These should be considered with every direct mail, magazines, website as appropriate. Furthermore, this could be funded by asking the operator to contribute 1%–2% of food and beverage sales for this purpose.

Special events and catering

The Museum may want to consider modifying its rental policies to include wedding receptions and not-for-profit clients, with clear restrictions:

- Weddings could be restricted to the Courtyard and the New Grand Hall (not yet opened). Typically, there is a demand in the market for this type of venue for weddings, and the Museum should not be an exception.

- Not-for-profits could be considered on a case-

by-case basis to ensure there is no conflict with the Museum mission. This group, in particular, which was noted as active in the market is currently often turned away.

We recommend investigating a room management system to help manage the inventory of rooms and dates and avoid conflicts or miscommunication regarding special events. There are several good systems, but other institutions have recommended Dale Evans & Associates (www.dea.com) as a reliable and easy system to use. Using this type of system would allow the Museum to block out certain dates for internal needs and leave the balance of the inventory available for the Facility Rental Group to market and sell.

We recommend simplifying the catering invoicing process. We benchmarked other cultural institutions and found that most of the add-on charges itemized by the Museum are included in the basic room rental fee. We also noted that most local venues include these costs in their basic fee. We demonstrated that while the Museum is not necessarily the most expensive venue in the city, the perception is that the Museum is too expensive. We further demonstrated that with one more rental per week, on average, these costs could be recovered. If the Museum chose not to

include all the listed add-on charges (e.g. gratuities), this cost recovery would be quicker. This would also speed up the invoicing process and should, as is common in the catering business, be finalized and collected the day of the event.

The operator should discontinue charging for client tastings. This is a normal cost associated with a catering business. Certainly, this assumes the client behaves in a reasonable manner and does not demand excessive tastings or an unreasonable number of tasters, in which case there could be a nominal charge on a case-by-case basis, which is waived if the client books the event as a way to discourage abuse.

Operator operations

The operator should re-evaluate the management structure and related costs to support the Café Museum and catering operations. We would recommend a reduction of at least one manager until the Museum re-opening, then evaluate if they should add the position back at that point.

Menu boards and promotions of daily specials are cluttered and confusing. We recommend simplifying the message and having a fresh look at how menus are organized and communicated. This is normally a strength of this operator and they may want to

consider using their marketing support resources to re-evaluate the marketing methods at Café Museum.

Speed of service issues should be addressed by additional server training and additional servers and equipment (butane burners). Production methods that don't compromise the quality (par-cooking meats ahead of time) will help move lines. This will become especially important once attendance grows after the Museum re-opening.

The Courtyard cart service should be closed during the construction period to save the current operating losses. When the Museum re-opens, this area could be re-opened as a unique service with a new look when visitor counts make it financially viable. We recommend if this is re-opened, the service cart should be built-in (possibly under the stairs?) to fit into the theme and look of the room. This can have a street café look and feel with new tables and chairs that help to express this theme. A simple, fresh menu could be offered along with signature coffees and beverages. This may include salads, fresh sandwiches, and soups not available in the Café Museum. It should be different and a draw of its own to be successful. This will also help to alleviate crowds in the Café Museum once the attendance grows to expected levels.

The Courtyard can also be converted into a unique

and different table service restaurant on special nights. This may include Friday nights in conjunction with the rotating entertainment scheduled. We envision wait staff with a unique, changing menu, with wines, beers, tablecloths, priced competitively with local restaurants or possibly offering a *Prix Fixe* menu. We have known this approach to be very successful at institutions around the country and it would offer a different experience at the Museum. It might possibly even turn into a "date night" option!

The operator should formalize the documentation of the menu planning and production records to help in the overall management of food production, purchasing and inventory controls.

Operator contract

We recommend starting now to renegotiate contractual terms with the operator to take effect when the Museum re-opens.

Triggers – when should the new terms start? Often this can be tied to certain milestones like attendance numbers, sales levels, etc.

We recommend a contract that is 100% profit and loss based and not split into part management fee and part profit and loss. A split contract creates accounting issues of allocating common expenses

(i.e. how much of the General Manger's salary should be in the management fee accounting?). This would require ongoing review, audit, etc., to ensure proper and accurate accounting and accountability.

If the Museum abandons the management fee contract approach, this will mean somewhat less flexibility as it relates to absolute control of menu pricing and hours of operation, for example.

Create a win-win contract that allows the operator the fair opportunity to make their required profits, but at the same time, shares the anticipated growth with the Museum. Conditions should be built into the contract regarding possible profit-sharing or commissions that grow as the business grows.

Consider assigning the control of the alcoholic beverage license and revenues to the operator in exchange for commissions paid to the Museum on these sales. The Museum would still own the license, but the daily management of the alcoholic beverages and related sales and resulting profits would be in the operator's control, simplifying the transactions with catering customers and incentivizing the operator to manage this portion of the business. It is important that this be clearly defined and commissions paid to the Museum are about the same as the net Museum income currently generated.

Space Availability	Average Capacity (Tables/chairs Classroom Style)	Days Available per Year 6 days/wk. = 312 5 days/wk. = 260	Times per Day Used Morning - Noon-1 Noon - Afternoon-1 Evening -1
Small Rooms			
Café Museum Conference	22	312	
Café Museum Board Room	45	312	
Total Small Rooms			
Medium Rooms			
Café Museum	150	312	
Gold Gallery	75	312	
Total Medium Rooms			
Large Rooms			
Grand Hall	300	260	
Artist Court	200	260	
Courtyard	150	260	
Total Large Rooms			
Totals			

Figure 10: Space availability

Use Opportunities per Year Inventory	Internal Requirements	Available External Marketing Inventory	Fee per Rental 100% Rental		Total Rental Income	
936	150	786	$	250	$	196,500
936	150	786	$	350	$	275,100
1,872	**300**	**1,572**			**$**	**471,600**
312	12	300	$	500	$	150,000
312	52	260	$	350	$	91,000
624	**64**	**560**			**$**	**241,000**
260	150	110	$	10,000	$	1,100,000
260	150	110	$	5,000	$	550,000
260	150	110	$	2,500	$	275,000
780	**450**	**330**	**$**	**2,500**	**$**	**1,925,000**
6,552	**1,628**	**4,924**			**$**	**2,637,600**

5

Foodservice Priorities for
a New Art Museum

The following report was prepared for a new Museum attracting several hundred thousand visitors a year. It is located in a small rural town and is not dramatically affected by seasonality. The Museum is well-funded and supported by local corporations interested in bringing high quality cultural events and organizations to the area.

Manask & Associates originally provided the Museum with space programming and foodservice operational projections and returned two years later to refine the space programming with the architect and re-project foodservice needs based on new design elements of the building. Contract strategies to consider when negotiating with potential outsourced operators were also provided.

The museum's food service consists of a self-service café, facility rentals and catering.

The resulting report examines:

- New museum space programming.
- Operational considerations.
- The coordination of space needs with the architect.
- Facility rentals.
- Catering services.
- Operator contract strategies.

Visitor foodservice, facility rental and special events study

New museum location

The central city by itself is a relatively small town. However, this is one of the fastest growing areas in the country with over 1,000 new residents per month, attracted by a reasonable cost of living and full employment. Several major corporations lead and support these communities. Many contractors and vendors to these companies are moving to this area.

The planned location of the new Museum is both attractive and challenging. The 100 acre parcel will connect with the central city in downtown via a gateway and path that will meander through the woods and down a valley about one mile back to the Museum and will include a quarter-mile Sculpture Trail. The gateway currently has a recently renovated home that serves as a small convention center and botanical garden.

The main car entrance is from the east and well outside of the downtown area, close to the main freeway. The Museum will not be visible from either downtown or the road, so clear signage will be required.

The Museum will be built in the valley and around

two man-made ponds, which will offer views of nature from almost every area. Glass, light, trees, and water will be the theme. The architects have provided space for visitor foodservice in one of the wings that will overlook lakes on each side and have glass walls and ceilings, creating a unique environment hard to match.

The special event and facility rental venues will include multiple spaces, ranging from small classrooms, expandable banquet halls, outdoor sculpture gardens, piazza and Grand Hall, and a 4,000 square foot glass island in the south lake.

The location and architecture of the Museum building will likely create an interest and draw as much as the art collection. To achieve the anticipated annual visitor attendance, it will need to draw on out-of-town visitors and tourists. Within about a two-hour drive are several much larger cities as well as tourist attractions.

The central city is aggressively preparing for the opening of the Museum and is hoping to attract a new downtown boutique hotel, restaurants, unique retail, and condominium housing. One of the driving missions of the Museum is to cultivate urban growth and it desires to attract business, not compete with it. There may be some operational synergies between a

new hotel and the Museum foodservice and catering needs which can be explored with the developer as plans for the hotel take shape.

Visitor foodservice

When developing the visitor foodservice model for the Museum, we need take into account several factors:

Visitor demographics.
Visitor demand (how many and when).
Local restaurant market and competition.
Additional Museum needs.
Style of service.

Visitor demographics: For the purpose of this report, we will assume visitor profiles and desires similar to our experience at many other art museums where we have completed studies.

Visitor demand: The Museum has refined the projected attendance range from 150,000 to 250,000 in the first year. For the purpose of this study, we will assume a fairly even demand throughout the year, with a heavier demand in the summer/fall and lighter in the winter/spring. Furthermore, as typical with museums, we will assume the demand to peak on weekends and holidays. In addition, the Museum

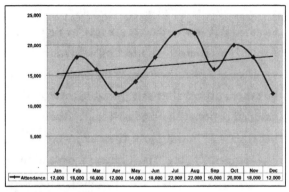

	Jan	Feb	Mar	Apr	May	Jun	Jul	Aug	Sep	Oct	Nov	Dec
Attendance	12,000	18,000	16,000	12,000	14,000	18,000	22,000	22,000	16,000	20,000	18,000	12,000

Figure 1: Projected attendance

expects approximately 15,000 students per year related to school trips, etc.

Using non-school-based visitor estimates of 200,000 and projected monthly and daily attendance trends, we can chart the anticipated visitor demand for foodservice as set out in Figure 1.

This data assumes the anticipated fluctuation in demand from as low as 275 visitors on a Monday in January to as high as 900-plus visitors on a Sunday in August. Obviously, it would not be advisable to build a café for either one of these extremes, but rather somewhere in between, with flexibility to grow and contract with the demand. The average demand would indicate to size the visitor foodservices to accommodate 500 to 600 visitors daily.

Local restaurant market and competition

We noted very few restaurants in the downtown area at this time. There is a collection of restaurants in two areas of town, the Express Boulevard area, and the other at the Walter exit from the freeway. Both included national chains, fast-food and some local favorites. We noted more than expected ethnic restaurants including Thai, Chinese and Mexican.

However, given the location of the new Museum, we do not consider any of these restaurants as competition for the future visitor foodservice. The Museum is isolated enough that visitors will not likely leave for other dining options and the setting is unique enough that it will attract diners from the surrounding community. The local restaurants should be considered relevant when considering style, menu and pricing. We noted, in restaurants visited during the study, that menus were creative, in tune with national trends and had higher than expected pricing.

We visited the following restaurants:

- *John's Place* – casual atmosphere, but up-scale grilled steak menu. Entrée pricing $25 – $45.
- *Willows Restaurant* – $35-$50 pricing.
- *Starbucks* – coffee house and pastries.
- *Panera Bread* – bakery, deli, soups, coffee, etc.

Pricing $3 – $8.

- *The Grill* – hunting lodge feel, creative menu with unusual combinations, pricing for lunch $9 – $15.
- *Woodfire Steakhouse* – traditional style, supposedly was the favorite of a local patriarch. Atmosphere linked to traditional charm with the owner walking the floor talking with regular customers. Steaks, chops, pit-style BBQ, etc. Pricing $15 – $25.
- *Burger Boys* – college-town-style bar and restaurant located in the cultural district of a nearby town. Burgers, BBQ, sandwiches, mug beer, etc. Pricing $6 – $10.
- *Thai Cuisine* – one of several Thai restaurants noted in the central city. Traditional Thai offerings and very good. Pricing $8 – $12.

A pricing analysis of the local market suggests that the market would support an average check of $9.00 to $15.00 for lunch service, including beverage and side dishes, the range having to do with style of service, ambience, etc.

Additional Museum needs: In addition to satisfying visitor demand for foodservice, it is important to consider additional needs for foodservice. At the

Museum, this will include:

- Catering and special events – the Museum has determined that it will outsource the foodservice management and catering rights. Given the current kitchen and support space configurations, it is doubtful that an exclusive operator can support all catering needs from the on-site facilities and will need to rely on off-site catering kitchens. This will likely lead to developing a list of approved caterers for these events and allowing the on-site operator to focus on visitor foodservice and some day catering. The catering support kitchen adjacent to the Grand Hall will allow for finishing and staging of events, but will need off-site support. The kitchen supporting the café will be exclusive to the café operator and should not be considered accessible to off-site caterers. For logistical reasons, this will lead to an exclusive operating deal for the café and catered events that take place in the Dining Wing.

- School and youth groups – school groups are projected to account for 10% of total attendance. However, this visitor group is not anticipated to use the café facilities and

is not included in the demand calculations. Many Museums we are familiar with have offered school and youth groups various levels of service ranging from pre-made sack or box lunches to vending machines in a designated lunch room. Our interviews did not indicate a strong demand for pre-made lunches and there was concern that many schools could not afford the costs of such a program. We recommend that this service be offered as an option for schools and youth groups to consider when arranging for their visit. A packaged box lunch can be offered at reasonable prices. These products are high quality, with stable shelf-life and variety to meet most needs. In either case, a separate room for these groups to take a break in or eat at should be considered. Spaces discussed included rooms of the piazza for this purpose.

- Motor coach groups – the motor coach market (tour groups) will likely be a significant market in the future planning of the Museum. Given the proximity to nearby major tourist attractions, it is likely that many tour operators may include the Museum on their planned tours to nearby attractions and it

should be considered in the planning to be able to accommodate a group of 40 to 120 visitors. We recommend that these groups either be allowed to use the café (if only one bus, or less than 40-50 people) or set up as a catered event in one of the special event venues, offering boxed lunches or deli buffet, etc.

• Staff and volunteers – it is anticipated that there will be some 100 staff and volunteers on site on any given day. Too often this group is overlooked when designing the café spaces and preparing operating plans. It is customary that this group is offered discounts in the café (10% to 20% depending on overall pricing strategy). In addition, the operator needs to be cognizant of the fact that this group is on site every day and needs variety much more than the two to three times per year average visitor.

Style of service: Our interviews revealed a consensus of vision for the style of foodservice. It was generally agreed that the service needed to be quick, offer a changing, but limited, daily variety and appeal to adult tastes with quality and uniqueness. It was

generally agreed that a modified self-service model would best match these needs.

There is interest in making the café an extension of the Museum mission. The overall theme should focus on state heritage, the celebration of the abundant nature and outdoor life, hunting, and local agriculture. Possible local specialty or signature items should be highlighted (game recipes, trout, pork tenderloin, etc.).

We have visited several museums for the purpose of benchmarking and have been impressed with the café and menu of the Kimbell Museum of Art in Ft. Worth, TX and the Skirball, in Los Angeles. We contacted these museums to obtain menus.

The Kimbell success comes from a creative operator that offers a very limited, but changing, daily menu of unique and freshly-prepared items. The menu usually offers soup, quiche, and a few types of sandwiches, salads, and dessert. The menu is priced reasonably and attracts many local luncheon customers.

The Skirball offers *Zeidler's Café* and features California Kosher Cuisine. The café is open for lunches, Sunday Brunch and Thursday evenings during the summer Sunset Concert series.

The Museum expressed the hope and goal that

its café will become a "must do" when visiting the Museum and a dining experience as unique as the building and environment; a place to meet for lunch.

With space use as critical as the menu, the current kitchen design is focused on table service concepts (as opposed to cafeteria support) and dedicates space for server pick up and support. The initial concept of also including a self-service buffet is a redundant use of space and we recommend that this area be changed to support the concept outlined below.

The model for this museum would consist of a unique local, fresh, changing daily menu that is displayed via high-tech LCD screens. The LCD screens allow for easy change to the menus, with highly visual media that can incorporate pictures, facts and other information to help the customer decide. This menu would include:

- A shortlist of fresh sandwiches, salads and soups.
- Specialty items from a daily changing menu of signature sandwiches, paninis, salads, hot soups and specialty entrées.
- Homemade desserts.
- Beverages including beer and wine (if permitted during Museum hours).
- A separate coffee bar with espresso-based

drinks as well as branded coffees (*Starbucks*, *Seattle's Best*, etc.) will be open before and after the main lunch period. This will likely offer a bakery counter of homemade scones, breakfast pastries, afternoon cookies, cakes, etc.

The customer would approach an order counter, place their order with a cashier, pay for their order and proceed to their table of their choice. With an assigned number displayed at the table, a server from the kitchen will deliver their order when ready along with beverages and desserts. While not quite a "full table service" concept, it combines the speed and flexibility of self-service without the cafeteria feel.

The café will likely be lunch service only during the public Museum hours, allowing it to be used for special events in the evenings. However, the Museum will be developing an active evening program of themed events that will be by reservation only and will include dinners and receptions as part of the evening. This will create a predictable revenue source that will be table service from a *prix fixe* menu. Other opportunities will include Sunday Brunch, especially for the obvious holidays (Easter, Mother's Day, etc.).

Foodservice revenue analysis

Using the projected visitor attendance, participation projections consistent with industry standards, and the average check observations noted above, we have prepared a Revenue Analysis that identifies the probable revenue range, from low to high, that can be expected from the café. This analysis indicates probable revenues of $630,000 per year as detailed in Figure 2.

This analysis assumes that the café will be positioned in an area easily seen and accessed by visitors without requiring paid admission.

With the given foodservice locations, kitchen and support spaces, the Museum should be aware that the logistics of running this operation will be quite complicated and will add to the labor and operating costs of the café. We estimate that at least one additional full-time-equivalent employee will be needed to receive and process deliveries at the loading dock, in addition to the internal deliveries needed between the remote storage area and kitchens. We have accounted for this in the following estimated profit and loss calculations at Figure 3. We project a small operating profit before any commissions or rent and not including catering revenues.

The figures also show a break-even point only 8%

Annual Attendance [1]	200,000
Participation % [2]	35%
Anticipated Customer Count	70,000
Average Check - Low	$ 9.00
Average Check - Mid	$ 12.00
Average Check - High	$ 15.00
Revenues - Low	$ 630,000
Revenues - Mid	$ 840,000
Revenues - High	$ 1,050,000

1. Client Assumption

2. Industry Standard and Manask & Associates

Observations of Similar Museums

Figure 2: Revenue analysis

lower than projected revenues. This allows very little room for error and leads us to predict that most operators will require a management fee contract that will guarantee them a minimum profit, shifting the burden of a loss to the Museum.

Visitor foodservice size requirements

The above analysis of visitor demand and revenue indicates that a café needs to be able to accommodate an average 170 to 300 customers on any given day, depending on the season, highlighting the need for

Projected Operating Profits			Break Even	
Revenues	$ 840,000		$ 769,231	
Cost of Goods Sold [1]	$ 277,200	33.0%	$ 253,846	33.0%
Labor Costs [2]	$ 400,000	47.6%	$ 400,000	52.0%
Other costs [3]	$ 126,000	15.0%	$ 115,385	15.0%
Operating Profit	$ 36,800	4.4%	$ -	0
1. Industry Standards based on $12.00 check average				
2. Assumes 4 customers per labor hour = 10 FTE employees plus 1 manager / 6 days + 1.5 FTE for remote Kitchen / receiving area				
3. Industry Standards				

Figure 3: Estimated foodservice operating profit

flexibility and expandability. When calculating the space requirements, certain industry standards are used for the various calculations:

- Table turns: the number of times the café table will be used during the 2-3 hour meal period. Given the style of service described and a family-orientated venue, it will be anticipated that the table turnover will be every 45 minutes, or 1.33/hour.

- Seating efficiency: all seats in any restaurant or café are not used 100% of the time. Often, only 2 or 3 of the 4 seats at a table are used at any given moment. For this analysis, it will be assumed that the seating efficiency is 85%, a common industry standard, indicating that 15% are unused at any given time.

- Dining area space requirements: depending on the style of service, seating density, etc.,

	Average	Peak
Anticipated Customer Count	233	333
Table Turns 11 am - 2pm	4	4
Seats Required	58	83
Seating Inefficiency	15%	15%
Total Seats Required	67	96
Dining S.F. per Seat	20	20
Total Dining Room Size	1,340	1,915
Kitchen Support s.f. / seat	12	12
Kitchen Space Required	804	1,149
Total Space Required	2,144	3,064

Figure 4: Visitor foodservice space requirements

once the number of seats is known, the overall dining area space requirements can be estimated. School cafeterias, with a high seating density, require only 10-14 square feet per seat. Fine dining, on the other hand, requires 25-30 square feet per seat. For the service style described above, the industry standard is 17-20 square feet per seat.

With these standards, the total size requirements are calculated as shown at Figure 4.

Building the café to accommodate approximately 233 customers will satisfy demand for most Mondays through Thursdays, but will be undersized for most Fridays through Sundays. Building for the peak

demand will satisfy demand for all but the very busiest days, but will be oversized, inefficient and feel empty on most days. However, given the current design that includes expandable space towards the windows and into the *Coffee Bar*, we recommend that the café area be built to the programmed 1,500 square feet, as well as the 800 square feet for the *Coffee Bar*. The dining area should be set for 75 seats and be expandable for known busy days or scheduled groups.

The *Coffee Bar* will be able to accommodate an additional 35-50 seats (assuming 700 square feet is available), depending on style and configuration. If the desire is to provide discussion areas, coffee tables, overstuffed chairs, etc., 35 seats should be planned. Tables and chairs, high top tables, and internet counters lined with seats will accommodate 50 or more. This concept will be developed to include espresso and drip coffee products, pre-made sandwiches, salads and other *grab 'n go* offerings during the day and would probably be the first to open and last to close. Late afternoon service would shift to a wine bar concept, offering wine by the glass, cheese, crackers and small plate menus. Depending on demand for this service, this will likely be open two to four evenings per week (Tuesday through Thursday?) and be dependent on other evening events

and programming.

The café space will also serve as ingress and egress from the gallery space and needs to accommodate a path that will not be intrusive to the diners, yet allow easy movement. We would suggest that the views out of the windows on each side of the dining area be preserved for diners and that the aisle for museum patrons go down the middle of the room, with planters, artworks or other dividers marking the route.

The Museum is also interested in providing a family space for children and parents to take a break during their visit. We have identified the rotunda in the northeast corner of the Museum to provide a play room for kids to explore and romp. The Museum also proposes a limited beverage service and seating area for parents to relax, but still be able to watch their kids in the playroom from outside the glassed-in area. We recommend several options:

1. Build in a small beverage kiosk with running water, sinks, electricity to accommodate a small espresso machine and cooler. Bottled or canned beverages, juices, coffee, possibly snacks or cookies could be offered by one employee during busy days or times.
2. Provide only the utility connections for

a portable cart to be opened as demand warrants. The cart can be designed to provide coffee, cold beverages, snacks, etc. A better understanding of local health department requirements is needed before using this option.

3. A self-service beverage bar with a bottle/can beverage vendor, single-brew coffee machines (*Flavia*, *Gevalia etc.*), could be set up and maintained daily by the foodservice provider.

4. Provide seating for approximately 16-20.

Special event and catering operations

We did not update the previous catering analysis and revenue projections for this study. With little exception, the facility spaces available for special events remained unchanged.

However, due to the elimination of the full production catering kitchen in previous plans, the on-site operator will be limited to on-site production for the café operation and events that are held in the Dining Wing. It is doubtful that the operator would be able to be able to prepare large events or multiple events from the kitchen spaces provided.

This limitation will require the Museum to contract with multiple "authorized caterers" for an

agreed-upon commission structure. These off-site caterers would be expected to handle the larger events as needed and provide support from their own off-site kitchens. They would use the support kitchen adjacent to the Grand Hall for finishing and staging the events.

Operational observations

The Museum has designed foodservice operations, special event spaces and support spaces that have created various operational issues that need to be addressed:

1. The on-site kitchens are not large enough to support both the café and catering demands. Off-site kitchen support is required to support larger or multiple catering events.

2. Café kitchen: the kitchen to support the café has been expanded to maximum use in the space available (approximately 1,165 sq.ft.). There is some basement storage space available for dry and cold storage (approximately 600 sq.ft.). According to the previous space programming requirements, this kitchen size should be sufficient to support the café operations, but would be too small to also support simultaneous catering

needs elsewhere in the building. Deliveries cannot be made directly to this location and must go through the receiving and storage commissary first. We reviewed the basic equipment design for this space and found it to provide the expected equipment and efficient layout. We would defer an opinion on the actual equipment selection and installation to the future operator and kitchen designer.

3. Receiving and storage: storage space is at a premium. The Museum has added a receiving, preparation and storage area that will be located at the loading dock. This will provide the bulk of cold and dry storage for the café and some catering operations. It is anticipated that deliveries will be processed here and whatever prep work is required to make the product ready for use in the kitchen. The distance of this facility to the kitchens is considerable and requires elevator use and transporting the product through public space, which will limit this function to off-hours or emergencies only.

4. Grand Hall support kitchen: this kitchen is well-designed to provide support for catered

events in the Grand Hall or to act as a second production kitchen for the café and other catered events throughout the building. The kitchen is approximately 1,237 sq.ft. and offers ovens, ware washing, work tables, room for food carts and plating. Deliveries directly to this kitchen will not be easy and may require transfer to small electric carts or a small van via a secondary route.

5. Garbage and trash: the café kitchen and Grand Hall kitchen will obviously generate trash that will need to be transported to the main trash collection area at the loading dock. It will not be allowed to be transported through the building in public spaces, so electric carts will have to be used on outside paths. Because of the lakes and rivers, the path from the café kitchen will be quite long. The Museum will need to consider designing in trash rooms to collect the trash during the day to be transported to the collection area. These trash rooms should have refrigeration to keep the smells, bugs and animals out.

6. Operational inefficiencies: these design features will create some labor inefficiencies for the future operator. The three locations

will require some level of staffing duplication as well as delivery staffing. Good planning and logistics will be necessary for the operator to keep these added costs at a minimum. However, these inefficiencies that are result of the infrastructure and design will impact operating contract options and costs.

Operating contract scenarios

Our observations on the lack of a full production kitchen will limit the type of contracts the Museum can expect when seeking a foodservice operator and caterers. Following is a summary of the contract types and probable financial impact for the Museum's consideration:

1. *Exclusive profit and loss contract*: If a local operator with off-site kitchens can support the catering requirements and can offer the range of catering the Museum and its customers will demand, then it is likely that a full profit and loss (P&L) contract can be negotiated. This would give the operator full rights to operate the café and all on-site catering (we usually recommend that in any contract, the Museum maintains the right to use another caterer up to three to five

times a year with the Director's approval). This type of contract would put the financial risk on the operator with the exception of utilities, infrastructure maintenance, and some other building costs. The operator may be willing to offer some investment and/or commission based on revenues. An exclusive contract will usually gain the strongest commission and may range 5% to 10% for the café and 10% to 20% for catering. *Advantage*: best financial terms.

Disadvantage: loss of control; tied to one operator.

2. *Exclusive café and semi-exclusive catering contract*: The operator is selected to operate the café and most day catering but is one of several on a shortlist of approved caterers for evening and social events. The customer decides on what caterer to use to cater their event. The café operator may or may not offer a profit and loss contract for the business, but likely would not offer a commission until certain revenue levels are met. The approved caterers will all agree to a certain commission structure for the catered events and pay the Museum monthly. These

commissions may range from 10% to 20%. *Advantage*: more flexibility with caterers. *Disadvantage*: must manage a larger list of caterers; may not get an operator to operate café on P&L due to risk.

3. *Management fee contracts with or without semi-exclusive catering*: Without exclusive catering or the capabilities to provide all catering services from on-site facilities, operators may propose to operate the café and day catering with a management fee contract. This contract guarantees the operator a certain fee per week/month/year and passes the losses or profits back to the Museum. This eliminates most risk from the operator as they make their fee no matter what, but the fee (operator profit) is usually lower, around 5% to 8% of sales. Clients that have this type of contract offset any café subsidies with commissions received from off-site caterers, but there is no guarantee that the total of commissions received would offset the total of the subsidies. The catering list can be small or large, it does not matter to the café operator. *Advantage*: high level of control for the Museum. Operator will do whatever

you want... "it's your money."

Disadvantage: open-ended subsidies may get out of control.

Summary and next steps

Visitor foodservice and café:

- Agreement on the style of service should be determined. This will help with the final design considerations for the kitchen and dining areas.
- Location and design of the receiving and storage commissary is more functional on the loading dock level. Final design space and equipment will help in the final design and equipment needs for the other kitchens.
- Delivery routes, either inside the building or outside, need to be identified to support the two kitchens from the commissary.
- Trash rooms with refrigeration should be designed into the two kitchen areas.

Facility rentals and special events:

The Museum should consider purchasing special event and room booking software to coordinate the various support functions, billing and catering.

Next steps:

Client should begin the RFP process for the operator selection 18-24 months before the scheduled Museum grand opening at the latest. This will allow for a thoughtful, careful process over six to nine months and have the operator on board with sufficient time to participate in the final design and construction details and begin the marketing and promotion of the Special Event venues.

Potential operators that will likely be interested in the café and catering contract will probably include local restaurant and catering operators and the large, national contractors that already have a presence in the local market.

6

A Zoo's Masterplan
for Food Concessions

The report which follows was prepared for a zoo which attracts over one million visitors annually, with a high attendance in April through August. Outsourced concessions are located throughout the zoo park, anchored by one main café. Carts and vending are used to meet demand in peak season.

The Zoo is planning a new exhibit and expects a significant increase in attendance. Current concessions are not able to keep up with demand on busy days and the Zoo wants a short- and long-term master plan that will address the service issues and be able to expand to meet future demand.

The organization has outsourced its concessions for many years and the contract has presented challenges in maintaining the facilities and investing in new facilities. However, the Zoo does not want to give up the earned income generated by the current contract.

Manask & Associates, with an architectural design firm, visited the Zoo to conduct interviews, observe operations and develop a five year masterplan. The resulting report included:

- A review of current concession menus, prices, service and operations.
- A review of contract financial terms and conditions.

- The development of new concession operating strategies.
- Revenue projections.
- Return on investment analysis.

A social event at Cleveland Metroparks Zoo, Ohio, USA

Masterplan for foodservice concessions

We used the interview process to meet and hear from the various key Zoo and operator stakeholders about what they believe is important to the visitor; what is important to each person and their position, role and area of responsibility; and what they think the visitor would enjoy seeing changed. During this process, we repeatedly heard that the underlying issues with the current foodservice concessions are related to value (quality for price); that there is "resentment" associated with being forced to pay high prices for below average products and service. An important goal of this report is to help turn that resentment into enthusiasm and so add to the overall experience of the Zoo visit, not detract from that experience.

The Zoo is set along the river on more than 50 wooded acres in the downtown area near the central city. It is a very manageable size and visitors have an average 3-4 hour visit. When we commented on the apparent lack of way-finding, it was explained that this was intentional in the effort to create a sense of discovery, like a walk through the woods or a mountain trail: the visitor is transported to another world of sights, smells, sounds and experiences that they can only find at the Zoo. However, it should be noted that the first-time or once-a-year visitor tends

to be a better foodservice customer and may be frustrated by the lack of directional way-finding for foodservice and may end up taking the first option they encounter rather than one that may better suit their needs. This is a key and important part of the desired visitor experience based on input from Zoo interviewees.

The goal for the foodservice concessions is to take advantage of this sense of discovery and create food, beverage, snack and menu offerings that are creative, unique and connected to the overall Zoo experience. Creating dining options that enhance the visitor's experience will drive repeat and referred business. At the same time, the foodservice concessions need to be efficient, affordable, recognizable and satisfy the basic need of refreshment and refueling. Foodservice concessions contribute significant money to the operating budget of the Zoo and are expected to continue to do so, and ideally continue to grow, as a result of the master plan recommendations and improvements.

With these goals in mind, we offer the following observations and recommendations relative to a five-year foodservice concessions master plan.

Current visitor trends

The monthly visitor attendance is typical of zoos in the region. The peak attendance follows the average temperature, increases through the summer and is lowest during the cold winter months. This trend is very consistent over the past several years with an average peak of 184,000 visitors in July and the lowest average attendance of 7,500 in February. The upturn in attendance in October is related to the Halloween programming and December events leading up to the holidays. These trends are shown in Figure 1.

Included in these figures are the 36,000 member households (equals approximately 115,000 individuals) that account for approximately 40-42% of all attendance. As members are typically frequent, repeat visitors, they are very important to consider and tend to be most vocal and critical of existing foodservice concessions. They also tend to be less frequent users of the foodservice concessions, opting to bring food or make other meal plans before or after their visit. While there has not been a specific member survey relative to current foodservice concessions (which we believe is very important and the Zoo should consider doing on a regular basis), anecdotal feedback during interviews support this statement. This group represents a large opportunity to grow

Figure 1: Monthly zoo attendance trends

foodservice concession business.

These trends are important to identify as they relate to how best to plan and operate foodservice concessions at the Zoo. It is not practical to design and build services to meet one attendance extreme or another. Rather, services should be flexible and expandable to adjust to the peaks of June, July and August and still meeting the limitations of January and February. This can be done by use of carts and kiosk operations, as well as scalable services in the permanent locations.

For the purpose of this report, we will assume the current attendance trends will continue and will peak at 1,300,000 visitors with the opening of the new exhibit. We will assume the design day attendance of 10,000. Projected monthly attendance will be as set out in Figure 2.

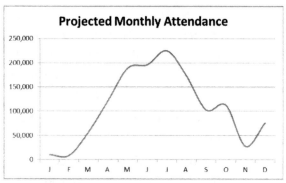

Figure 2: Projected monthly attendance

Current operations

The foodservice concessions are outsourced under a management service agreement with the incumbent operator, a contract foodservice management company. The operator has many years' experience and a large number of clients. They gained the Zoo contract some years ago when they acquired another catering company. The operator continues to service the Zoo under the original contract terms and conditions.

Current venues: There are four permanent foodservice concession buildings operated by the operator. These are defined as:

- Main Café – This is the main concession operation and offers limited climate-controlled seating. This is the only venue that

is open year round.

- West Café – This offers multiple walk-up service windows and a similar menu to the Main Café. Only outdoor seating is available.
- Snack Shop – This offers two walk-up service windows and sells predominately snacks, ice cream and nachos.
- The Lookout – This offers a walk-through service line, currently limited to pizza and wrap sandwiches.

In addition to the permanent locations, carts are used in multiple locations to offer snacks, beverages, frozen novelties, *Dippin Dots*, etc. Up to seven carts can be in operation depending on the size of the attendance. While convenient and accessible, carts can contribute to lower *per capita* spending as visitors may "trade down" their purchases at the carts compared to the concession operations.

The foodservice concession's seating capacity is predominantly outdoor, non-climate-controlled spaces. The Main Café has the only indoor, climate-controlled seating (other than the Garden Café in the Gardens, which is not being used at the present). Figure 3 summarizes the seating available by venue.

As compared to other similar zoos, the amount of

Current Seating Capacities			
	Indoor	Outdoor	Total
Main Café	104	312	416
West Café		204	204
The Lookout		76	76
Snack Shop		20	20
Dippin Dot Cart		20	20
Total	**104**	**632**	**736**

Figure 3: Current seating capacities

indoor seating at the Zoo is well below average. This can be seen to have an impact on *per capita* spending, but is not 100% correlated as shown below. There are multiple factors that influence *per capita* spending, seating is just one of them (see Figure 4).

Menus and pricing: Based on stakeholder interviews and a review of the Complaint Log maintained by the Zoo, the customer perception is that menus offered offer little variety and are generally seen as repetitive, ordinary and poor value.

The menu is dominated by fast-food items. The fact that the operator's experience is with stadiums, arena and convention centers may be an influence on the style of menu being used at the Zoo. This is shown by the Menu Matrix illustrated at Figure 5.

This shows a heavy emphasis on grill foods, hamburgers, hot dogs, pizza, chicken wings, etc. Even though there are healthy options available such

Zoo	Attendance	Indoor Seating	Per Capita $
Zoo	1,100,000	104	$ 2.65
Mid West A	2,932,152	675	$ 2.15
Mid West B	1,872,544	540	$ 3.61
Canadian	1,150,000	500	$ 3.02
Mid West C	1,565,928	280	$ 2.45
Mid West D	903,651	328	$ 2.57
Mid West E	1,283,394	275	$ 2.68
East	1,967,033	215	$ 3.78

Figure 4: Multiple factors influence per capita spending

as the wraps, salads and veggie burger, it appears to be overwhelmed by non-healthy fast-food.

We also noted that Combo Meals are not offered, as typically found at most zoos and quick service restaurants. Instead, the offer is to make any entrée a Combo Meal by adding $3.49 to include a regular soda and bag of chips. The customer needs to do the math in their head and probably doesn't realize the saving of $1.19 over the individual pricing for these items. Consequently, the perceived value and convenience of ordering #2 or #7 (as most of us are now accustomed) is lost with this menu strategy.

Snacks and beverages are also repeated at most locations with a few exceptions as noted in the Menu Matrix at Figure 6.

While average transaction data was not provided, it is easy to estimate that a family of four can easily spend $25 to $30 for an average fast-food lunch.

Menu Matrix - Entrees					
Entrée Menus	Price	Main Café	West Café	Lookout	Snack Shop
Grilled Chicken Sandwich	$ 4.99	X			
Chicken Tenders	$ 4.99	X			
Cheeseburger	$ 3.99	X	X		
Veggie Burger	$ 3.99	X	X		
Hot Dog	$ 2.99	X	X		
French Fries	$ 2.59	X	X		
Pepperoni Pizza	$ 4.49	X		X	
Cheese Pizza	$ 4.49	X		X	
Breadsticks	$ 3.19	X		X	
Southwest Chicken Wrap	$ 5.99	X		X	
Asian Vegetable Wrap	$ 5.99	X		X	
Hoosier Chef Salad	$ 5.99	X		X	
Garden Salad	$ 3.99	X		X	
Kid's Hot Dog Meal	$ 5.99	X	X		
Kid's Ham / Turkey Sand. Meal	$ 5.99	X			
Kid's Chicken Meal	$ 6.99		X		
Boneless Wings 6pc	$ 7.49		X		
Boneless Wings 12pc	$ 13.99		X		
Taco Salad	$ 6.49				X
Nachos	$ 6.49				X
Salsa & Chips	$ 3.49				X
Cheese & Chips	$ 3.49				X
Make any entrée a combo meal	$ 3.49	X	X	X	X

Figure 5: Menu matrix - entrées

(At zoos, a typical transaction can include up to four to six orders for the family. This does not produce the standard average check data tracked by most restaurants. Rather, Zoo foodservice concessions typically track *per capita* spending as the barometer of foodservice revenues.) Our personal experience was an average of $8.15 per meal for two days of on-site meals.

Observed operations: We observed the current foodservice concessions over the three-day on-site visit. The days observed were a Thursday, Friday and Saturday. None of these days were at capacity for the Zoo or the concessions. The Friday was the busiest

Menu Matrix - Snack/Beverage					
Snacks / Beverages	Price	Main Café	West Café	Lookout	Snack Shop
Cotton Candy	$ 3.49	X			
Pretzel	$ 3.49	X			
Popcorn	$ 2.99	X			X
Chips	$ 1.49	X	X		
Cookies	$ 1.49	X			
Animal Crackers	$ 1.49	X			
All Day Refillable Beverage	$ 8.99	X	X	X	X
Souvenir Cup	$ 5.99	X	X	X	X
Animal Sipper	$ 3.19	X			
Bottle Juice	$ 3.19	X			
Regular Soda / Iced Tea	$ 3.19	X	X	X	X
Bottle Water	$ 2.79	X	X	X	X
Ice Cream Bars	$ 2.49		X		X
Ice Cream Bars	$ 3.99		X		X
Churros	$ 3.49				X
Chip Stix	$ 3.49				X
Float	$ 3.99				X
Ice Cream Waffle Cone	$ 3.99				X
Ice Cream Cup/Cone	$ 2.99				X

Figure 6: Menu matrix - snacks and beverages

day and nicest weather. The Saturday, expected to be busy, was hampered by morning rain, keeping the attendance below normal for the day.

During these observed days, we noted the following:

General

- Lack of way-finding made it difficult to plan out the route and when and where to stop for meals.
- The Zoo Map, given out with admission, has fairly clear symbols for the food concession venues, but not the carts/kiosks.
- The Zoo Map does a good job of describing the food selections available at each concession.
- The trails are lined with trees and bushes. The

heavy flora often blocked the sightlines to the concession venues and signage.

- There was no directional signage, even right next to the buildings to point potential customers to the various concessions.
- No information was provided at entrance to announce what venues are "open today" so that visitors could plan their meals and routes. Visitors are left to find venues open or closed when they walk up to them.
- The Main Café signage and sightlines for visitors exiting the penguin exhibit do not indicate what this building is.
- The West Café signage is blocked by tree branches.
- Menus at each location are poorly designed and do not communicate well.
- Pricing of menu items does not include sales tax. This creates odd totals, requiring change and slowing the speed of line service.
- Food at all locations was cooked far in advance and kept in warmers or under heat lamps creating quality issues.
- Kitchens and equipment are all at, or near, the end of their useful lives. Most equipment is more than 20 years old and has been

maintained with minimal reinvestment from the operator or the Zoo. Only $25,000 from the operator per year has been available for repair and replacement. Walk-in refrigeration and freezers in Main Café have settled and doors will not close properly, causing ice build-up and inefficient energy use.

- Ventilation in the Main Café is not adequate and the kitchen is quite smoke-filled. The operator has removed several of the grease filters on the hood to improve ventilation, but this causes grease build-up in ducts which require more frequent cleaning and greater cost.

Main Café

- The straight lines for each cashier can create frustration for the customer when in a slow moving line. Inefficient use of space.
- All customers are required to come inside to order even if they choose to sit outside. Very crowded, even on a relatively slow day.
- The *Food Station* icons would lead a customer to believe they need to go to one line for Deli, another for Grill and another for Pizza while these foods are available at all registers. These

stations icons are confusing and misleading.
- Condiments are set on a cart, near the queuing area, adding to the congestion.
- Interior seating is crowded and there is no room for strollers.

West Café
- Menu repeats that of the Main Café.
- A unique menu item, wings, is not obvious and is lost on separate menus to far left and far right of service windows.
- We sampled a cheeseburger, fries and soda meal (not offered by the cashier, we had to ask for it). Very poor quality. Too long under heat lamps and dried out, cheese sticking to bun. Nothing but bun, burger and cheese. Fries were stale and old.
- On the days on which this venue is closed (rainy Saturday during our visit) there was simply a sign in the window that said *Closed*. No redirection to other open food venues.
- Queuing area is hampered by tree boxes made of railroad ties.
- This venue has good equipment and ventilation and could offer more, unique items.

Snack Shop

- This venue is poorly designed and does not appear to be a food venue – two small windows, small menus, and hard to tell if it's open or closed (closed during most of our visit).
- Menu offers unique items, taco salad and nachos, but this is not obvious or advertised.
- We observed visitors standing right in front of the Snack Shop with a Zoo Map in their hands looking for *The Snack Shop*!
- No signage on the building.

Carts

- Carts lack consistent image or theming. The operator is using vendor-supplied commercial carts. Very commercial, fair-like appearance. Placement appears to be very haphazard.
- One cart, named *Wild Café*, under a semi-permanent tent, had a professional look and is consistent with the Zoo's image. This is a good example for the other Zoo cart locations.
- Cart menus focused on snacks, beverages and novelties. There was not much variety from one to the next except for the *Dippin Dots*.

Lookout

- Complete duplicate of the Main Café.
- Pizza sampled here was hot, fresh and good value.
- Wraps and salads are offered here, but menus lack attention to this.
- Only four tables are in direct sun out in the main pathway. Limited nearby seating.

Garden Café

- Located in the Gardens conservatory building.
- Closed during our visit.
- The Zoo claims about 10-15% of visitors go through this botanical exhibit which is included in Zoo admission. We did not observe more than 5 to 10 people in this area at any given time.
- Beautiful special event spaces, outdoors and indoors with great views of the river and downtown skyline.
- Garden Café, if open, would offer coffee, snacks, pre-made sandwiches and salads.

Operator contract terms: We did not have access to the operator contract and relied on information provided by the Zoo and the operator for details. Following is

our understanding of the key terms and conditions of this contract:

1. The contract was assumed by the operator through acquisition of the local company as previously indicated.

2. The contract expires in about two years. However, the operator has options to renew the contract and/or match a competitor proposal which, in our experience, is not standard industry practice.

3. There was minimal operator capital investment in fixtures, equipment or buildings. The operator is obligated to provide $25,000 per year for equipment repair and replacement. Whatever ongoing capital investment is made by the operator will be written off (fully amortized) by the end of the contract term.

4. The operator pays for the cost of the utilities used.

5. The operator pays the Zoo a commission based on gross revenues based on a step scale set out at Figure 7.

We have worked with many zoos across the country and have done studies, financial evaluations,

Foodservice concessions/vending annual revenue		
From	To	%
$0	$500,000	31%
$500,001	$1,000,000	36%
$1,000,001	All	41%
Special event (external) catering		
All external catering revenues		8%

Figure 7: Operator commissions paid to the Zoo

helped to manage RFPs and negotiate client-operator contracts. The foodservice (not catering) commissions currently paid by the operator at the Zoo are the highest observed and certainly can, and likely do, contribute to some of the service, quality and value issues observed.

We have found that the average commission percentage paid by operators at other zoos with around one million annual visitors is about 21% for foodservice concessions, 16% for catering (catering sales volume varies dramatically from zoo to zoo and the percentage commission is dramatically impacted by the quantity and type of catering done at each zoo) and have committed an average $1,722,000 capital investment into renovation, remodeling, new or

Summary of Proposed Commissions and Investments since 2007

Zoo Description	Operator Proposal	Operator A	Operator B	Operator C
Midwest Attendance 1.2m	Net Concessions Commission %	23%	25%	25%
	Net Catering Commissions %	22%	16%	15%
	Per Capita $	$ 2.96	$ 2.78	$ 3.16
	Capital Investment $	$ 1,300,000	$ 2,450,000	$ 2,723,000

Zoo Description	Operator Proposal	Operator A	Operator B	Operator C
Midwest Attendance 1.1m	Net Concessions Commission %	20%	18%	15%
	Net Catering Commissions %	18%	15%	11%
	Per Capita $	$ 3.31	$ 2.80	$ 2.88
	Capital Investment $	$ 941,000	$ 1,800,000	$ 1,400,000

Zoo Description	Operator Proposal	Operator A	Operator B	Operator C	Operator D
West Attendance 1.0m	Net Commission %	20%	23%	20%	19%
	Net Catering Commissions %	15%	20%	12%	15%
	Per Capita $	$ 2.91	$ 3.03	$ 3.04	2.59
	Capital Investment $	$ 950,000	$ 1,497,000	$ 2,801,000	$ 1,361,000

Figure 8: Summary of proposed commissions and investments since 2007

expanded foodservice concession stands, carts and kiosks and FF&E.

Based on historical revenues, we calculate that the operator paid 38.4% commissions on the foodservice concessions and 8% on catering for the past three years. Operating costs for the operator are estimated (from unverified information provided by the operator) at 22% for food, 16% for labor and 15% for other direct costs (insurance, disposables, janitorial, investment amortization, etc.) leaving 9% for profit. This illustrates the fact that the operator's biggest cost is the commission (which is a non-controllable expense) and they manage the only "controllable", variable costs of food and labor as tight as they can to achieve this profit.

At Figure 8, we provide the following summaries of zoos that we have worked with and the resulting proposed or actual commission percentage paid by operators and capital investment offered.

Historical financials: The reported revenues for the operator have declined since the high point in 2005. Both gross revenues and *per capita* spending have declined in recent years. Visitor attendance during these years has fluctuated from a high of 1,164,000 to a low of 1,032,601 or only 85,584 from high to low (7.6%). These trends are illustrated in the graph at Figure 9.

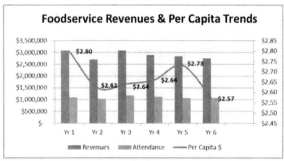

Figure 9: Foodservice revenues and per capita trends

Per capita spending is the traditional tracking statistic used by most zoos and is a good indicator of visitor use and menu popularity. The average *per capita* spending over the past seven years has been $2.65 and is considered above average for the zoo industry. Referring to the *State of the Industry* report published in 2007 for AZA and IAAPA (the most recent publication of this data), zoos of similar size saw an average *per capita* spending for food concessions of $2.20. While this is several years old, this is consistent with observed *per capita* spending at zoos familiar to us as indicated at Figure 10.

This illustrates that there is an opportunity to improve the *per capita* spending at the Zoo and that a peak of $2.80 to $2.90 should be considered as the goal for future operations.

Individual Zoo foodservice concession by location

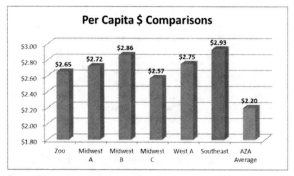

Figure 10: Per capita spending comparisons

per capita data provided by the Zoo is summarized at Figure 11. This shows a significant reliance on carts to service the visitor, as they are the second highest *per capita* income at $.52 or 20% of the total $2.65. We would hope to capture increased *per capita* spending in the permanent venues through increased capacity and new and improved dining concepts.

Master plan recommendations

General strategy: Based on the Zoo's goals and our experience with industry best practices and trends at zoos and other family entertainment attractions, we are recommending a change to creating unique menu and service destinations within the Zoo. This will result in three totally unique, non-repetitious menu and dining offerings at the current Main Café, Lookout and West Café. This will be supplemented

Per Capita $ by Venue Trends								
	Yr 4		Yr 5		Yr 6		Average	
Main Café	$	1.33	$	1.41	$	1.40	$	1.38
Carts	$	0.56	$	0.49	$	0.51	$	0.52
West Café	$	0.36	$	0.37	$	0.33	$	0.36
Lookout	$	0.23	$	0.30	$	0.19	$	0.24
Snack Shop	$	0.09	$	0.10	$	0.06	$	0.09
Vending	$	0.05	$	0.04	$	0.07	$	0.05
Garden Café	$	0.02	$	0.02	$	0.00	$	0.01
Total	$	2.66	$	2.73	$	2.57	$	2.65

Figure 11: Per capita spending at the Zoo's foodservice venues

with the flexibility of cart and kiosk services that can be adjusted to attendance demand. This will help to address the current perception that there is no variety.

In addition, we are recommending some changes to seating, seating capacity and service methods to improve customer throughput and seating.

We are not proposing specific selling prices for the new menu items recommended. Without a detailed understanding of the operator's purchasing costs and targeted food costs, it would not be appropriate to recommend these selling prices at this time. However, as a general statement, we are recommending that the current price structure and strategy be maintained with savings associated with contract renegotiations put back on the plate with improved product quality, portions and new products and improved speed of service.

Finally, these changes cannot be successful without significant capital investment which,

if funded by the operator, will have to be from a combination of a reduction in the commission structure and increased *per capita* spending by customers, based on the current operator contract and financial arrangements as we understand them.

Phased approach: We prepared recommendations for implementation on a phased approach over a five year period (the periods of time can be modified depending on capital availability to make the changes). The phases are defined below and are represented in the drawings included with this report and related costs of implementation.

- Phase I: Immediate/year 1 impact. Focus on capacity, menu concepts, signage, brand image and menu communications. No major construction or renovations to buildings.
- Phase II: Years 2-5. Focus on renovation of buildings and re-equipping. Additional new menu concepts, building and seating area renovations.

Main Café: Concept description – This will continue to be the main foodservice concession available throughout the year. The menu will continue to feature a "quick service restaurant" style and focus on:

- 1/4 lb. hamburgers and garden burgers
- Hot dogs
- Noble Roman pizza
- Salads
- Wraps and deli sandwiches

In addition, we recommend adding an upgraded menu featuring:

- 1/3 lb. hamburgers
- Grilled chicken breast sandwich
- Grilled chicken salads

Phase I

- Trim trees and bushes to improve sightlines from walkways to buildings and branding.
- Add new building signage to backside facing penguin exhibit.
- Add LED menu boards for improved menu communications and brand image. The Zoo should consider working with their preferred suppliers (*Coke/Pepsi*) to fund the costs of these menu boards. Yes, this will include built-in advertising for their product, but is a reasonable exchange for the costs and maintenance of the boards. Pictures help sell and up-sell the menu items.

- Add two walk-up outdoor electronic menu order kiosks which allow customers to order, pay and sit outside. Orders will be delivered through a new walk-up window when the order number is displayed. This will help alleviate the crowds inside.
- Add condiment stand outside for these same customers.
- Add shading over existing seating area on east side of building which overlooks the bird exhibit.

Phase II
- Expand dining room walls to maximum perimeter of building footprint. Enclose the existing playground area. This will add 208 climate-controlled seats inside.
- Expand kitchen and storage spaces to incorporate the space currently used under tents and lean-to covers. Replace most kitchen equipment, coolers, freezers and expand kitchen capacity to allow for cold production inside (currently done outside in tents). This will primarily add to catering production capacity as well as continue to support foodservice concessions

throughout the Zoo.

- Redesign service line by moving back to allow for more queuing space without interfering with seating area.

Lookout – re-theme as Country Smokehouse: Concept Description – barbecue and smoked meats are always popular and offer a chance to focus on local history and products. We are recommending converting the Lookout into the *Country Smokehouse* featuring smoked meats and a country-style menu. The meat will be smoked on-site, for the visitors to see and smell as it smokes away. The menu will feature a manageable variety of core items with a changing *Special of the Day* menu:

- Pulled pork
- Smoked brisket of beef
- Smoked chicken quarters
- Daily changing specials: smoked sausage, turkey legs, ribs
- Macaroni and cheese
- Cornbread
- Corn on the cob
- Ranch beans
- Ice tea
- Lemonade

- Home-style root beer

All Phase I
- Add smoker to outside of building.
- Re-equip kitchen with warmers to hold smoked meats and other menu items.
- Remove pizza oven.
- Re-theme building to reflect a smokehouse brand and image.
- Keep center door entrance with duplicate lines going left and right and exit existing side doors.
- Add condiment stand outside for BBQ sauces, napkins, etc.
- Reconfigure hillside knoll behind building on path to the Arena for added seating. If trees do not stay, add pergola shading. Adds 96 seats.

West Café Complex – Three venues/themes: Tex-Mex Café, Snack Shop, and Food Carts & Mobile Food Trucks
Current West Café Concept Description – re-theme by adding another unique-menu-style destination with the always popular Tex-Mex theme. The menu will feature a variety of core items:
- Tacos
- Beef

- Chicken
- Burritos
- Chimichungas
- Taco salad
- Beef
- Chicken
- Nachos and cheese
- Churros
- Sodas

Phase I
- Re-theme building and façade to reflect Tex-Mex image and branding.
- Install LED menus.
- Re-equip kitchen with specific equipment needed for Tex-Mex concept.
- Add condiment stand outside for hot sauces, napkins, etc.

Snack Shop – Streamline Concepts, Reconfigure Service Windows: Concept Description – we like the basic concept of making this simply ice cream and other snacks. Offer high quality soft-serve ice cream, "concrete mixers" (ice cream mixed with various candies selected by customer), ice cream novelties, and signature ice cream cookies made on-site daily.

Phase I
- Implement new menu concept.
- Themed menu boards, easy to read, *Soda Fountain*-style.

Phase II
- Reconfigure service windows to be replaced by large window across entire front of building allowing customers to see in. Bright neon lights signal that the venue is open.
- Re-theme building to reflect old-fashioned soda fountain. Red and white stripe awnings.

New menu items for the Snack Bar would include *Cookie Burgers* made on-site every day. These would consist of two chocolate chip cookies with soft serve ice cream centers, made into a sandwich and wrapped and frozen. This is a good way to use the left over ice cream at the end of each day.

West Café Seating Area: Concept Description – this seating area is a great destination with ample shade between the Tex-Mex and Snack Shop. We recommend adding additional cart and mobile food truck services surrounding the seating area. This will allow the operator to sub-contract with some of the

well-known food truck operators on the busiest days and add some unique products from carts.

Phase I
- Remove tree boxes in seating and queuing areas. Replace with urban metal grates for drainage.
- Selective removal of concrete planters to enhance flow-through for seating and access to cart/mobile truck service.
- Supplement daily concession operations with trailer concessions similar to those found at the State Fair. This would allow for the temporary addition of popular food items and menus without the significant cost of building permanent infrastructure.

Phase II
- Add food carts to seating area to feature, unique items: Roasted Corn, Funnel Cakes, Roasted Nuts, Pretzel Grill and Kettle Corn.

Kid's Corner (currently closed) – Convert to Slushie/Yogurt Concept: Concept Description – this area is currently closed, but when re-opened, adding this new trend concept will provide a unique and fun area that is

family-friendly. Similar concepts opening across the country include *16 Handles*, *YoCream*, *BTO*, *FroYo* and all follow a similar theme: self-serve frozen yogurt flavors and multiple toppings sold by the ounce after building the creation. Usually in the $.40–$.50 per ounce range.

In addition, selling Slushie drinks with self-service cups allows the customer to mix up their own concoction. The operator sells the empty cup to the customer and they decide what they want to mix.

While these concepts are operating around the country in large and small cities, they have not been seen in operation at a Zoo. This is a great opportunity, albeit untested in a Zoo based on our current knowledge – but it is a potentially viable and popular menu option that needs to be explored further before implementation.

Phase II
- When this area is scheduled for re-opening, this concept could be installed relatively quickly.
- Power, water and drainage need to be accessible to the space identified for this use.
- The area would be covered and screened in and considered only for summer use.

Carts: Concept Description – the cart operations will play an important part in the operator's ability to service peak demands. A successful foodservice concession needs to have the ability and flexibility to expand and contract points of service to match demand and attendance. During the summer and on busy days, these carts will add capacity to provide beverages, snacks, and unique products not found in the main concessions, adding both convenience and impulse sales.

We recommend five to six carts located throughout the park in designated locations, not randomly placed along the path. As identified earlier, we like the image of the branded *The Zoo* cart and would recommend using this theme throughout the park. The carts should be placed on concrete pads, removed from and adjacent to the main path and have trellis or pergola covers to designate their location and give a sense of belonging to the location. These carts should be themed to the location in the Zoo, if appropriate and the connection is obvious.

Menu offerings will include: Bottle Beverages, Dippin Dots, Pretzels, Cotton Candy, Frozen Novelties, and Animal Cookies.

Seating capacity: With the adoption of our

New Seating Capacities	"After"			"Before"			"Gain"		
	Indoor	Outdoor	Total	Indoor	Outdoor	Total	Indoor	Outdoor	Total
Main Café	312	312	624	104	312	416	208		208
West Café		204	204		204	204			
Smokehouse		172	172		76	76		96	96
Snack Shop		20	20		20	20			
Kid's Corner - Icey Treat		40	40					40	40
Dippin Dot Cart		20	20		20	20			
Total	312	768	1,080	104	632	736	208	136	344

Figure 12: New seating capacities

recommendations, seating capacity will increase by 344 (47%), including the conversion of the playground to indoor café seating. This will help with current capacity issues and accommodate the anticipated visitor attendance increase to over million visitors. Figure 12 provides a comparison of the before and after seating capacities.

New menu matrix: With the above recommendations implemented, the new menu matrix would feature a unique entrée menu at each of the three main foodservice venues. This would create destinations within the Zoo and enhance the variety of options available. We realize that there is some downside to this approach with a family that wants pizza, tacos and smoked sausage – which would require three different destinations. Enhanced signage and map details will help with these decisions before the family gets to the order window.

We also recommend a sign at the ticket booth entrance with a clear notice of *Foodservice Concessions*

New Menu Matrix - Entrees

Entrée Menus	Price	Main Café	Tex-Mex	Smokehouse	Carts/Trucks
Grilled Chicken Sandwich	$ 4.99	X			
Chicken Tenders	$ 4.99	X			
Cheeseburger	$ 3.99	X			
Veggie Burger	$ 3.99	X			
Hot Dog	$ 2.99	X			
French Fries	$ 2.59	X			
Pepperoni Pizza	$ 4.49	X			
Cheese Pizza	$ 4.49	X			
Breadsticks	$ 3.19	X			
Southwest Chicken Wrap	$ 5.99	X			
Asian Vegetable Wrap	$ 5.99	X			
Hoosier Chef Salad	$ 5.99	X			
Garden Salad	$ 3.99	X			
Kid's Hot Dog Meal	$ 5.99	X			
Kid's Ham / Turkey Sand. Meal	$ 5.99	X			
1/3 lb. Gourmet Burger	TBD	X			
Grilled Chicken Salads Delux	TBD	X			
Indiana Tenderloin Sandwich	TBD	X			
Pulled Pork Sandwich	TBD			X	
Smoked Brisket Sandwich	TBD			X	
Smoked Chicken Quarter	TBD			X	
Smoked Sausage Links	TBD			X	
Combo Plate - 2 meats, 2 sides	TBD			X	
Combo Plate - 3 meats, 2 sides	TBD			X	
Sides:	TBD				
Mac & Cheese	TBD			X	
Corn on cob	TBD			X	
Skillet cornbread	TBD			X	
Ranch beans	TBD			X	
In season Fruit Cobbler	TBD			X	
Kid's Plate - 1/2 meat + 1 side	TBD			X	
Taco- ea	TBD		X		
Taco Plate - 2 tacos + 2 sides	TBD		X		
Burrito - ea	TBD		X		
Buritto Plate - + 2 sides	TBD		X		
Chimichunga - ea	TBD		X		
Chimichunga Plate + 2 sides	TBD		X		
Taco Salad in Tortilla Shell	TBD		X		
Nachos	TBD		X		
Sides:	TBD		X		
Mexican Rice	TBD		X		
Refried Beans	TBD		X		
Tortillas	TBD		X		
Kids Plate - 1 Taco + 1 side	TBD		X		
Mobile Truck Menus	TBD				X
Cart - Roasted Corn	TBD				X
Cart - Funnel Cakes	TBD				X
Cart - Roasted Nuts	TBD				X
Cart - Hot Dog Grill	TBD				X

Figure 13a: New menu matrix - entrées

Open Today so that visitors know in advance what will be available and where it will be located. This is similar to how a ski resort announces the runs that are open on any given day to avoid disappointment by the visitor later.

The new menu matrix if our recommendations are adopted is set out at Figures 13a and 13b.

Capital budget

We have prepared the estimated capital investment for the phased recommendations identified above. Whether this is funded by the Zoo, the operator or some combination, these estimates are based on our experience, industry rule-of-thumb, and what we see being done at other client zoos. These estimates include costs for build-out, equipment replacement (including installation and sales tax), renovations/construction and re-theming buildings. The total estimated capital budget required for full implementation of our recommendations is detailed at Figure 14.

While the above summary is our estimate, if the Zoo (and the operator) pursue any of our recommendations, the Zoo (and operator) should have detailed drawings and cost estimates developed for each of the phases and recommendations

New Menu Matrix - Snack/Beverage						
Snacks / Beverages	Price	Main Café	Tex-Mex	Smokehouse	Snack Shop	Kid's Corner
Cotton Candy	$ 3.49	X				
Pretzel	$ 3.49	X				
Popcorn	$ 2.99	X			X	
Chips	$ 1.49	X	X			
Cookies	$ 1.49	X				
Animal Crackers	$ 1.49	X				
All Day Refillable Beverage	$ 8.99	X	X	X	X	
Souvenir Cup	$ 5.99	X	X	X	X	
Animal Sipper	$ 3.19	X				
Bottle Juice	$ 3.19	X				
Regular Soda / Iced Tea	$ 3.19	X	X	X	X	
Bottle Water	$ 2.79	X	X	X	X	X
Ice Cream Bars	$ 2.49		X	X	X	
Ice Cream Bars - Large	$ 3.99		X	X	X	
Ice Cream "Cookie Burgers"	TBD				X	
Churros	$ 3.49		X		X	
Float	$ 3.99				X	
Ice Cream Waffle Cone	$ 3.99				X	
Ice Cream cup / Cone	$ 3.99				X	
Yogurt by the Ounce - Self Serve	TBD					X
Yogurt Toppings by the Ounce - $	TBD					X
Slushy self serve - small cup	TBD					X
Slushy self serve - medium cup	TBD					X
Slushy self serve - large cup	TBD					X
Slushy self serve - souvenir cup	TBD					X

Figure 13b: New menu matrix - snacks and beverages

considered in this report before finalizing any capital cost estimates or negotiating any contractual financial terms and conditions between the Zoo and the operator.

Operator contract recommendations

As noted earlier, the commissions required by the current contract are higher than any zoo-operator contracts familiar to us. It is concluded that this contract's financial terms have forced the operator to cut back in the areas of food quality and service to achieve their desired level of profits.

The Zoo will be seeking this capital investment from the operator to implement the Master Plan over

Zoo Food Service Master Plan		
Concept Estimate - Summary		
Main Café - Phase 1	$	184,006
Main Cafe - Phase 2	$	2,206,425
West Café Complex	$	572,856
Kid's Corner Icey Treats	$	348,875
Country Smokehouse	$	128,475
Carts	$	449,900
Total	**$**	**3,890,538**

Figure 14: Foodservice master plan

the next five years. In order to attract this level of investment, the commissions and the amortization term will need to be adjusted to allow the operator to amortize this investment and maintain a similar level of profit.

For example, a $3 million operator investment, amortized over the life of the contract (10 years minimum, but should be longer to minimize any negative impact on commission rates) will impact the commission structure. At Figure 15 is a table that can be used as a guide to the relationship between investment and commission.

This demonstrates that with a $3 million investment by the operator, they should be willing to trade a reduction in commissions between 4% and 10% depending on the projected revenues

Impact of Investment on Commissions						
Revenues	$	3,000,000	$	3,500,000	$	3,750,000
$3 million Amortization over life of contract:						
10 years	$	300,000	$	300,000	$	300,000
% of Revenue		10%		9%		8%
15 Years	$	200,000	$	200,000	$	200,000
% of Revenue		7%		6%		5%
20 Years	$	150,000	$	150,000	$	150,000
% of Revenue		5%		4%		4%

Figure 15: The impact of investment on commissions

and length of the contract/amortization. It would seem reasonable to expect the middle value of a 6% reduction in commissions.

In addition, to make a positive impact on the quality of food and service, while keeping prices at or below where they are now, a reduction of an additional 4% would take the overall commission structure from the current 38% to 28%. These commissions would still be considered high in the zoo industry, but closer to realistic expectations. The operator will need to demonstrate a plan to convert these commission savings into quality and service improvements and not simply add to their profits.

A West Coast zoo client, with a similar attendance to this zoo, adopted a reduced menu pricing strategy with their operator and made significant capital investment ($2.8 million), introduced new and unique food concepts, improved food quality on the plate and

Current Concession Revenues	$	2,862,000
Current Commissions $	$	1,099,000
Current Commission %		38%
Required Concession Revenues to Maintain Current	$	3,925,000
Proposed Commission %		28%
Revenue Growth Required		137%

Figure 16: Current and required concession revenues

– yes – lowered food and beverage selling prices. *Per capita* spending improved 127% from $2.18 to $2.77 and is holding or improving three years later.

At the Zoo, we calculate that revenues will need to increase by 137% to ensure you maintain the current level of commission income from foodservice concessions. This would be achieved with a $3.01 *per capita* spending (with 1.3 million attendance). This is shown at Figure 16.

Financial projections

We have prepared revenue, earned income and return-on-investment projections using the information provided in this report. These projections will help to determine if the investments recommended are financially viable.

Revenues: The revenue projections are based on a projected *per capita* spending, by venue, starting

Food Service Concession Revenue Projections	
	Totals
Current Per Capita $	$ 2.65
Growth in Per Capita $:	
Conservative 10%	$ 3.00
Mid-Range 15%	$ 3.15
Optimistic 20%	$ 3.30
Attendance Yr 1	1,300,000
Revenues:	
Conservative	$ 3,893,500
Mid-Range	$ 4,091,750
Optimistic	$ 4,290,000
Attendance Yr 2	1,250,000
Revenues:	
Conservative	$ 3,743,750
Mid-Range	$ 3,934,375
Optimistic	$ 4,125,000
Attendance Yr 3	1,200,000
Revenues:	
Conservative	$ 3,594,000
Mid-Range	$ 3,777,000
Optimistic	$ 3,960,000

Figure 17: Foodservice concession revenue projections

when the new exhibit opens. We used attendance projections provided by the Zoo and prepared conservative, mid-range and optimistic projections based on *per capita* growth and projected attendance.

Other key assumptions included:

- Vending *per capita* spending would decrease with the improvements in the foodservice concessions and carts.
- Conservative growth = 10%
- Mid-range growth = 15%
- Optimistic growth = 20%

A summary of these results is set out at Figure 17. These projections are based on Best in Class and assume full implementation of the recommendations included in this report. If projects are selectively implemented or delayed, then the full impact of *per capita* growth will not be achieved in the timeline identified.

Earned income: We used the revenue projections to calculate projected earned income. These earned income projections assume that the operator will make the capital investments or that Zoo will obtain donations for these projects and not have any debt burden. We also assume that the Zoo will reduce the commissions to an average 28% (vs. the 38% currently) to allow the operator to pay for the investments and improve product quality and service. We used the Year 2 revenue projections for conservative, mid-range and

Zoo Earned Income			
	Revenues	Commission %	Commission $
Current	$ 2,862,000	38.4%	$ 1,099,000
Future - Yr 2			
Conservative	$ 3,743,750	28.0%	$ 1,048,250
Mid Range	$ 3,934,375	28.0%	$ 1,101,625
Optimistic	$ 4,125,000	28.0%	$ 1,155,000

Figure 18: Zoo earned income projections

optimistic results. The results are shown at Figure 18.

This illustrates, as detailed earlier, that revenues would need to increase by over $1 million, the optimistic level, to maintain the current level of earned income for the Zoo at the reduced commission rates. Consequently, the Zoo will need to look beyond solely the financial return to justify these changes. Improved visitor experience would be the driving force behind these changes.

Return-on-investment: We assume that if the operator is going to be incentivized to make a significant investment at the Zoo, they will need to justify this investment by looking at the return-on-investment. Most operators look for 20% to 30% return on their investment. If it is below 20%, they need to justify this to their management group and identify other, non-financial, benefits such as market growth, client retention, competitive strategy, etc.

For this analysis, we used the incremental revenues and resulting incremental profits garnered

Operator Return on Investment			
	Conservative	Mid-Range	Optimistic
Incremental Revenues - Yr 2	$ 881,750	$ 1,072,375	$ 1,263,000
Operator Incremental Profit			
30%	$ 264,525	$ 321,713	$ 378,900
35%	$ 308,613	$ 375,331	$ 442,050
40%	$ 352,700	$ 428,950	$ 505,200
Return on Investment: (using 35% profit projections)			
$ 2,000,000	15.4%	18.8%	22.1%
$ 3,000,000	10.3%	12.5%	14.7%
$ 4,000,000	7.7%	9.4%	11.1%

Figure 19: Operator return-on-investment

from the changes caused by the investment. We identified three levels of incremental profits (30%, 35% and 40%) on these incremental revenues to identify the increased profits they would realize. We assumed that the investment amortization costs are covered by the reduction in commissions and that improved quality and service is also paid from the reduction in commission as discussed previously. Thus, all other fixed costs are already covered and this analysis focuses on the incremental profits after variable costs.

We assumed three investment levels of $2 million, $3 million and $4 million.

The results of this analysis indicate that the operator will only achieve the normally expected return on investment goals of approximately 20% to 30% with the optimistic projections. Consequently, for the Zoo to negotiate these levels of investments from

the operator, there will need to be additional incentives for the operator, such as longer contract terms.

The results of the return-on-investment analysis are shown at Figure 19.

Summary and next steps

Summary

- The current foodservice concessions lack variety, quality and perceived value.
- Foodservice concessions do not add to and enhance the visitor experience and can be a source of negative feedback.
- Earned income from foodservice concessions is considerable and, at over $1 million per year, is above industry standards and is a critical part of the Zoo's annual earned income.
- Foodservice concession venues and equipment are aging (most are original 1988 vintage) and will need replacement and/or significant refurbishment to service the anticipated increased attendance and customer demand. Repair, refurbishment and replacement have been underfunded at $25,000 per year under the current operator contract.
- Foodservice concession venues are undersized

and face capacity issues on busy days.

- Our recommendations focused on turning visitor resentment into enthusiasm and excitement by growing venue capacity, introducing new concepts and improving the menu variety.

- A significant capital investment of some $4 million will be needed to implement our recommendations.

- We identified foodservice concession revenue and earned income growth based on conservative, mid-range and optimistic scenarios and identified that it will be difficult for the revenue growth to justify the capital investment on a pure return-on-investment basis. Other factors such as significantly improving visitor (and member) experience, increasing frequency of use, and increasing *per capita* spending will need to be part of this decision.

- The operator's contract has industry high financial terms in favor of the Zoo. Commissions average 38.5% of foodservice concession revenues, which is some 10% higher than most other zoos with similar annual visitor levels and foodservice sales.

- This high commission structure contributes to lower food quality and service issues. The operator has to cut back on the quality and variety of ingredients and level of staff in order to pay almost 40% of revenues to the Zoo and remain profitable.
- The operator contract has one-sided cancellation terms, in favor of the operator, which restrict the Zoo's options for negotiations or conducting a Request for Proposal. As with the commission rate, these terms are unusual and not consistent with industry standards.

Next steps

- We would encourage the Zoo to review the key elements of this report with the operator to solicit their input and operating details for the various new concepts recommended. We can prepare an operator version of this report, removing some of the confidential or sensitive content.
- When both parties agree on the various concepts and design changes, more detailed costs analysis can be prepared by the operator for specific physical changes and equipment needs.

- The operator can recommend menu pricing and confirm the transition timing to convert the venues into the new concepts.
- If the Zoo wants elements of this Master Plan implemented before or with the opening of the new exhibit, the only option will be to renegotiate the current contract with the current operator. This will allow for investment and operating changes to be implemented in the next three years to be ready for the new exhibit opening.
- If our understanding of the current operator contract is accurate, the Zoo will need to renegotiate the existing contract to include a new commission structure in exchange for the operator's capital investment. As noted in this report, the projected return on investment for the operator will likely be below industry standards, so the Zoo may need to supplement part of the investment, or consider a further reduction in commission income in exchange for additional investment.
- If the Zoo is not successful with renegotiation and our understanding of the current contract is not accurate, this Master Plan can be used

as guidelines for a Request for Proposal (RFP) process to attract proposals from the various national operators capable of this size of operation and capable of making this level of investment. If going with an RFP, it should start late next year to conclude in the fall of the following year, with implementation of the new contract and operator (if changed) in January of the following year.

7

Benchmarking Visitor
Menu Pricing

The report on the following pages was prepared for a museum in a downtown location, which currently attracts close to a million visitors a year, and which offers multiple dining options for visitors, staff and volunteers. The style of service, menus and pricing vary by location and offer an extensive variety. These dining locations are outsourced to a restaurant operator.

The Museum wants to ensure that its menu pricing is within the normal range, as found at similar dining operations in other museums in the region.

The resulting report provides advice and information on:

- restaurant menu price benchmarking;
- restaurant menu analysis.

Walker Art Gallery, National Museums Liverpool, UK

Visitor foodservice pricing benchmark study

The Art Museum offers multiple dining options for visitors, staff and volunteers (the Bistro, Café, Gallery and Cafeteria). Style of service, menus and pricing vary by location and offer an extensive variety of menus, service styles and pricing options. These dining locations are outsourced to a restaurant operator.

The Museum wants to ensure that the pricing at these dining options is within the normal range of visitor foodservice menu pricing as found at similar dining operations at other museums in the region.

Benchmark pricing observations

When benchmarking café and restaurant pricing, it is often difficult to make "apples to apples" comparisons. There are so many variables, including portion size, brands, ingredients, quality, style of service and operating requirements (hours, staffing, etc.) and differences that can create cost differences that lead to pricing differences. It is not practical to compare the price of a casserole to a New York Steak, for example. It can even be difficult to compare seemingly similar items, such as hamburgers, coffee or soup, for the reasons stated above. We must realize that coffee quality (*Starbucks, Dunkin Donuts*

or no-name brand for example) can and does have an influence on the pricing. A basic 4oz. hamburger as compared to a fresh-ground, organic, grass-fed beef 8oz. burger offered at many high end restaurants is another example.

Benchmark pricing: When collecting this benchmarking data, we were diligent to compare, as closely as possible, similar portion size, quality and service styles. As noted above, the primary comparison is with other cultural institutions, primarily art museums. It is not likely that many museum dining customers are directly comparing prices at museum restaurants in other parts of the country. But the exercise does help to measure the visitor perceived experience against these other similar institutions. While visitors to cultural institutions may have come to expect dining prices to be higher than neighborhood dining options in some cases, they may have similar experiences at these other regional cultural institutions and compare the Museum's dining experience to these. At the same time, dining customers that may comment about high prices often may not know what particular menu item is overpriced, or by how much, just that the total cost of the meal was "higher than expected" or "higher than they pay at XYZ". With this in mind, we

not only compared individual menu item prices but also calculated a *virtual meal* and compared the *virtual check totals* for the various benchmarked institutions. We picked a mid-range priced appetizer, entrée, beverage and dessert. These totals are revealing, as some menu strategies focus on relatively lower priced center-of-the-plate menu items but higher pricing for beverages, desserts, appetizers. The results of this analysis, at Figure 1, indicate that the Museum Cafeteria prices slightly less than other cultural institution restaurants while the Museum Café and Bistro locations are higher.

Museum Cafeteria: This indicates that the Cafeteria pricing is 81.3% of the benchmarked average for similar items (or 18.7% less). Breakfast was difficult to gather sufficient benchmark data to conclude anything about this pricing. Lunch items appeared to be generally lower than the benchmark data. A few items such as soup and pre-made side salad were lower than benchmark data while pizza, kids' meals and fountain soda were higher than similar products at benchmarked institutions.

Café: The Café virtual meal is 109.1% (or 9.1% higher) than the benchmarked group. As the uniqueness and style of service increase, it is increasingly difficult to compare benchmark data.

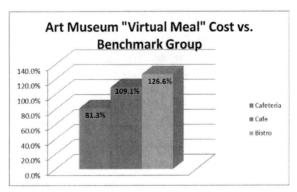

Figure 1: Comparative virtual meal pricing

We noted that center-of-the-plate items (entrée/protein) were consistently higher than the benchmark data. This included pizza, gourmet hamburger, panini and other entrées. Other items including appetizers and beverages were comparable.

Bistro: The Bistro virtual meal was 126% (or 26% higher) of the benchmarked group. As noted with the Café, the level of service and unique menus make these price comparisons even more difficult. We were not provided prices for beverages and desserts, so this comparison is focused on appetizer and entrées. We did not benchmark dinner or brunch prices as there was insufficient comparable data from the benchmark institutions.

Member discounts: We observed that the discount offered to Museum members is 15% as compared

to 10% (or nothing) at all other benchmarking institutions. While this does not apply to all visitors, it does offer Museum members an additional 5% discount as compared to members at all other institutions. The benchmark data in this report is based on the actual selling price, not including member (or staff/volunteer) discounts.

We noted that menus include a short statement that members receive this discount, but this is not prominent or readily identified.

Neighborhood benchmarks: We decided to compare the Café pricing to reasonably comparable restaurants within one mile of the Museum. While not part of the original scope of work, we wanted a glimpse of pricing that some visitors may be directly comparing to Museum pricing. Again, it was difficult to compare menus, quality and style of service line-by-line, but the virtual meal comparison did show that Museum pricing would be considered higher than the neighborhood. However, for Museum members, after the 15% discount, the overall cost would be less than at the neighborhood establishments. This is shown at Figure 2.

We did not compare the Bistro pricing to the neighborhood options as the Bistro menu is so unique and it is difficult to compare the style of service

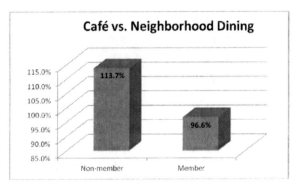

Figure 2: Café and neighborhood pricing compared

and menu items to the neighborhood restaurants identified.

Summary

We found the pricing at Museum to be generally comparable to similar cultural institutions in the benchmarking matrix. The Cafeteria pricing was at or below comparable pricing with a few noted exceptions. The Café was observed to be a bit higher than comparable dining experiences, but as noted, unique menus and differences in product quality make this hard to compare. Finally, the Bistro was observed to be generally higher priced than similar dining experiences.

The Museum and the restaurant operator should be aware that the membership benefit of a 15%

discount is 50% higher than all other institutions benchmarked. We are not recommending any change to this, but instead recommend taking advantage of this benefit.

Figures 3-5 are summary charts showing the Museum versus the benchmarked institutions for each foodservice venue.

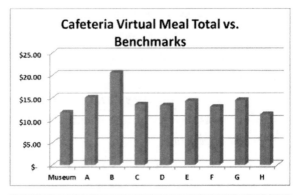

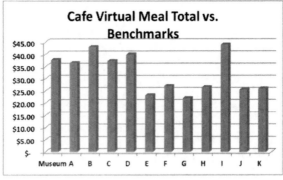

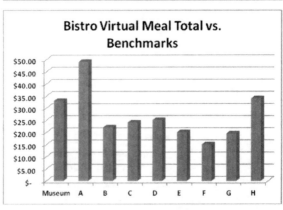

Figures 3-5: Museum pricing compared to other institutions

8

Working with Independent Restaurant Operators

The report which follows was prepared for an art museum in a mid-sized city, which attracts over 100,000 visitors annually, and currently provides an outsourced table service restaurant and exclusive catering services.

The Museum has an exclusive operating agreement with a local restaurant operator. Policy changes relating to evening programming and a decision to open on Fridays with free admission caused a significant drop in facility rentals and related catering which, in turn, cut into the operator's expected profits and his ability to continue operating without the Museum's financial support.

As a result, the Museum decided to evaluate the restaurant and catering operations to determine how much the policy changes impacted the operator's business and what the next steps with the operator should be.

The resulting report includes:

- Operational analysis.
- Catering history trends.
- Projected operator financial pro-formas.
- Contract strategies.
- Recommended next steps.

Metropolitan Museum of Art, New York City, USA

Restaurant study

This art museum has been renovated and expanded over the years to house one of the country's most renowned collections of contemporary art.

The on-site restaurant was opened in the 1960s after a museum expansion project. Originally started as a Tea Room, it has evolved into a full-service restaurant currently operated by a local operator.

Over the years, several contracted operators, as well as the Museum itself, have operated the restaurant.

The foodservice operator's contract recently expired and the operator is continuing operations on a month-to-month basis under the same terms and conditions. The Museum opted for this month-to-month arrangement to provide time to assess the future of the restaurant and the operator relationship.

The Museum's annual visitor count is spread out fairly evenly during the course of twelve months.

A recent shift in approach has led to fewer blockbuster-type events in favor of building attendance gradually with new programs and offering free Friday evening admissions. The Museum has also downplayed the role of facility rentals due to a concern with the wear and tear on the facility and works of art. This has changed the dynamics of the

foodservice operations.

Museum goals are to elevate the level of service, menu and ambiance of the restaurant, creating a unique, destination facility. It believes there is demand in the local market for a trend-setting restaurant with familiar, but uniquely prepared, menu items, interesting desserts and wines. Napa Valley-style service and menus was referenced as a comparison.

The Museum would like to know what its foodservice opportunities are, including the possibility of making the restaurant more of a destination for local residents and business people and not solely dependent on Museum visitors.

Attendance: During the past twelve months, there were over 100,000 visitors. The Museum has a detailed analysis and a clear understanding of their attendance data and visitor demographic. It has made a conscious decision to not pursue the path of blockbuster exhibits, focusing instead on steady, long-term growth. This has affected attendance and, consequently, restaurant revenues.

The Museum launched *Taste at the Gallery*, providing free admission on Fridays into the evening hours. This has been very popular, attracting 800 to

1,200 per Friday night. Friday is now the most active attendance day in the week.

Existing operations: The Courtyard Restaurant is conveniently located near the entrance, easily accessed by visitors and on a central courtyard and it can be seen (the outdoor dining seats) by all visitors coming in the main entrance which is very good. We had lunch in the facility and found the experience to be satisfactory. In particular, we noted the following:

- Service – adequate, not great. Lack of a uniform look and too casual for the style desired. The server had knowledge of the menu and made suggestions. Left dirty dishes on our table too long, even walking away empty- handed.
- Quality – adequate, not great. Presentation of items nicely prepared. Seared tuna was cooked to "well" rather than the expected and normal "rare" (We acknowledge that this may be local preference and tastes).
- Menu variety – Good variety and unique menu items. Nicely balanced between sandwiches, Asian flavors, soups and salads. Wine selection limited and pedestrian, offering no upscale labels.
- Menu pricing – Excellent value. Lunch

pricing appeared low to us, but may meet local market expectations. On the other hand, dinner prices (applicable to Friday *Taste* nights) seemed high with entrées ranging $16 to $24. Children's menus are available upon request.

- Sanitation – Generally poor, cluttered and disorganized. We noted storeroom violations, with product and boxes directly on the floor or on improper racks (milk cartons inverted).

- Merchandising and presentation – Generally poor, uninteresting and not connected with the Museum's mission. The operator is using contemporary new china recommended by a renowned designer and artist, but it is impractical for restaurant use. We noted some art work in the restaurant, but it could be better connected to this Museum's experience. Table top presentation mundane with plain white tablecloths.

- Parking – The $5 parking fee is not waived for restaurant use and could be a deterrent for public use. However, based on information from the Museum, almost 5,000 visitors came only to use the restaurant in the past twelve months.

- Advertising and marketing – There is a lack of a concerted effort by either the Museum or the operator to advertise the Courtyard Restaurant to the general public or visitors. However, the Museum website does a good job of highlighting the restaurant on the front page and provides a link to the menu. The operator does not advertise or cross-market the Courtyard Restaurant with his other restaurant operations in the area.

- The location of the restaurant is central, but this presents other logistical issues. The public spaces and hallways need to be used for deliveries and the operator needs to move product to catered events elsewhere in the Museum. We also noted the generally uninviting entrance to the restaurant.

We noted that restaurant sales trends are mixed, with Year 1 being the best year, related to the last blockbuster event sponsored by the Museum. However, starting October Year 2, when the *Taste* Friday nights started, Courtyard Restaurant sales have significantly exceeded those of the prior year. Other than the "blockbuster" months of June through July in Year 1, sales have trended upward until May Year 3.

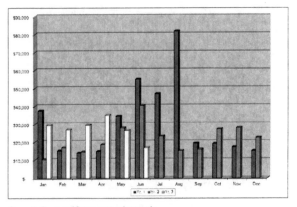

Figure 1: Courtyard Restaurant sales trends

The graph at Figure 1 shows this trend.

In February, March and April Year 3, attendance was strong, thanks to a special exhibit, with June dropping nearly 66% compared to April.

When we evaluate a museum's visitor foodservice operation, we first compare the revenue levels to what should normally be expected. Using industry average benchmarks (with similar-sized art museums that have cafés/restaurants) we can calculate expected sales from attendance data. Figure 2 indicates that expected sales should be greater than those experienced at the Courtyard Restaurant.

We noted that the current operator does not track actual customer counts or other normally expected statistics such as check average, menu movement,

Year 1/2	Attendance [1]	Expected C.C [2]	Expected Sales [3]	Actual Sales [4]
Jul	5,042	1,765	$ 19,412	$ 23,341
Aug	4,878	1,707	$ 18,780	$ 15,172
Sep	2,508	878	$ 9,656	$ 15,976
Oct	8,855	3,099	$ 34,092	$ 27,426
Nov	8,949	3,132	$ 34,454	$ 28,108
Dec	7,538	2,638	$ 29,021	$ 22,601
Jan	7,544	2,640	$ 29,044	$ 29,505
Feb	12,270	4,295	$ 47,240	$ 26,922
Mar	13,732	4,806	$ 52,868	$ 29,625
Apr	17,408	6,093	$ 67,021	$ 34,972
May	9,432	3,301	$ 36,313	$ 26,563
Jun	5,973	2,091	$ 22,996	$ 16,790
Total	104,129	36,445	$ 400,897	$ 297,001

1. Art Museum Admissions Data
2. Industry Standard – Expect 35% of attendance to use foodservice based on location and visibility of Client restaurant
3. $11.00 check average for each customer based on information provided by Operator
4. Client provided data

Figure 2: Courtyard Restaurant sales analysis

beverage versus food sales, etc. The operator provided his estimate of current check average at $11.00. With the current menu prices, this does not seem out of line and is within the range ($8 to $15 for visitor foodservice lunch) of check averages observed at similar museums.

Special events and catering: The Courtyard Restaurant operator is the exclusive provider of catering services at the Museum.

During the twelve months July to June there were 38 special events and external caterings serving a total of 4,700 guests. The events range from receptions for 500-plus to sit-down dinners for 30. The chart at Figure 3 summarizes the Special Event activity during the past 12 months. This indicates a relatively slow

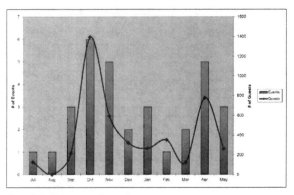

Figure 3: Special events and guest data

Special Events calendar with no more than six events in any month and three months which had only one event each. The introduction of *Taste at the Gallery* in October has taken Fridays out of the Special Event market, a typically popular and busy day for Special Events.

Most operators of restaurants and cafés within museum settings rely on catering income as their primary profit source. The restaurants and cafés typically break even, at best, leaving the operator to look to catering for their profits.

We prepared a sales trend analysis (Figure 4) and note that, with a few exceptions, catering sales are generally down compared to pre-*Taste* figures.

Facility rental rates are priced ranging from $500 for the Courtyard Restaurant to $15,000 for the

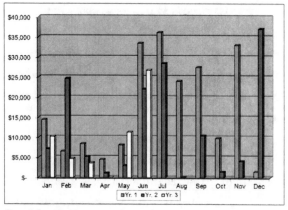

Figure 4: Catering sales

Modern Court. This latter rate was recently raised from $5,000 and reflects the management/board policies to discourage over-use of the gallery facilities and the wear and tear that accompanies it. Museum spaces to do special events without affecting or harming the collection are very limited and, for most events, art works have to be moved out of the event spaces – something which is not cost-effective and puts the collection at risk from excessive handling.

Roger Hall, a space that can lend itself to special events, is attached to the main Museum buildings by a long, underground corridor. While Roger Hall itself is nice and spacious, most customers do not like to use it as their guests complain about the distance and the "detached" feeling from the rest of the Museum.

The room is priced at $2,000 for weekdays and $3,000 for weekends.

Special event and facility rental information is nicely presented in a professional color brochure that clearly shows each space, capacities and rules and guidelines.

In addition to special events and external catering, there were 33 internal (Museum-sponsored) catered events in the past twelve months. These events are not typically as profitable for the operator since discounts are usually applied to food and beverage prices.

The Museum expressed disappointment with the current operator's catering methods and organization. Too often, events are set up at the last minute and appear to be disorganized. The Museum is frustrated with what appears to be a lack of care for the facility by the operator, and pointed to marks on walls, doors and elevators claimed to have been made by the operator.

The Museum also believes that the operator does not actively participate in the sales and marketing effort to attract catering events there.

Finance: So, is the foodservice profitable? Looking at the trends and the continued decline in catering sales, we estimate that the current operator is likely unprofitable, or making cuts which are in neither the

	Year 1		Year 2		Year 3 Y.T.D. June	
	Café	Catering	Café	Catering	Café	Catering
Sales	$371,165	$207,349	$261,881	$144,672	$164,377	$56,638
Food Costs	$129,908	$ 62,205	$ 91,658	$ 43,402	$ 57,532	$16,991
%	35%	30%	35%	30%	35%	30%
Labor Costs	$150,000	$ 51,837	$150,000	$ 36,168	$ 75,000	$14,160
%	40%	25%	57%	25%	46%	25%
Other Costs	$ 55,675	$ 20,735	$ 39,282	$ 14,467	$ 24,657	$ 5,664
%	15%	10%	15%	10%	15%	10%
Operating Profit	$ 35,583	$ 72,572	$(19,060)	$ 50,635	$ 7,189	$19,823
%	10%	35%	-7%	35%	4%	35%
Commissions	$ 44,540	$ 24,882	$ 31,426	$ 17,361	$ 19,725	$ 6,797
%	12%	12%	12%	12%	12%	12%
Net Profit	$ (8,957)	$ 47,690	$(50,485)	$ 33,275	$(12,537)	$13,027
%	-2%	23%	-19%	23%	-8%	23%
Combined Profit	$	38,733	$	(17,211)	$	490
%	6.7%		-4.2%		0.2%	

Figure 5: Estimated foodservice profitability

Museum's nor his best interests through trying to keep a positive cashflow. Figure 5 estimates the profits for the past two-plus years using industry averages and our experience with similar café, restaurant and catering operations with 100,000-200,000 annual attendance.

Foodservice contract

The existing contract had expired three months before we were engaged. We noted that the agreement currently/formerly in place is not consistent with industry standards from the Museum's standpoint. While the length is not at issue, the many details that are not covered in this contract are of concern.

We also noted the unusual commission language, essentially where the Museum is claiming ownership

RESTAURANTS, CATERING AND FACILITY RENTALS

of all revenues and refunding "compensation" to the operator of 10%, 12% or 15% depending on the revenue levels. Normally, this is reversed, with the operator owning the revenues and paying a percentage commission to the Museum. While mathematically equivalent, it does add administrative and reporting duties to the Museum to handle the revenues, report sales tax, etc. that is not commonly found in museums with foodservice contracts of this type.

The "compensation" or commission rates are the same for both the restaurant and catering sales. As demonstrated above, catering is the profitable side of the business and typically pays a higher commission than the restaurant to the Museum.

Restaurant and catering operator

The current operator is also owner and operator of local restaurants. We visited one of his restaurants for dinner and were favorably impressed with the service, ambiance, menu and pricing. The restaurant was busy, modern and had chic decor. The menu was similar to the Museum's Courtyard Restaurant. The activity during our visit and reviews in local publications indicate that these are popular restaurants.

There would appear to be a lack of communication between the restaurant owner and the Museum.

There were several issues noted that had totally diverse positions when comparing what the Museum understood and what the operator understood. For example:

- Local restaurant concept: the Museum said the operator would not bring his local restaurant concept to the Museum due to operating conflicts. The operator claims he has offered to bring this concept in, without restrictions.

- Member/staff discounts: the Museum claims the operator has refused to offer discounts to members/staff and volunteers. The operator claims he wanted to implement discounts, but the previous Museum Director said not to, or only for certain levels of membership.

The operator is proud of his affiliation with the Museum and believes he operates at the highest level. He indicated to us that while he is willing to bring a local concept to Museum, it has to be done "right" and he would need the Museum's help with the capital required to renovate and decorate the restaurant.

The Museum would hope that, if the operator's restaurant concept were implemented there, the owner's partner would be more actively involved.

Evidently, she is perceived as a key element to the success of the operator's local restaurant, previously worked at the Courtyard Restaurant, and was greatly admired.

The operator is happy with the current kitchen size and layout, but noted the need for consolidated and adequate storage space. We did note the lack of Point of Sale (POS) equipment normally found in restaurant operations. The POS system helps to control guest check activity and provides detailed statistical information lacking in the current operation.

Recommendations

Keeping in mind that one of the key goals of this study was to determine if an upscale, destination restaurant is feasible, we recommend two courses of action for the immediate/near-term and longer-term solutions.

Immediate/near-term

- Talk to selected operators, on a confidential basis, who have the proven ability to operate museum restaurants and catering and the ability to support an operation in the local area to determine if there is interest in operating the Museum contract. If there is interest, we

suggest that the prospective operator(s) visit the Museum (confidentially), have lunch and be given some basic information such as visitor counts, café and catering sales history and special event activity. These operators should be able to determine if they think there is business potential for them and basically what they would suggest for operational changes and contract terms. (We can provide a list of operators that meet these criteria.)

- Depending on the outcome of step one, the Museum can move forward and renegotiate the contract with the local operator for a three- to five-year term with the knowledge that there are, or are not, other prospective operators and if there are, what kind of financial terms and conditions would be expected from the Museum.

- Given the current operator's willingness to develop a local restaurant concept at the Museum, we recommend working with him to achieve this goal (provided the contract terms are reasonable and mutually satisfactory). The operator's own restaurant concept seems to have local acceptance

and offers a quality menu and interesting selections at reasonable price points. He estimated a cost of $25,000 to establish the look of their local restaurant, without any significant construction required. It is likely that the Museum would need to pay for these renovations as part of the new agreement.

- With the introduction of the operator's local restaurant concept, attention would need to be paid to back-of-house issues such as storage spaces and organization skills. Appropriate racks, shelves and storage techniques are a must.

- We recommend that the current contractor and Museum senior management take trips to other museums for the express purpose of visiting their foodservice operations, meeting the operators and museum personnel responsible for foodservice, and sharing ideas and learning from each other. We recommend visiting: Isabella Stewart Gardner Museum, Boston; Hillwood Museum and Gardens, Washington, DC; Norton Museum of Art, West Palm Beach; Corcoran Art Gallery, Washington, DC; and Memphis Brooks Museum of Art, Memphis.

Three to five years

- If there was strong operator interest expressed from the selected operators discussed above, the Museum may want to pursue a formal Request for Proposal process for a long-term contract. This process can take six to nine (or more) months to complete, if done in a thoughtful, deliberate way. Consequently, we suggest starting this process a full 18 months before the current (or re-negotiated) contract term expires.

- We advise that given the current Museum philosophy and less aggressive special event (facility rental) policies, it may be difficult to attract operators with strong financial packages – ones which are favorable to the Museum and provide earned income. Many operators may shy away from this type of contract, given a relatively low visitor attendance and a slow special event (facility rental) calendar.

Special events and catering

- There are essentially two venues available for special event rentals, the Courtyard Restaurant and Roger Hall. The other venues,

the Modern Court and Upper Galleries are priced to discourage all but the deepest pockets.

- To encourage acceptance and more use of the Roger Hall, we recommend renovation of the front entrance to better accommodate access directly from the street. This would include installing handicap access, circle drive and valet parking, better adjacent catering support facilities, coat room, etc. This would eliminate the long walk from the side of the Museum, but still allow access to the art for those who wanted to go to it. This would also enable Roger Hall to be used unrelated to a Museum tour or event.

- Assuming that moving people from the Museum spaces to Roger Hall is an obstacle, we have seen creative solutions to address this kind of problem. This may include the use of mimes, musicians, magicians, characters in costume, etc. to attract and move the crowd down to Roger Hall.

- Restrictions should be removed for the rental of the Courtyard Restaurant during off hours, including days the Museum is closed. This will enable the Museum and the operator to book

the restaurant for special events and increase earned income in this underused space. This would include coordinating security, staff, parking, etc. when the restaurant is rented for business meetings or dinners.

Marketing and merchandising

- Depending on the outcome of the contract issues described above, we recommend authorizing the current operator to cross-market the Museum restaurant at his local facilities. This should include table tents, or similar marketing materials, to let his customers know he operates a restaurant at the Museum. Possibly offer incentives to visit with a complimentary dessert or free Museum admission, etc.

- The restaurant should continue to be prominently displayed on the Museum website. However, it appears to be stagnant information, not changing in the few months that we have checked the information.

- Outside signage (tastefully designed and in keeping with the Museum's image) for the Museum restaurant will help to attract potential customers.

- Consideration should be given to refunding (or not charging) the parking fee for restaurant-only customers to encourage public use. This can be accomplished from the restaurant by validating the parking ticket for a refund at the main ticket office.

Summary

The current operator and operations impressed us as good, but not great or exceptional. The restaurant is dated and lacking a "connection" to the Museum. The operator indicates he is a willing and enthusiastic partner who wants to continue at the Museum, but needs assurance with a financially viable contract renewal to re-invest his efforts, energy and money into improving the restaurant concept. Given the economic model observed, we do not believe a significantly stronger financial contract is available from the incumbent operator, or from a new operator, with the operational and physical improvements that may come with a locally-based restaurant concept.

ESSAYS

Estonian Open Air Museum, Tallinn

Increasing Your Earned Income in an Economic Downturn

ARTHUR M MANASK
Manask & Associates

Cultural institutions have seen their earned income increase and decrease in many areas with economic upturns and downturns. This chapter will share ways to help reverse downward trends.

Visitor foodservice

If you have a restaurant/café, here is how *not* to increase earned income for your institution:

- Raise menu prices.
- Cut the advertising/promotion budget.
- Lower the quality of food and/or beverages.
- Eliminate discounts for staff and volunteers.
- Reduce staffing/customer service.
- Charge an admission fee to dine in the restaurant.
- Reduce staff wage rates and/or hours of operation.

Increase visitors' participation. It's easy!

On average, how many of your visitors purchase lunch (not just a snack or beverage) each day?

You should be serving at least 25% to 30% of your total annual visitor count. The actual percentage will vary up and down depending on the location of your restaurant, its size, convenience, appeal (menu variety, merchandising, presentation and dining area

A quick point-of-sale [Science Museum of Minnesota, USA]

aesthetics) and other factors.

Opportunity: Efforts should be made to increase the number of visitors having lunch by at least 10% from the current level. Approximately 50% of every additional dollar spent in the restaurant falls directly to the bottom line (profit to your institution and/or profit sharing with your operator).

How much does your average visitor spend for lunch?

In most cases, regardless of the current average check for visitors having lunch at your restaurant, it is likely that you can increase this average through re-engineering the restaurant menu and pricing, improved merchandising, innovative, healthy and sustainable menu items and combinations (value meals), and possibly, menu price reductions. Yes, reductions! Adjust/reduce and right-size menu portions/ingredients and provide more attractive pricing that better competes with local retail restaurants.

Opportunity: Work hard to increase the daily customer counts and percentage of visitors, staff and volunteers that use the restaurant every day. A goal should be set and measured. Using lunch only, if currently your institution has 300,000 annual visitors and the restaurant serves 60,000 annual lunches,

ARTHUR M MANASK | 295

that is about 20% annual participation. Let's say your current average lunch check is $10 for hot or cold entrée and beverage. If you re-engineer menu, portions and prices and reduce the check average to, say $9.00 for the same two menu items, that reduces your annual sales for lunch only from about $600K to $540K. If, through changes and improvements mentioned in this chapter, you can increase your annual customer count for lunch by 10%, that would add 30,000 lunches a year giving a total of 90,000 lunches served. A total of 90,000 lunches a year at a $9.00 average check is $810,000 annual sales compared to 60,000 lunches at a $10 average check which is $600,000 annual sales. Assuming your re-engineering of the menu and pricing keeps the food cost about the same, of the approximately $200,000 annual increase in lunch sales, about $100,000 will fall directly to the restaurant's bottom line profitability. Take a tip from the retail restaurant industry in recent years and re-engineer and re-imagine your entire restaurant to create increased earned income for the institution and the operator (if outsourced).

Attract people to your restaurant instead of your competitor's! Do not assume that raising menu prices will increase your revenue and bottom line profit (or commission

contribution from your operator). Following are the steps you should take when evaluating what to do, or not do, with your menu variety and pricing:

1. What nearby restaurants (with a comparable style of service) are the competitors for your restaurant? Where do your visitors dine, when they are not at your institution, before or after their visit?

2. Obtain menus and menu prices from these establishments.

3. Dine at each of these competitor locations several times to see which are the most popular menu items (see what customers order and ask your server).

4. Compare your menu items and prices to what is offered by your competition.

5. Your competition is offering local, sustainable, organic nutritional information and healthy dining options. Are you?

6. Re-engineer your menu variety and prices to be sure it reflects what your visitors want and expect at prices they are used to paying. Note: menu engineering is a science in and of itself.

7. Do competitive shopping annually and update your menus and prices at least annually (in addition to seasonal menu changes and

themed menus for special exhibitions, etc.).

8. Consider visitor, member and staff/volunteer intercept surveys to learn more about how dining in your restaurant is actually perceived and why it is not used more frequently.

9. Your institution's staff and volunteers are very important goodwill ambassadors for your restaurant so be sure service and pricing meet their needs too.

Generate more income from every dollar!
Self-operated restaurant (and/or outsourced with a management fee type of contract): If your institution operates its own restaurant then, of course, the changes and improvements you make will mean 100% of the new earned income will come back totally to your institution.

If you outsource your foodservice to an operator that operates on a management fee basis, it is likely that all or most of the profits from the foodservice operation will go to the institution after the operator receives its management fee (and incentive/profit-sharing, if applicable).

Outsourced restaurant: If you contract out (outsource) your restaurant, how can your institution benefit by some of the changes detailed in this chapter?

If your operator institutes some of the above changes (with your input and approval, of course), then your institution should benefit financially – assuming your institution has a financial arrangement with your operator where you receive a percentage of gross visitor foodservice revenue.

However, if your operator is successful, likely with your help and support, and increases total revenues by say, 5% or $50,000 per year, and your commission is for example 10%, then your institution will receive $5,000 of this increase in total revenues. Of the $50,000 increase, using some or all of the above strategies, the operator will have an out-of-pocket cost (primarily for food and supplies) of an amount likely not to exceed 50% of total revenue. The operator's gross profit from this $50,000 increase in annual revenues may be as high as $25,000. Your institution receives 10% or $5,000 additional income and the operator may earn $20,000 additional income. Is this fair?

If your operator is taking the initiative in the above areas and making the changes and improvements with increased customer counts and gross revenue with your institution's role being one of only review and approval, then yes, this disproportionate profit sharing is fair.

If, however, it is your institution that is the one

inquiring, pushing and pursuing the above issues and suggested changes, and possibly even funding some of the time, energy and resources involved to make the changes, then it is highly recommended you reach an upfront agreement with your operator as to a different revenue sharing arrangement, if gross revenues increase through a combined effort between your institution and the operator. Operators are usually most gracious and willing to share profits with their clients. This might simply mean the operator is willing to pay a slightly higher percentage commission to the institution. Alternatively, you can base it on a sliding scale of annual revenue with the increased percentage rate starting when annual sales surpass certain milestones.

Facility rentals and catering

We see more and more cultural institutions looking to this to increase earned income. In most cases we find there are numerous opportunities to grow this area depending how aggressive, creative and innovative the institution is willing to be in this area.

Facility rentals and catering 101

Most institutions approach this earned income area as follows:

- Charge a facility rental fee to outside groups and organizations, or require a donation, corporate or other membership or co-sponsorship with the institution (for tax reasons); and,
- Collect a fee or percentage of gross revenues from the caterer(s) (or receive the profit if self-operated by the institution).

The sum of the above equals annual income from facility rentals, catering and special events. Cultural institutions operate this area a number of ways:

1. The institution handles all booking and collecting of facility rental fees.
2. If not self-operated, there is a list of approved caterers, anywhere from a few to a dozen or more, that provide food and alcoholic beverage catering.
3. There is a list of other approved vendors (rental companies, florists, entertainment providers, decorators, valet parking, etc.).
4. The institution has the alcoholic beverage license and handles the alcoholic beverage sales and service while set-up is handled by the caterer(s) or, the caterer(s) are licensed and handle sales in this area too.

The Field Museum, Chicago, Illinois, USA: © Botanicals

5. There is one off-premise or on-premise (who may also be your restaurant operator) exclusive caterer for food and alcoholic beverages that handles all catering at the institution.

Permitted events

Internal events (sponsored and paid for by the institution) can represent about two-thirds of the total annual events at many institutions.

External events are for outside groups and organizations. Following are the most common types of external events that are booked in cultural institutions:

- Corporate events
- Non-profit events
- Weddings and other social events

The most common events not permitted at many/most institutions are:

- Political events
- Religious events
- Any event that might be of a controversial or disruptive nature.

Potential

Cultural institutions are very desirable locations for the three most commonly permitted events listed

above. Corporate events, non-profit events, weddings and wedding receptions and other social events are excellent areas for cultural institutions to grow their earned income.

In recent years many institutions – even art museums which have historically been the most conservative as to the types of events permitted – have become much more open and liberal in this regard with increased facility rental and catering earned income as a result.

Conflicts, culture and politics
Many institutions have progressive boards and senior staff while others have boards and senior staff that either do not want change, or want little change from past practices as it relates to permitted events. These philosophies and attitudes determine to what extent the institution can grow, market and advertise its availability for permitted events.

Furthermore, internal events which represent the institution's mission and programming, can often conflict with the desire, ability, and capacity to expand and grow earned income. Institutions vary greatly in this regard. This ranges from smaller art museums with under 100,000 annual visitors that are the most popular place in their community for weddings,

wedding receptions and rehearsal dinners, to all sizes of institutions that in no way, shape or form would permit a wedding reception (or ceremony) on-site.

The difference between those that permit weddings and those that do not, is reflected in earned income as well as in the institution's visibility in the community – not just visibility with corporate sponsors and business members, but with the local and oftentimes prominent residents that are members, or might become members, if exposed to the museums. These people might become donors, members or sponsors if, as a guest at a wedding, they were exposed to this fabulous local institution.

If your institution's board and senior management want to increase earned income, then it is important for staff to tell them that increasing earned income in this area is not just a factor of raising facility rental fees, but most importantly, of considering all options and opportunities, progressively and open-mindedly in order to create optimum earnings potential. It cannot be done the way institutions have done it in the past. It requires new innovative and creative approaches and strategies.

How to increase earned income

If your institution has decided to be progressive

and aggressive, and in good taste, develop and grow facility rentals, consider the following steps and activities:

1. If you have an approved list of caterers, it should be as short as possible (ideally 2-3 maximum).

2. The short-list of caterers should represent a cross-section of menu, price and style of service to reasonably ensure that any user (outside group or internal event department) can find the menu, price, quality and service to meet their needs.

3. Advise the caterers that you want their financial, advertising/marketing support to actively bring events to your institution (based on, of course, your institution's guidelines and policies).

4. In return for them being on the short-list they should provide your institution a minimum annual dollar guarantee against a percentage of their total food and alcohol sales to the users. This is the basis of their proposal/bid to be on the short-list, along with, of course, experience, reputation, and all the normal qualifications you would expect with any caterer working at your institution.

5. Furthermore, these short-listed caterers should be selected based on the amount of discount (percentage off standard retail prices) they will extend on internal-sponsored events as well as an annual or more frequent donation of catering services, or possibly sponsoring a high-profile event at your institution.

The above actions will guarantee increased earned income to your institution in the following ways:

1. A short-list of caterers puts total catering revenues in pockets of a few, increasing all caterers' profit potential.

2. Caterers on the short-list have a financial incentive to bring clients/business to your institution because they are paying an annual minimum dollar amount to be on the approved list.

3. The institution is assured a minimum annual dollar amount (commission) from its caterers, not just dependent on a percentage of caterer sales "if" they do any events at your institution.

4. Increased facility rental fees (not increased rental rates).

5. Reduced cost of catering for internal events.
6. The value of donated catering services.

Yes, the above is a cuttingedge and aggressive approach to increasing earned and bottom-line income for many cultural institutions, but it is an approach that has worked in some cultural institutions that we work with and may work in many, many others if the institution is willing to be creative, innovative, aggressive and has a sincere desire to increase its income in this area.

Bonus earned income

If your institution moves forward with the above program, then consider applying the same program to approved vendors in the other categories that provide services for special events at your institution, such as rental companies, decorating companies, and valet parking.

Powerful Marketing Materials Can Increase Special Event Revenue – with no Budget!

KELLEY MCCALL

Museum Facility Rental & Event Director

Not unlike other museums and cultural institutions, the state history museum I work for is on a fixed budget with limited resources. Approximately seven years ago, we found an opportunity to increase revenue through special events and have since seen our facility rental program thrive and grow, generating thousands of dollars for artifact purchases and educational programming. A powerful means of advertising and promoting events at the museum is through the use of written handout materials distributed from our information desk, staffed by receptionists with limited knowledge of the special events program. The museum faces a greater marketing challenge than most, as a majority of our visitors and prospective clients don't naturally perceive the museum as a special events venue. It's only recently, as clients have started thinking outside the box, that museums are more often being considered to host events. We offer the perfect balance of cultural significance and refined sophistication that puts us a step ahead of the average banquet hall.

As Special Events Coordinator, it occurred to me that we could increase business if we were able to communicate our message to potential clients through an inexpensive and professional medium. Our existing brochure didn't address the museum's

The Field Museum, Chicago, Illinois, USA [© Ivan Carlson]

full range of business, barely mentioning our wedding business that was steadily on the rise. It also didn't pack any punch when it came to aesthetics; the lackluster pictures didn't properly showcase our venue. Most of all, the brochure needed more comprehensive information. I routinely provided clients with supplemental materials necessary to understanding our facility rental program. Better marketing materials could result in more income and better use of my time with clients. They would allow me to more efficiently sell and coordinate events rather than answering basic questions and inquiries.

Almost instantly, I faced obstacles that hindered my ability to accomplish this goal. First, I had an almost non-existent budget, certainly not enough to produce brand-new marketing materials. I was also acquainted with the inherent challenges of working for a state government bureaucracy. The obligation to follow a rigid set of procedures impedes new ideas from being carried out.

Creating a brochure that wasn't the exclusive product of the museum solved my problem. I came across Hawthorn Publications, a company that provides customized marketing publications free-of-charge to the global hospitality market. The museum's partnership with Hawthorn helped us realize our goal

of creating a new brochure. Hawthorn's business model is to connect clients with their customers through highly focused distribution channels using carefully-crafted editorial and cutting-edge design. Costs are offset by advertisements placed by the venue's preferred vendors to satisfy reader interest. The entire project from start to finish was completed at no cost to the museum.

I was naturally skeptical about a proposal that promised to deliver an industry average of $11,000 in marketing collateral – free. We signed an agreement with Hawthorn after we were assured that there was zero risk involved. Hawthorn's role was to solicit advertisements from our preferred vendors (caterers, rental companies, florists, entertainers, etc.), layout and design the brochure according to the museum's specifications, print the brochures and post a complimentary feature page on www.elegala.com, a wedding web site that reaches more than 2.2 million brides. My role as the museum liaison was to supply the preferred vendor contact list and museum letterhead, approve all correspondence with vendors, supply photographs and text, direct design decisions and distribute brochures to prospective clients. In short, the publication was managed by Hawthorn, but we were given complete control throughout the process.

The production process typically spans 4 to 6 months and involves three phases: sale of advertisements, design of the brochure, and editorial consultations. The second and third phases are contingent upon the successful completion of the sales phase, which on average takes five weeks until completion. Hawthorn's sales team respectfully approaches preferred vendors and invites them to participate in the brochure. Hawthorn Publications can only provide the brochure free-of-cost to the client if a certain advertising revenue quota is achieved. The specifications of each venue's brochure are based on the total sum of advertising sales. At Hawthorn, the minimum revenue achievement is $8,000, which converts to 1,000 copies of a 12-page brochure for the client. Advertising revenue above this limit ensures more copies and increased brochure pages ($9,000 = 1500 copies/12-page brochure, $10,000 = 1,500 copies/16-page brochure). The client always has the option to upgrade to the next brochure level by paying the difference between the revenue achieved and the revenue required for the desired brochure specifications. If you don't reach the $8,000 threshold, you have a couple options. You can discontinue at no penalty, in which case Hawthorn simply refunds any deposits received from vendors

who already committed. Alternatively, if you are just shy of the mark, you are welcome to assume financial responsibility and pay the difference if you want to see the project move forward.

The collaboration between the museum and Hawthorn Publications has been hugely successful. Our new materials seamlessly meld aesthetics with an effective message, inform readers and dramatically influence their buying decisions. As proof, in the six months that the brochure has been in circulation there has been a more than 50% increase in special events revenue, largely due to our new marketing materials. We've completely redefined our event business, continually attracting higher-end clientele. Most notably, there has been a dramatic increase in wedding inquiries since our new brochure more adequately addresses this kind of business. I also receive several event inquiry emails each month through our direct lead campaign on www.elegala.com. Overall, we've created an aggressive marketing platform that is paying off in more than just dollars and cents, bringing a wider audience to the museum.

The inventive marketing strategy that Hawthorn Publications puts into action is beneficial to everyone involved. The client receives beautiful new marketing materials free-of-cost, preferred

vendors receive increased exposure through a more widespread distribution medium (online and print) and Hawthorn profits from advertising sales. Since Hawthorn started the multi-year option, over 60% of their partners have signed a multi-year contract, a true testament to client satisfaction. Working with Hawthorn has provided the museum with stunning marketing content that complements our venue and clearly showcases our marketing direction. Since we began the distribution of the brochure to prospective clients the collateral has yielded a huge return – for absolutely no cost to us.

How Safe Is My Food?

DON J AVALIER
Manask & Associates

Since the publicity surrounding the *E Coli* outbreak at fast-food operators Taco Bell and Taco John's, every museum, aquarium, zoo, cultural center and historic site – whether the foodservice is outsourced or self-operated and whether it is your café/restaurant or catering services – must ask themselves the question: *How Safe is My Food?*

What would happen if your institution received the same type of national publicity that Taco Bell, Taco John's and other restaurants experienced? The ripple effect from such an outbreak, and the associated publicity, can negatively impact an institution's reputation and bottom line earned income for years to come.

Despite all the publicity concerning food-borne illnesses, America still has the safest food in the world. However, there are so many places where food contamination can arise that it is impossible to completely guarantee that no possible contamination will occur. Food contamination can happen from the growing fields to the irrigation/water source, harvesting, processing and packaging, distributing, transporting and, ultimately, the storage and handling at your kitchen or catering pantry.

Oversight for the safety of our food products is spread among several governmental agencies

including, but not limited to the FDA (produce and seafood), the USDA (meat and poultry) and The Center for Disease Control. Each of these agencies has established their own standards and/or recommendations related to food safety; however, they do not have the regulatory authority to enforce their standards. Furthermore, with the constant pressure of budgetary restraints at all levels of government, the number of inspectors to check the level of voluntary compliance is woefully inadequate.

That being said, the most common cause of food-borne illness still comes from contamination by foodservice employees, in your kitchen/pantry or your caterer's kitchen, who do not properly wash their hands as they complete each kitchen task and following the use of the restroom facilities.

The following list is not intended to be all-inclusive but rather some basic items for management to check for when observing your self-operated, or outsourced foodservice operation.

Health Department inspection reports
Your institution's top management should receive a copy of all Health Department Inspection Reports from their operator, or if self-operated, from their person in-charge of overseeing the visitor

foodservice/concessions/catering. These reports are provided to the food facility operator at the close of each inspection. While these inspection reports are not uniform throughout the country, they are quite similar and the major infractions tend to be listed on the first page of the report and may be headed with the title of *Foodborne Illness Risk Factors and Public Health Interventions*, or similar verbiage, and have the highest point value for the infractions.

Training

The on-site foodservice person in-charge of your restaurant/café/kitchen should be trained in proper food safety and sanitation and should have a current food handler's permit. Ask to see the permit and check the expiration date to ensure that it is current. There should always be at least one person with a current food handler's permit present during operating hours.

Good hygiene practices

Ensure that hand washing sinks are available and accessible to all foodservice employees. Be sure that all hand washing stations and restrooms have adequate water pressure and are supplied with hot water, anti-bacterial soap and paper towels at all times. Some of the newer faucets have knee- or foot-activated levers to turn

the water on and off so that the employees' hands do not have to touch the faucet handles after being sanitized.

Contamination by hands

Never touch "ready-to-eat" foods with bare hands. Use, foodservice approved disposable gloves when handling raw food. Remove gloves immediately after completing the current task and then wash hands. Never touch cooked food after touching raw foods without first thoroughly washing hands. Wash all fruits and vegetables before using. When using/displaying disposable plastic flatware for the public to pick up, make sure it is either wrapped or stored upright in a clean container with the handles facing upwards to the guests.

Cutting boards

Use color-coded cutting boards to assist in preventing cross-contamination of foods (green boards for produce, yellow for poultry, red for meat, and blue for fish). Clean all cutting boards following use. *Do not* place cooked foods on a cutting board used for working with raw products.

Food storage

Make sure that all foods are covered in the walk-in and reach-in refrigerators. Ensure that raw foods

are always stored on the lowest level of shelving and cooked foods stored above raw foods. Make sure all foods are labeled and dated (use by date). Rotate foods daily, using the *First-in, First-out* principle (FIFO). Make sure that all foods are in their original containers or an approved foodservice container.

Vermin

There is an immediate risk associated with all signs of vermin including: rodents (look for signs of rodent droppings), cockroaches and flies. Use clear trash can liners on all garbage cans and keep them covered when not in use. Keep the back door closed when not receiving goods. Install an air door over the back door to keep flies out when the door is opened.

Time and temperature control

Check to ensure that the person-in-charge is using an instant read, digital, thermometer to check both hot and cold food temperatures on a regular basis. Check that all re-usable hot foods designated for storage are brought down to prescribed temperatures within the guidelines established by the U.S. Public Health Service Food Code. All frozen foods should be thawed either in the refrigerator or under running water, or in the microwave oven if they are to be immediately

cooked following the thawing process.

Use of utensils and food contact surfaces

Utensils must be stored in a clean container when not in use. Look for knives, tongs, spoons, spatulas and other utensils lying on unclean surfaces and then reused to prepare foods. Look for cooks wiping their utensils with dirty rags and then using those same utensils on foods. Check to ensure that all food contact surfaces are clean and sanitized and not coated with dust and kitchen grease.

Chemical storage

The law requires that all chemicals (floor and wall cleaners, sanitizers, all dishwashing products, soaps, final rinse agents, de-liming chemicals, stainless steel cleaners, degreasers, etc.) be stored in a separate area away from all food products.

Independent food safety/sanitation inspections are highly recommended: due to the serious nature of any potential food borne illness outbreak, and the limited number of visits that the local health departments are able to provide, many institutions have gone to outside firms to conduct more intensive inspections on a more regular basis than what is provided by the local health inspectors.

Operator Financial Hardship: Renegotiate or Not?

ARTHUR M MANASK
Manask & Associates

Catering events at cultural institutions have dropped 30% to 40% since the U.S. economy began its sharpest downturn in several decades. The result of the decline was a wave of operator and caterer contract renegotiation requests.

In recent years we have helped many clients renegotiate with their foodservice operators, some of whom were losing so much revenue that they threatened to cancel their contracts if they did not get contract adjustments. If your foodservice operator has not approached your institution about revisiting its contract, don't be surprised if you hear from them when and if there are ups or downs in the economy.

A large downturn in catering revenue, which most foodservice operators rely on to supplement or underwrite their visitor foodservice operations, may make these requests quite legitimate. Many foodservice providers are asking for justifiable relief – and getting it.

However, there are a number of issues you should consider if your foodservice operator wants to renegotiate the business terms of a contract you thought was settled years ago.

In the course of several contract renegotiations, we advised our clients first to require that their foodservice-provider partner with them in positive

efforts to cut costs and boost visitor participation. This is what commercial restaurant operators, similarly hurt by the economic downturn, have been doing.

Operators may ask solely for financial relief rather than devising plans to increase customer count, improve service, increase participation (the percentage of your visitors, staff, volunteers and members using the café/restaurant and likewise with catering for facility rental customer, group tours and others) and customer experience. Institutions should ask: what can their operator (with institutional support) do to improve the effectiveness of their advertising, promotions and marketing? What plans do they have to improve visitor excitement and perception relative to their foodservice?

Make sure that conversations with your foodservice operator include ideas about operational changes, right-sizing menu items and changing menu pricing (down), advertising, promotion, marketing and public relations in order to combat lost revenue from catering and visitor foodservice.

If, for instance, an average day sees 20% to 25% of your institution's visitors dining at the on-site restaurant, ask your operator how they and you can boost that number to 25% to 30%. Setting and

achieving that goal will provide financial relief to the operator without cutting quality or service. For every 100,000 annual visitors you have, if you can get an additional 5,000 dining with you at, say $12 per person average check, that adds $60,000 top-line gross revenue and you should see at least $10,000 of that drop directly toward bottom-line profitability.

It is important to impress upon your foodservice operator that while some of the contract changes they are requesting may be valid, they must also make efforts to grow top line sales, change or modify internal operating processes (not to the detriment of customer service, of course) and mitigate losses in order for their operations to become more profitable.

If you agree to discuss financial relief in conjunction with improving operations, it is likely that the operator will request a reduction in the commission percentage they pay to your institution on all sales. They may also ask for a reduction or elimination of any minimum annual guaranteed commission that applies.

Another request we have seen quite often is for contract term extensions that will change or modify the terms of the operator's capital investment amortization. For instance, if the operator invested $500,000 at the outset of the contract, they may have

originally amortized that amount over their 10-year contract with your institution. By requesting a five-year extension on that contract, they will be able to amortize the remaining balance over a longer time period, which will improve their profit-and-loss (P&L) statement.

However, we have strongly advised our clients against agreeing to such contract term extensions. This should be the last option which institutions agree to, particularly since there are other operational changes that would similarly improve operators' P&L, such as modification or reduction of services, reduced operating hours, staffing changes, modifying their menu, right-sizing portions and prices, or changing their style of service, among the other areas discussed above.

Here are some steps that your institution can take to minimize the reduction of earned income if you enter into contract renegotiations with your foodservice operator:

- Request copies of your foodservice operator's internal (and official) historical, current and projected P&L statements as they are now, with no operational, financial or contractual changes. The projections should be based on your institution's realistic visitor attendance projections.

MAXIMIZING EARNED INCOME

- Make sure that you carefully review and evaluate every income and expense line on the P&Ls. If you do not understand what an item represents, ask for more information.
- Realize that foodservice operators sometimes have income from other sources that does not directly show up on the P&L. Ask your operator whether the P&Ls they have given you reflect all income and expenses for their organization. Is there anything your institution needs to consider that is not reflected on the financial documents?
- Get a specific written proposal from the operator for proposed modifications to the contract, including changes to commissions, annual minimum guarantees and capital investment terms. The proposal should lay out what they recommend and it should include details of how they will invest to grow participation, customer count and average check at their foodservice sites. The current economic situation should be specifically factored into their plans.
- Request projected P&Ls for the next two to three years that reflect the changes they are proposing. Make sure that the operators

include specifics about the underlying assumptions they have made when drawing up their projections.

- Insist that their plan include a clear goal that is reflected in their projected P&Ls. For instance, if they want to improve their bottom line by $100,000 annually, their proposal should achieve that with minimum reduction to your institution's income from commissions.

- Make it clear that any financial relief you provide will be temporary. All contract changes you agree to should include built-in triggers that reverse the contract changes so they revert back to where they are now (or to where they were) when the contract was signed. Triggers can be specific events, such as reaching a certain gross sales level, visitor count or number of catered events. You may need to include an amendment to the contract that ensures the changes you're making now will revert within a specific timeframe, say two to three years.

Finally, your foodservice operator should be aware that you will have to consider getting proposals

from other foodservice providers if you and they cannot agree to mutual terms and conditions within a reasonable time frame, say 90 days. If you come to an impasse, or if your operator submits a proposal that is not aggressive or responsive to your requests and is not industry competitive, they should realize that your institution needs to end up with no less than what would be competitive in today's market. Making this really crystal clear will give your operator a powerful incentive to spend the time necessary to devise their best financial and operational proposal the first time around.

Celebrity Chefs
Seek Out Cultural Institutions:
A Growing Trend

ARTHUR M MANASK
WITH ROBERT D SCHWARTZ

Manask & Associates

In the past decade (and continuing) we have seen significant growth and interest from high profile local, regional and national restaurateurs, and celebrity chefs wanting to get involved with their local museum or cultural institution throughout the U.S. and Europe. A few examples over the years include Kevin Taylor at Denver Art Museum, Danny Meyer at MOMA in New York, Wolfgang Puck at Museum of Contemporary Art in Chicago, Newseum in Washington, D.C., Museum of Science in Boston and Georgia Aquarium in Atlanta. Others are Joachim Splichal at Los Angeles County Museum of Art, Cindy Pawlcyn in partnership with Aramark at Monterey Bay Aquarium, Stephen Starr at Philadelphia Museum of Art, John Shields at Baltimore Museum of Art and many, many more. The motivation is not 100% financial. Following are some of the key motivators:

1. A love for the arts (chefs are, in fact, artists and artistic people).

2. Community involvement.

3. Brand expansion with cross-promotion opportunities with your institution and your operator's other restaurants in the area.

4. They also do catering at their restaurants and possibly off-premise which is a large part of cultural institution foodservices.

The Eden Project, Cornwall, UK

5. In some cases, with smaller institutions, the operator's off-site restaurant kitchen supports the institution's restaurant and catering services that might have limited on-site kitchen/support.

6. Extending their brand and new local ways to grow their business with much smaller capital investment – which is harder to find in down economic times.

7. The financial arrangements might include the chef receiving a fee or royalty in exchange for providing ongoing culinary training and menu development. Personal appearances and participation at the institution's annual gala and marketing or promoting the institution by attending special exhibition openings and fundraisers are also other key motivators.

8. Having a reasonably large annual attendance is important but not critical depending on the type of financial arrangement the institution is willing to offer. Some institutions feel there is so much value in having a high quality brand associated with their institution that they are willing to underwrite certain costs and expenses.

9. Where your restaurant/café space is located –

within the institution or at/near the entrance, possibly with its own separate entrance so it can operate somewhat independently; the latter being more attractive.

Is this a growing trend?
Yes, without a doubt we will see all types of cultural institutions (art museums primarily but also botanic gardens, performing arts centers, and some other venues like aquariums or zoos that have restaurants, and science and natural history museums) attract local, regional and national well-known, high quality celebrity chefs and restaurateurs.

How can you attract these operators to your institution?

- Do not do a typical Request for Proposal (RFP); this will likely scare them away!
- Reach out to your board members, major donors and volunteers (that likely dine in these restaurants locally and regionally and know many of the owners) to make personal calls or contacts on your behalf.
- Invite prospective operators out for a personal meeting and tour with your senior management, just as if you were trying to attract a major donor or sponsor.

- If there is interest, provide them with as much easy to read information as possible about your institution and the current (if applicable) restaurant and catering; and then, simply ask them for a proposal.

What's the downside? A possible downside may be that they have never operated a restaurant (catering) in a cultural institution. There is a 12-month learning curve. You need to help educate them.

Upon receipt of the proposal would be the best time to get expert advice from a consultant that specializes in this area. The consultant can take you through all the next steps to be sure you establish a contract that is mutually fair, has reasonable business terms and that neither party has unrealistic expectations.

Enhancing Your Visitor and Guest Experience

MISTIE LONARDO
EyeSpy Critiquing and Consulting

If outstanding guest experience is the bread and butter of your bottom line earned income, then your bottom line depends on how well you understand your visitors' experience. How can you get out of the box of your own perspective and experience your restaurant' like your visitors do?

In its early days, mystery shopping was a little like paying people to fill out glorified feedback forms. The information gathered was too general and too shallow to be of any assistance to a manager or institution that was serious about improving the visitors' experience. Thankfully, the mystery shopping industry has made tremendous advances. No longer are there just glorified feedback forms; mystery shopping reports now offer many insights into visitors' experience and have proven to be an important tool in the restaurant industry.

When I was the regional manager of a chain of restaurants, I quickly discovered I couldn't simply trust my own experience. My employees were all at their best when I walked on the floor, often skewing my perspective of the customer's experience and satisfaction. Feedback forms felt out of place in my restaurants and I suspected that only problematic or exceptional events would be reported. I needed a different approach and decided to hire people to come

Adjacent shop and cafe at The Design Museum, London, UK

in as customers to report their findings to me.

Suddenly, I had eyes in the back of my head. I could see problems that had been present all along. I took it a step further and taught my mystery diners to look beyond their direct experiences and observe the way the restaurant functioned as a whole. They were trained to look around and sense the other visitors' experience and how they were influenced by staff interactions. From this feedback I began to see how I could fine-tune my restaurants to increase guest satisfaction (and their repeat business). Applying what I learned, our sales doubled and our operating costs were cut by a third. For many retailers – public attractions and cultural institutions, individually-owned restaurants and small, intermediate and national chains – mystery shopping has come of age. The technology has improved to allow management to focus on specific aspects of the restaurant experience. The evaluators themselves can be specially chosen and individually trained to be better representatives of a particular institution's customer base.

Today's leading-edge mystery shopping companies create a virtual dashboard that allows an institution to peer into the inner workings of its restaurant. Using a state-of-the-art blend of well-trained evaluators, customized evaluation forms and

powerful web-based analysis tools, mystery shopping companies can zero-in, track and report on any area of your business you desire.

How inviting is the weekday restaurant lunch host? Which bartender's over-pouring caused the inordinate liquor expense last weekend? Is the taste and quality of our new menu item better when Cook A or Cook B prepares it? What do people really think of the choices on our new menu? Which employees need more training?

What's more, the reports can gather and return information to you in a matter of hours or days. In so doing, you can now maximize your visitors' experience and, as a result, maximize your visitor/guest satisfaction which helps extend visitor stay.

Another major benefit of state-of-the-art mystery shopping services is trend-tracking and location comparison. As all the evaluations are placed into your own private database, you can use web-based tools to compare the performance of shifts or locations (if you have more than one café or restaurant) and you can track changes across months or even years.

As a cultural institution, if you're going to make the investment in mystery shopping, it is important that you contract with the right company. Does the

company provide the exact services you think you'll need? Does the company (and its evaluators) have extensive experience in the restaurant industry thus bringing a higher level of knowledge to the table? What percentage of its business is devoted to your industry? What type of evaluators is the company using? How well are the evaluators trained? Will you receive a customized form that tailors to the sequence of service and standards of your restaurant/café rather than just the basic industry standards? Does the company provide a turn-around time that allows you to take action and make changes if need be? Lastly and most important, does the company practice what it preaches – exceptional service that is dedicated to helping your institution provide an exceptional guest experience?

Visitors return to your restaurant when their experience of service, quality, taste, value, and ambiance all add up to favoring your restaurant/café over nearby local competitors. What is less obvious is how to understand visitors' experience. No longer is it a one-dimensional service.

A good mystery shopping company provides the guidance and feedback you need to get where you're going. Choose the right company and you will be able to enhance the visitor experience, extend the visitor stay, increase visitor satisfaction, and keep visitors

coming back to your restaurant or café time and time again.

NOTES

1. While this chapter focuses on your restaurant/café, the same principles apply to your gift shop, ticketing, parking and other guest and visitor services.

Benchmarking Your Café or Restaurant

ROBERT D SCHWARTZ
Manask & Associates

We are often asked "What are the most important benchmarks that we should be monitoring?" While that often depends on the particular situation at each institution, there are three benchmarks that are universally regarded as key indicators of any and all foodservice operations.

1. *Participation percentage (café customer count ÷ visitor attendance):* measures the popularity of your foodservice operations by calculating the percentage of visitors that use the café. This can be calculated by day, week, month, quarter, and year. There are many factors that can affect this measurement, but a good starting point is 30% or better.

2. *Check average (café sales ÷ café customer count):* this measures the customer's spending habits in the café operation and is a good indicator of affordability for your targeted visitor. Certainly a table-service restaurant in an art museum will likely have a higher check average than a self-service café in a children's museum. However, we typically find that self-service café check averages range from $5.00 to $10.00 and table-service cafés range from $10.00 to $20.00. What is most important is to know where you want your institution to

fall on that scale, and then watch the trends. An increasing check average is not always a good sign if participation is dropping at the same time. This could indicate that the café menu is overpriced and driving your visitors to other options.

3. *Per-capita spending (café sales ÷ visitor attendance)*: this is a hybrid of the first two. It tells you if your visitors are using the foodservice facilities and shows their spending habits. *Per capita* benchmarks vary widely by type of institution so it is imperative to track your specific trend of this important measurement. Trending up indicates positive response by your visitors; trending down indicates you should consider getting expert outside support to reverse this trend!

So why are these key indicators important? If you monitor, and help influence, positive trends with these indicators, your earned income will likely grow as a result!

Operator Capital Investment In Your Restaurant or Café: The Pros and Cons

ARTHUR M MANASK
WITH ROBERT D SCHWARTZ
Manask & Associates

Most cultural institutions we work with across the country are looking to their current or prospective restaurant operator to provide all or most of the capital investment to build-out the new café or restaurant and/or pay for a renovation as part of an expansion. Many cultural institutions have not budgeted for the build-out of foodservices and have not included this in their capital campaign, fund-raising and/or as part of the Tax Exempt Revenue Bond (TERB) funds for the new or expanded institution. They know this restaurant/café will be a part of the project but they do not account for all of the adequate funding.

Philosophically, the restaurant or foodservice facilities in a museum, zoo, aquarium, botanic garden, or historic home are an important and integral visitor service. Most are also an extension of that institution's image and mission. As such, why do most institutions not provide the funding for these important services?

Many institutions look to their current or prospective operator as a source of capital funding. In reality, however, when these funds are provided by the operator they are a loan because they are almost always tied to buy-back protection. Buy-back protection is a contractual guarantee by the client organization (or passed on to the successor

Kunstmuseum Wolfsburg, Germany

operator by the client organization) to reimburse the unamortized portion of the operator investment if the contract is terminated early. The amortization period ranges from 10 to 20 years depending on the total dollar amount of the investment (usually the higher the dollar amount the longer period of years). Operators usually require the amortization period to be equal to the contract term. If the operator will not fully amortize their capital investment and your buy-back obligation for the unamortized balance is within the initial term of the contract, then do not accept the capital investment dollars on that basis. It is very important that the operator capital investment be fully amortized at the end of the contract term so you or the next operator do not have a financial obligation beyond the end of the contract term.

One example would be a large museum client looking for about $1.5 million to renovate its current foodservices that were about 15 years old and needed upgrading and updating, along with about $2 million currently on the current operator's books that had not been fully amortized. This means that if this institution selected a new operator, the institution or new operator would need to write a check for about $3.5 million to cover both these amounts. While the $2 million was contractually the client institution's

responsibility and obligation to pay the current operator if they left, fortunately for that institution, the overall foodservice revenue and potential profitability justified prospective operators paying the total amount.

Another example is an institution that is building a new restaurant/café (none currently exists) with total capital costs of about $1.5 million. In this case the institution does not have the funds in their capital budget to build-out the restaurant/café, kitchen or catering support spaces. This institution received proposals that included the operator capital investment, again with 100% operator buy-back protection.

The operator typically does not charge interest or carrying fees. But don't be fooled, these funds are never "free". In both the preceding examples, the operators are making the capital investment and paying the institution a percentage of gross revenue (commission). We always recommend that an institution ask prospective operators to propose with and without capital investment so the institution can determine the value of the deal and see that the commission percentage will usually increase if there is little or no capital investment by the operator. The important point here is that if the commission

percentage increases to the institution, the amount of the increase might be more valuable than the amount the institution is saving in not borrowing the money from a bank.

We realize that some institutions do not want bank loans on their books or may have other reasons for not considering this as an option (keep in mind that conservative accounting practices would require the client institution to record this contingent liability, buy-back, on their books). Most importantly an institution should have its eyes wide-open and carefully study and analyze the pros and cons of operator capital investment versus commission income.

For example, typically operator contracts run 10+ years. If your gross foodservice revenue is $1 million per year and you can get an extra 2% or 3% commission by using your capital instead of the operator's capital, this would increase your earned income by $20,000 to $30,000 per year or $200,000 to $300,000 over a 10-year period. Depending on the capital investment offered, this may or may not be a good deal!

If it is your institution's goal to optimize earned income or cashflow from foodservices and achieve the highest possible return from the visitor foodservice

and catering (facility rentals), then make every effort to raise the capital on your end rather than borrow it from your foodservice operator.

Naming and donor opportunities

We have seen some institutions offer their restaurant/café to a donor for a naming opportunity. This is a great way to get the capital required to build out or renovate your restaurant/café. An example of this is the Kidspace Museum in Pasadena, California who named their café the *Nestle Café* in recognition of The Nestle Company that provided a donation to build-out the space.

Foodservice Construction: How To Estimate Realistic Project Costs Before Committing to the Project

STEPHEN R HOSA
Hosa Design Associates

It has been our experience that when most restaurants fail within the first year, it is usually due to unexpected construction costs due to poor budget planning. The same principles apply to the foodservice facilities we have planned for our cultural institution clients. In order to avoid this pitfall, and based upon our 25 years of restaurant design and planning experience, our firm has developed a simple step-by-step Budget Planning Guide to assist our clients in establishing realistic cost projections for a typical foodservice remodel, renovation, or new construction before committing to the project.

Step one: select professionals for assistance

It is highly recommended that the client secure the services of a qualified design professional specializing in restaurant planning and design to assist with each of the following budget planning steps, remembering that the success of this program is directly based upon the accuracy of the data collected and the competence of the design professional interpreting the information – so references and experience are important. Most design professionals charge very little ($1,000 – $1,500) to provide this service and often waive their fee for their repeat clients.

Step 2: site inspection

If you are remodeling or renovating an existing space, arrange to have a physical inspection to determine the age and condition of the existing building, mechanical systems, and foodservice equipment (if any) in order to establish a budget line item for Repairs & Maintenance.

Step 3: city planning and code issues

Contact the city agencies having jurisdiction over the foodservice location and determine which of the following items apply to your project, and establish a budget line for each item, or – worst case scenario – determine if any of these items might red flag or cancel the project if your foodservice operation cannot satisfy the city's requirements:

- Parking requirements.
- Existing use permit and allowable hours of operation.
- Pending code violations and required code updates.
- Planning commission requirements.

Step 4: seating capacity and projected sales

Prepare a very schematic floor plan to determine the approximate maximum seating capacity, and use

this number to determine your estimated annual projected sales, which is typically estimated by:

- average sales ticket per person
- *multiplied by* number of seats
- *multiplied by* number of seat turnovers per dining period (breakfast/lunch/dinner)
- *multiplied by* days of operation per year.

Step 5: estimate total renovation costs

Prepare a very rough budget estimate using per-square-foot and rule-of-thumb methods with a line item cost for each of the following categories as they apply to your project (some may not apply):

- Demolition of existing interior and equipment
- General new construction
- Kitchen equipment (installed)
- Fixtures and furnishings
- Artifacts and interior/exterior planting
- Signage and exterior treatments
- Fees – design and permits
- Liquor license
- Uniforms and menus
- Special building repairs and maintenance (from step 2)
- Special city requirements (from step 3).

As a guideline, we still use $150 to $200 per square foot as a rough benchmark for a complete interior renovation, which you can use as a good double check for your calculated numbers. Remember that this excludes the building shell (which is assumed to be by others or existing), any signage or exterior building treatments, and all fees and licenses, any pre-opening costs, and any special building repairs or city requirements which will need to be estimated in addition to the $150 – $200 per square foot allowance.

Step 6: the formula for budget success

This budget formula is based on information gathered from our most successful restaurateurs and foodservice operations clients, and is based on the assumption that the restaurant or foodservice facility generates a net profit of 10% after all operational and food costs have been paid, and that the client is looking for a 100% payback of the initial renovation cost within five years.

Here is the budget formula: Total Renovation Cost (total from step 5) should not exceed one-half of your Annual Projected (Gross) Sales (from step 4).

If your numbers do not work out at first, keep adjusting until they do and you will have a realistic budget for your project. Good luck and good planning!

Case Study:
Consultant's Evaluation is Key in Making a Museum's Foodservice a Great Operation

*Museum Deputy Director
Administration*[1]

During a major expansion and renovation of our medium-sized art museum, we contracted with Manask & Associates to help us prepare an RFP (Request for Proposal) and assist our staff committee in vetting possibilities for foodservice and foodservice operators. We were expanding our catering and café facilities significantly and were looking for an additional source of operations revenue. We awarded the contract for exclusive catering and café operations to a local independent caterer. The contractual arrangements provided the museum a percentage of gross revenues on café and external catering sales and a discount on museum catering.

After a year of full operation, we were generally satisfied with the catering service as well as with the financial success of increased facility use and rental income. The museum employed a facility sales/ adult group tour coordinator who was successful in attracting a number of new clients. We also began accepting wedding receptions in the off-season. The museum and catering staff met regularly to plan internal and external special events, and most of the glitches were being resolved. However, the quality of the food and service of the café was not acceptable. A combination of factors impacted the quality and consistency of the food; the quality of the on-site

management of the kitchen, restaurant and staff was clearly an issue, and trying to provide both self- and seated-service was problematic. In addition, there was a developing "us and them" mentality with the museum and catering/café staff. It was clearly time for a third-party objective evaluation and review.

Two years after doing the RFP, we asked Manask & Associates to come back and perform an assessment and evaluation of the foodservice operations and mutual (museum and operator) contract compliance. The museum provided historical and current museum attendance, internal and external special events, foodservice sales, customer counts, and related statistical and contractual data. Art Manask, principal of the consultants, came on-site for mystery shopping of the visitor foodservice and catering services. Neither museum staff nor foodservice staff were aware of the visit. Following the anonymous visit, the consultant then interviewed key museum staff representatives that interface with the foodservice operation as well as the foodservice operator staff.

The resultant report made excellent and insightful recommendations for all areas of foodservice and catering, which will be reviewed and implemented in the upcoming years. It is important to note that

bringing in a knowledgeable consultant highlights many areas on both sides of a relationship that most museum managements would not see, or be watching-out for, due to a lack of technical knowledge and expertise.

For purposes of this case study, the focus will be on visitor foodservice, which was in the most serious need of assessment and attention. Following are the museum's actions and activities.

As the Director of Administration, in charge of the foodservice relationship for the Museum, I organized a café taskforce including the key user staff of the museum and the foodservice operator. Each member of the committee was given a copy of the report for review and met for two seasons, spring and fall. The primary focus was on the style of foodservice for the restaurant, the menu, tour group menus, pricing, and promotional events.

The first meeting was spent smoothing out the relationship between the museum and operator and airing issues for both parties. Many things were working well. We decided to focus on the areas that could be improved, to bring the dining experience to a level that locals would talk about and so have the urge to "do lunch" (our café is open and available to non-museum visitors). The focus group then reviewed the

American Museum of Natural History, New York City, USA

foodservice, group tour layout, the menu, staffing levels, and training. The operator agreed with the consultant's report that the chef/kitchen manager was not performing to the quality required, which led to the conclusion that a professional restaurant manager needed to be hired to train staff. We reviewed the physical layout, ongoing comments from the customer survey and budgetary issues and decided to commit to a table service restaurant year round, to remodel the separate espresso bar location as a private dining/meeting room, to place the group tour seating in the loggia that had been previously used for self-service seating; and to add a less expensive box lunch option to the group tour selection. Concerning us all, was the ability to service the museum visitors during the busiest days of the week when attendance to the museum tripled.

During the slow season, a new chef/kitchen manager and a restaurant manager, both with extensive experience, were hired by our foodservice operator and immediately began to develop a new menu, and to recruit and train staff. A wine/coffee bar was purchased by the museum, along with additional high-top tables and bar stools, providing a service area for the customer who only wanted a beverage, wine or dessert, as well as providing a

station for restaurant staff to pick up beverages and wine. This unit is portable and can also be used as a bar for special events. Two busing stations were built for each end of the courtyard and POS units were installed on all three locations with the goal of keeping the wait staff visible on the floor at all times. Several larger tables with cloths were added to accommodate groups of six or more. The café now takes advance reservations and also keeps a wait list for the walk-in customer so that they can continue to enjoy the museum while they are waiting for a table. Currently, the café can seat 90 visitors.

The foodservice operator and museum staff dined in several area restaurants that would be competition for lunchtime business; they also visited other museum cafés when traveling out of the area. The operator conducted tastings for the taskforce staff. The museum introduced customer survey cards, as recommended by the consultants, and reported back to the committee with all the comments. A new limited menu was introduced during the summer and fall seasons. The restaurant manager concentrated on training the staff in communications, service and wines. The museum began promoting the café in membership publications and offered special openings for special *prix fixe* dinners.

Responding to the consultant's recommendations and the museum's group tour sales manager, our foodservice operator added a less expensive "box lunch" option, which has been popular with the local groups during the slower season, spring and summer. In addition, it lessened the highest price preset menu and the cost of using the private dining room for groups with that level of service.

The museum is upgrading its website to promote the café, as well as its facility rentals, catering and group tours; the operator is also developing a website which will be linked with the museum's. The museum recently received city approval for an on-site exterior banner program promoting our exhibitions as well as a banner program to attract visitors to the café.

While it is still early for all these changes, we are already seeing a solid increase in positive comments about our food and service from museum visitors and restaurant customers. The percentage of museum visitors using the café decreased in the first two months of the changeover, but the revenue per museum visitor increased 10% and *per capita* revenue per café visitor increased almost 50%. The bottom line is that the museum received a small commission (percentage of gross revenues) the second month of the changeover. Previously, the revenues exceeded the

minimum base revenues only in the three months of peak-season (we are in a very seasonal location).

Special *prix fixe* dinners for membership openings have become quite popular and a great way to introduce the new menu, format and chef to a loyal museum audience. The group tour season is just beginning so it is too early to report on results. The chef has also started a special wine "flight" and food pairing for Saturday afternoons in the café throughout the season.

We continue to monitor the restaurant customer survey cards and are generally receiving "met my expectations" and "exceeded my expectations" responses, with minimal negative comments. We will look to increase our marketing of the café for the spring and summer season.

The relationship between operator and museum should always be viewed as a work in progress, especially in a highly seasonal resort area due to the range of demands and expectations for quality of food and service. Constant communication and feedback, with regularly scheduled meetings, are essential for a healthy, productive and financially successful relationship to thrive. An objective and independent review by a third-party consultant has helped both parties to focus on the facts and ignore personalities.

We have much work ahead of us as we move forward with this relationship, but the consultant provided a good road map for our future.

Results of changes

Café gross sales increased from $13,833 to $32,144 year-over-year for December. The *per capita* revenue from café visitors went up from $7.49 to $10.62. The revenue per museum visitor went from $2.68 to $3.34. The café is attracting 31.49% of the museum's visitors, a decrease from the same month in the previous year which was 35.85%. Obviously, the café is losing some visitors who do not want a full lunch, but they have been regularly attracting 175 customers for lunch, in addition to tour groups. Additionally, the catering division has been busy with internal events.

NOTE

1. This chapter was authored by a Manask & Associates client that wanted her name and that of her museum to be anonymous. She is the Deputy Director Administration of the Museum.

Marriage Counselling Foodservice Style

ARTHUR M MANASK
Manask & Associates

Most cultural institutions outsource their foodservice operations and in doing so oftentimes take comfort that the responsibility has been transferred to a third party. Outsourcing relieves the institution from the day-to-day headaches of the restaurant/foodservice business – but does not relieve the institution from the ultimate responsibility of providing outstanding and excellent visitor foodservice and catering for special events.

We find that many institutions do not treat the foodservice operator (and its on-site management) managing/operating the foodservices as an integral and important part of the institution. They are not treated like any other department within the institution.

Since museum, zoo, aquarium, botanic garden and historic home professionals, for the most part, do not know or understand the foodservice business (which, of course, is why it is outsourced), there can be ongoing issues, concerns, criticisms and complaints from staff, volunteers, board members and/or visitors that are not addressed and resolved promptly by both parties.

We also find that many foodservice operators working in this environment are not accustomed to the service demands, which can cause frustration and

concerns on this side of the partnership/relationship as well.

We are normally contacted when stress and tension between the parties begins to reach the highest level. The institution is not quite ready to get a divorce, but needs to sort through the issues before such a harsh or hasty decision is reached.

When we are contacted with this type of issue, which is more often than you might think, following is the process we use to identify the issues and concerns to make recommendations for the respective parties' best mutual interests.

Step one: Receive and review all details about the current relationship (contract, financial statistics, attendance, facility rental history, customer/visitor surveys, etc.)

Step two: On-site one-on-one meetings/interviews with all parties on both sides of the partnership. These meetings are candid and confidential with the purpose of clearly identifying the respective issues and concerns.

Step three: Provide definitive recommendations for the next steps, which can include additional counseling, but which in most cases involve the development of an action plan that will put the institution and the foodservice operator on the same

page, with the same agenda, the same goals and objectives.

Step four: Help the institution (and the operator) take foodservices to the next level. The next level is defined as whatever the goals/objectives of the institution may be, consistent with good business practices and profitability for both parties.

If your institution has issues, concerns and/or problems with your foodservice operator, act upon these issues, communicate regularly (weekly in a formal meeting with on-site management and a monthly meeting with regional management) and do not let a small list of issues become so large that a divorce is the only way out. Being pro-active in this regard will result in a much better long-term relationship for both parties.

Alcoholic Beverage Licensing and Serving: $105M Verdict Makes Operators Rethink Training for Workers Who Serve Alcohol

ARTHUR M MANASK

WITH ROBERT D SCHWARTZ

Manask & Associates

Some questions to consider:

- Does your institution own an alcoholic beverage license?
- Does your institution self-operate alcoholic beverage services or outsource this service to a caterer or foodservice operator?
- If self-operated and/or your institution owns the license, what are the risks?
- Are the rewards worth the potential risks?
- If you outsource the services, are you adequately protected in your contract(s) with the caterers and/or foodservice operator from a liability and insurance standpoint?

In an article by Paul King in *Nation's Restaurant News*, Mr. King writes, "While Operator prepares to appeal a $105 million judgment recently levied against it in a case involving a 1999 drunk-driving accident that left a young girl paralyzed, operators industry-wide are examining the efficacy of their alcohol server training programs."

The article continues:

Though many foodservice operators were reluctant to discuss the ruling, several admitted that the huge financial award – believed to be one of the largest ever in terms of gross value – had given them reason

*to pause, especially as it underlined the phenomenon
of escalating monetary penalties in drunk-driving-
related lawsuits.*

*Jim Boudreau, Senior Vice President of Risk Manage-
ment for the National Restaurant Association Edu-
cational Foundation said the incident points to the
need for stronger alcohol server training. Boudreau
further said, "Insurance companies are telling us
premiums and deductibles are getting higher. Judg-
ments are rising precipitously," he explained. "There
were at least three critical cases last year with
awards in the $20 million to $40 million range, and
this is distressing to us. On top of that, dram-shop
laws are increasing servers' liability." Boudreau
said "the NRAEF's new program, Serv-Safe Alcohol,
will differ from the Bar Code (training system) in at
least two major areas. First, it will include increased
training in the checking of consumers' ID's. Second,
it entails a video-based approach to teaching people
how to read signs of intoxication and how to handle
people exhibiting those signs."*

What to do?

Manask & Associates recommends that every
institution that permits the sale/service of alcoholic
beverage talk to its foodservice operator, caterer(s)

and/or its own staff that manages these services to be sure proper and comprehensive training is in place and that all such training is closely monitored by the institution's management that oversees the foodservice/catering contracts and special events. Also, importantly, the institution should check with their risk manager or insurance agent to be sure the institution is properly and adequately covered and that, in any contract the institution has with a foodservice operator or caterer, the terms in that contract provide the institution with the appropriate amount of coverage and indemnification.

You can contact the National Restaurant Association at www.restaurant.org. *Nation's Restaurant News* can be reached at www.nrn.com.

Success in Foodservice Begins with Planning, Not Cooking

DAVID B GREENBAUM
SmithGroup Learning & Discovery Studio

It is extremely important to involve a foodservice planning team early in the design process. I am an architect who has worked closely with many prestigious cultural institutions, and I have learned how critical such early involvement is to the success in foodservice and foodservice planning. The measure of success is foodservice that enhances the public's visit and foodservice that delivers revenue to the institution.

A complete visitor experience

All aspects of revenue generation should express the character of an institution. Of course, an institution's purpose is not to simply provide revenue, but to extend the experience, help make a memorable impression, and perhaps offer the visitor something to take home. Sensitive foodservice planning contributes to this by offering a place for reflection, absorption, and relaxation. Changing environments and varying light levels also combat museum fatigue and enhance the visitor experience.

Thoughtful selection of an appropriate food menu further defines an institution's character. Not only is it important to develop a menu that is of interest to the audience, but it is also vital to reinforce an institution's mission through an elegant

presentation. The available menu and type of service has an enormous impact on planning requirements as it guides the type of kitchen and support one needs. Be it a café, food court, cart, or fine dining.

Examine the synergies of revenue generation

The real estate adage of "location, location, location" applies to revenue generation as well. To maximize revenue, facilities must be conspicuous to visitors. Co-locating them in free-zones allows for extended hours of operation and offers visitors the chance to browse through a shop after dining, before a lecture, or following a movie. Facilities can be designed in a way that does not compromise the importance of the interpretive message and a visitor's first impression of an institution.

For larger institutions, multiple clusters of food and retail offerings not only offer choices to the visitor, but also may help capitalize on temporary exhibits or unique places within a building.

Special events, such as banquets and lectures, offer great potential for income to an institution and expose attendees to a facility they might not ordinarily visit. Making the special events area simple to operate will make it easier to market and improve the likelihood that a facility will be rented on a more

frequent basis.

For foodservice you must ask: What is appropriate to your location and visitation? Who is your competition? Are the facilities sized correctly to provide optimum revenue? What does my audience expect and what is the take-away message?

Operations

In the early stages of pre-design, I explore anecdotal paths. That is, I attempt to put myself in the shoes of foodservice staff, vendors, the public and others that will use a facility. It is also important to determine primary staff and vendor functions, such as the handling of incoming food products, garbage collection, and cash management. Limiting the access of foodservice staff, caterers, and vendors to public venues is preferred in order to prevent theft and damage to exhibits. Some other questions that should be addressed include: What will be the added cost of security guards if physical barriers are not provided? Does the staff require changing areas, lockers, and separate restrooms? How many staff will be required to support foodservice?

In the early phases of design, it is important to determine what type and size of utilities and engineering support will be required such as water,

power, gas and kitchen exhaust and make-up air. Many of these services should be crafted based on the anticipated menu and style of foodservice that is to be served.

Other considerations are determining the hours of operation. Will foodservice be available before and after museum opening? Who will operate your facility? Will it be in-house or contracted? If contracted, what impact will this vendor have on the museum? Bringing this vendor too late into the design process will most likely ensure last-minute changes.

Other questions to consider include: Will special events always be catered or will your foodservice operations provide the food? Who can you trust to take good care of, adequately clean up, and leave no traces of damage to finishes? It is obviously important to provide restrooms, a catering pantry, public and loading access adjacent to the event area. Consideration also needs to be given to permit pre-event set-up without disturbing daytime operations. What other support spaces will the caterer require to provide efficient service? (For example, loading and staging and food preparation).

Programming and planning
Advance planning of foodservices can yield long-

term benefits for an institution. Engaging foodservice planners in the earliest stage of schematic design and pre-design helps a facility maximize revenue and minimize costs, while adding to the visitor experience.

When and How
To Pick a Consultant

RUDY MIICK

There are times to use a consultant. There are times not to use a consultant. There really are consultants that provide an exponential return on investment through their work. Regardless of your business segment, or your project, there are times when you find yourself needing answers or the facilitation of your own answers. And likely, you'll need some combination of both.

So, two questions come up. *When* do we use a consultant (or not)? And, an even bigger question, *how* do we pick the right consultant for our project?

When

What we need: Solution	Time	Knowledge/ Skill	Resources/$
We *have* the:			
We do *not* have the:			

I have found the above grid useful for leaders when they have to make the decision to use a consultant (or not). When filling in the grid, be as honest as possible when you answer your own questions regarding the content in each box.

Simply ask yourself the following questions for your topic/issue/project.

Do we have the time?

- Do we have the time to do this project by ourselves *or* do we need additional support to get the project completed on the timeline we need it done? If we don't have time, bring in a consultant or push the project back.

- If we do have time (and resources) but not the knowledge or skill, it may be best use of our time and resources (lower budget) to bring in a consultant to guide us sooner than later.

Do we have the knowledge/skill?

- If we have knowledge, skill and resources, but we have *no time*, it is likely really smart to bring in a consultant to add depth and focus to our desired or required timeline. Note here, when there's less time than more, it's more likely the budget for an outside consultant may be higher. This is simply due to the opportunity cost of availability on short notice.

- If we have the knowledge and skill, but there's not the time or the budget, then your project had better be put off for now. *This* scenario is one that teaches your team to plan ahead, strategizing needs well in advance so that resources can be amassed. With time, it's

possible to develop or seek internal knowledge or skill as a viable alternative to using an outside consultant. Another outcome of planning is that your team can do a cost analysis, assessing the opportunity cost of a one-time project fee (from a consultant) versus the ongoing salary of a full-time resource.

Do we have the resources/$?

- If we have the time *and* resources, but we don't have the knowledge or skill, it may make more sense to do a search for an internal resource to add to our team and *not* use a consultant. The ultimate decision may even be some combination of both. If we do not have the resources/$, but we do have time and knowledge, we're likely better to do our project over time with our existing team.

How

In my experience, most companies have a harder time finding the right consultant than figuring out if they need or want a consultant. Let's take a look at four questions that can assist in consultant selection.

What do we need?

Assessment? Answers/solutions? Or do we need facilitation to find our own answers/solutions? Do we need all three?

Any of the following could be true: We are looking for assessment. We are looking for an answer guy or gal. We are looking for someone who can be the answer guy or gal, who is also adept at supporting us to find our own answers. Pay attention here. Any one of the three offerings can be effective. However, each is different and it depends on your business culture as to which will be a better fit or not based on what your habits are and *where* you want to end up with new habits!

What's the consultant's track record?

Beware here. Good consulting has its own skill set. An out of work executive may *not* make a great consultant. At the same time, a long-time consultant that hasn't maintained their own knowledge or systems development, or track record, can also be a bad bet. Talk with past or current clients, read their articles, websites or blogs. Ask colleagues who they've used with success.

Big or small?

A small consulting group can actually have more ability than a larger one. Smaller may or may not mean you get more for less. Smaller may provide you with more personal attention and flexibility. Too small may mean one-person and no back-up, support and limited experience. Talk about this.

What's the ROI?

Don't be fooled by price, high or low. A consultant with a proven track record and great client testimonials is typically more expensive up-front than someone without a track record. Pay attention here. Often times expensive up-front is the better deal down the road. A great consultant is worth every penny they charge, because return on work well done creates its own ongoing value. Regardless of size, great consultants can speak clearly about their results and the ongoing return on investment.

Glossary

Accounting Period

The fiscal term for describing the accounting month. Usually it is defined by the same cut-off day each week (i.e. Sundays) and is made up of 13 weeks per quarter. This is divided into two 4-week accounting periods and one 5-week accounting period. This is in contrast to using the calendar month which ends on different days of the week and may consist of 28 to 31 days. The fiscal accounting period is more consistent and comparable for management reports as they are always 28 or 35 days, always include the same number of Fridays or Tuesdays, etc.

Administrative and General Expenses

A foodservice operator will assess each of its client foodservice operations an administrative and general expense fee to cover the cost of operating the business but not directly related to customer service, or charge usually equal to a percentage of gross operating revenue ranging from three to five percent depending on the size (dollar volume) of the overall foodservice operations (the higher the gross operating revenue the lower the percentage).

Agreement

Used interchangeably with the word *contract* in the

on-site foodservice industry. The Agreement clearly sets forth all the business terms and conditions covering the relationship between the client and the foodservice operator. Included, but not necessarily limited to: Recitals that provide an overview of the client institution, the operator and the services contemplated under the Agreement; Term and Termination; Financial, Capital Investment, and Payment terms and conditions; Services; What is provided by the client and what is provided by the operator; Insurance; Indemnity; Security; Health & Safety; Legal terms and conditions and Exhibit covering the space alloted for foodservices, menus, prices, catering terms and conditions, financial reporting format, sample customer survey forms, minimum food specifications, etc.

Agreement Term/Year
Defined by the contract and indicates when the contract year begins and ends. May not be the same as the calendar year or may not be the same as the Client fiscal year.

A La Carte
Items on the menu that are priced individually.

All Day Menu

A menu that offers breakfast, lunch and dinner items on one menu, with all items being available at all times of the day. Also referred to as a *California Menu* in some areas.

Approved Caterer

A local caterer that has met certain standards as it relates to experience, having a health department approved catering kitchen (and vehicles), appropriate insurance as evidenced by a certificate of insurance provided to the cultural institution, that has signed an Approved Caterer Agreement with the institution to provide food and beverage catering services at the institution. Only Approved Caterers (and the in-house caterer if one exists) can provide catering services at the institution.

Approved Caterer Agreement

The Agreement (contract) that is signed by the Approved Caterer, usually a year-to-year agreement that is cancelable upon 30-days notice, that details the terms and conditions under which the off-premise caterer will provide its catering services at the institution. This Agreement usually provides for a commission payment to the institution on food and

beverage (only) sales, sometimes a minimum annual dollar guarantee to the institution, as well as the guarantee of an annual dollar donation of services.

Approved Caterer List
Usually a shortlist of local caterers that meet the institution's minimum standards to be an Approved Caterer, have executed an Approved Caterer agreement, and provided a certificate of insurance to the institution.

Attendance
The annual visitor count for admission to the institution. Normally does not include attendance at evening rental events.

Back Of The House
The food storage (refrigerated and non-refrigerated), office, staff, production, and preparation areas (kitchen areas) as opposed to front of the house which is the serving and dining or "public" areas.

Base Fee
The minimum dollar amount received by the foodservice operator under a management fee agreement.
Benchmark

A standard, or point of reference, used for comparing similar products and services offered at one institution to other similar institutions for the purpose of evaluating how these products and services rank to each other (restaurants, cafés, facility rental rates and catering pricing for example).

Branded Concepts
Nationally, regional and/or local trade-marked or well-known (recognizable names) concepts that can be incorporated into a foodservice program on a licensing or franchise arrangement. Includes celebrity chefs and restaurateurs. Not all branded concepts will license or franchise their foodservice program. Some branded concepts can be operated in cultural institutions, but have to be operated by an approved franchisee of the franchisor.

Branded Products and Costs
The products that must be used and/or the cost of supplies and products that must be purchased from a specific vendor as part of a franchise or licensing agreement. Branded products can also include everyday food and beverages sold in the restaurant or café, including but not necessarily limited to soft drinks, bottled and canned beverages, condiments

(ketchup, mustard, etc.), and snack foods like chips and cookies. These branded products are readily available from wholesale institutional distributors that service the restaurant and foodservice industry.

Bussing

To manually clear soiled dishes, utensils, trays, etc. from tables and placing them in trash containers designated for recyclable or non-recyclable materials.

Buy-Back

When an operator provides a capital investment in the owner/client's restaurant, café and/or foodservice facilities, the operator will amortize the investment over the term of the contract, straight-line, normally without interest or mark-up. If the contract is terminated before the end of the term, normally the operator is reimbursed for the unamortized amount of the operator capital investment.

By-The-Ounce

A program whereby customers make their own salads or sandwiches (including other selected menu items such as soup) and are charged by the ounce so that those who eat light pay less than those who have hearty appetites and are willing to pay more.

Café
Normally considered a small restaurant, casual in atmosphere (and dress), offering table-service and/or self-service and/or a combination of customer self-service and table-service food and beverages.

Cafeteria
A self-service restaurant where the customer has a tray and moves through a straight-line serving counter and/or goes to individual food and beverage serving stations within a serving area (called a *scramble or scatter system*) and either takes a pre-prepared and plated food or beverage selection or is served by a foodservice staff person (line server).

Call Brand
An alcoholic beverage product called for by its brand name by a customer.

Cannibalize
When adding a new menu item, point-of-sale or new concept that might take away sales of existing points-of-sale and products.

Capital Investment
Foodservice operators may be willing to make

a capital investment towards improvements in an existing or planned restaurant in a cultural institution. As a general rule-of-thumb an operator will invest $100,000 per $25,000 of projected profit from the foodservice operations at the cultural institutions. Traditionally, operators will invest more dollars at a lower ratio in cultural institutions with several or more million dollars of annual revenues and, importantly, where such investment is likely to materially (and positively) impact the revenues and net profit.

Cash Box

On occasion a cash box (a metal or plastic box that has compartments for change and multi-denomination dollar bills) is used to sell food and/or beverages at certain high volume foodservice operations where power might not be available to operate an electronic cash register. While cash boxes should be discouraged, the cash received can be audited and accounted for if the products sold are under close and strict inventory control. If, for example, a cash box is used at a cart selling hot pretzels, if the pretzels are inventoried at the beginning and end of the seller's shift, the consumption will be known and the number consumed (sold) times the selling price should equal

the cash received. The seller should also note any waste or spoilage to insure accurate accounting.

Cash Over or Short

The foodservice operator balances the cash it collects at its points of sale to the cash register tapes. The cash register has a continuous and non-resettable reading that records all cash transactions. The day's reading is determined by taking the beginning register reading at the start of the day or the cashier's shift and subtracting the ending reading. If there is more cash than indicated by the reading on the tape then there is a *cash over*. If there is less cash than the amount indicated on the tape then there is a *cash shortage*. Cash overages and shortages, as a rule of thumb, should not exceed .1 to .3% of total Gross Cash Revenues.

Catering

To provide prearranged food and/or beverage services to the specific needs of any group or organization including your own institution.

Celebrity Chef or Restaurateur

A well-known, highly recognizable chef or restaurant operator that has name (and restaurant) recognition locally, regionally, nationally and/or internationally.

Central Kitchen

A single production area, on-site or off-site, where foods are prepared and transported to one or more service areas. Also known as a central *commissary*.

Check Average

Total restaurant revenue divided by the total number of daily customers for separate day-parts (breakfast or pre-lunch period, lunch period, afternoon period and/or dinner period).

Children's Menu

Menus designed to appeal to children and featuring simple, nutritious food served in small portions. Children's menus will typically be available to young guests up to a certain pre-defined age. Some may contain an entrée, snack, fruit, dessert and beverage at a fixed price.

Client/Owner

The owner of the cultural institution, school, college, public attraction, office building or other location where the foodservice operation(s) is located.

Client Liaison

The client or owner representative that has the

administrative responsibility for the foodservice operations at their location. This is the person that interacts with the foodservice operator (if outsourced) and is the one to represent the owner's employees, staff and visitors in dealing with the foodservice operator. This person may also have contractual oversight responsibility for negotiating and amending the contract between the institution and foodservice operator.

Coffee Cart
Portable or semi-stationary serving cart offering coffee, espresso and related coffee beverages with the possible addition of cold bottled beverages, pre-packaged sandwiches, salads, bakery and other snacks.

Collective Bargaining
The process that establishes conditions and wages acceptable to both union members and management. The hourly foodservice employees at some cultural institutions are covered under a collective bargaining agreement.

Commencement Date
The date a contract starts. May not be the same day

that the agreement was signed.

Commercial Foodservice
Operations such as restaurants of all kinds which compete for customers in the open market. A restaurant at a museum that had direct street access (can be accessed without going into the museum or without admission) could be considered a commercial foodservice under this definition.

Commission Guarantee
Where the operator provides the client/owner an annual minimum dollar guarantee and is obligated to pay the greater of the commission percentage of sales or the annual minimum guarantee. The annual guaranteed dollar amount should be set at least at about 80% or higher of the actual commission dollars paid each year to be meaningful. If a minimum guarantee is established it is normally also based on a reciprocal minimum annual attendance guarantee by the client/owner. And if the annual attendance is lower than the attendance guarantee, the annual dollar guarantee is reduced by X amount of cents per visitor.

Commissions

The percentage of gross operating revenue paid to the client or owner for the right to provide foodservice in and at their venue by the foodservice operator.

Commissions: Tiered

Provides for a change in commission terms based on different levels of revenues. Typically, as revenues grow, so do the commissions as defined by agreed upon tiers.

Comp

Food/beverages provided by the operator at no cost to guests/customers for public relations purposes. Most common in commercial, retail public restaurants. Not used frequently or extensively in on-site foodservice.

Concept

Elements in a foodservice operation that contribute to its function as a complete and organized system serving the guests' needs and expectations. This includes menu, décor, merchandising, signing, staff uniforms, etc.

Concessions

A term usually used to define foodservice operations

typically found in zoos, theme parks and outdoor attractions. Usually defines a more casual, walk-up style of foodservice operation as also found in performing art centers such as *intermission concession services* (i.e. bars).

Contract

Used interchangeably with the word *agreement* in the on-site foodservice industry.

Contract Foodservice Operator

A foodservice company that specializes in operating restaurants (and catering and related food and beverage services) in cultural institutions, public attractions, corporate office (corporate dining), college, school or university, convention center, stadium, hospital or similar facilities where the owner of the facility outsources this service. The operator may exclusively operate only these types of foodservice facilities, or may be a commercial restaurant operator, hotel or off-premise catering company that also is a contract foodservice operator.

Contract Types

When outsourcing, most cultural institutions will contract either under a Profit & Loss or Management

Fee type of Agreement. See the end of this Glossary for a detailed explanation of these two contracts.

Controllable Expenses
The total of all payroll costs, direct operating, advertising/promotion, utilities, administrative and general, repair and maintenance and similar expenses that are under the control of the foodservice operator.

Cost Of Sales
The dollar total of all food and beverages actually used in a particular month or accounting period based on taking the beginning inventory, adding purchases.

Cover
A customer in a dining facility. Cover counts are synonymous with customer counts.

C-Stores
Cash-and-carry convenience stores that vend a variety of food, beverages, sundries and groceries.

Cuisine
Food cooked and served in a variety of styles from around the world.

Custom Catering

When not ordering from a pre-set menu of items and the customer works with the caterer (chef) to develop a menu (food and beverages) for the event that is specific for that customer.

Customer

The visitor, staff person, guest or other that patronizes the restaurant, cart and/or catering services.

Customer Counts

The number of cash register (point-of-sale) transactions. Note that the number of cash register transactions does not provide the exact number of *customers*, but the number of transactions divided into the total revenue is what is usually used to determine the Check Average (or average check). It is more accurate and preferred if point-of-sale equipment can track the actual number of customers served.

Day-Part

A portion of the day when the restaurant serves breakfast, lunch and/or dinner as well as the time-periods between breakfast and lunch and lunch and dinner.

Demographics
Statistical study of the characteristics of the cultural institution's visitor and/or staff characteristics.

Direct Operating Expenses
Those expenses directly attributable to food preparation and customer service such as uniforms, laundry, linen rentals, linen replacement, china, glassware, flatware and similar costs.

Discounted Sales
The revenues defined by the contract and that are discounted by a definedpercentage off retail pricing for certain groups (staff, volunteers, members). Typically these sales are identified separately and tracked as they may not be subject to commission payments.

Discounts
Commonly, the employees (staff) of the cultural institution and volunteers receive a discount of at least 10% (but as much as 30%) off the posted restaurant menu prices. Occasionally members receive 10% discounts. Discount sales should be tracked by the institution in order to determine the true cost to the institution. Discounts are also

commonly provided by the operator to the client/ owner for what is called internal catering (ordered and paid for by client/owner). These discounts can range from 10% to 30% depending on overall size (sales) of foodservice operations.

Earned Income
The revenues generated by institutions from the various business operations within the institution. Typically includes admission fees, gift shop, café, concessions, catering, facility rentals, rides and attractions ticket sales. This is in contrast to income generated for the institution from fund-raising, donations, grants, etc.

Electronic Cash Register
Records the menu items sold at their individual selling price as well as other management information such as customer counts and server identification (if table service is provided). Same as point-of-sale (POS) system.

Employee Meals
These are meals that are consumed by the foodservice staff. Depending on local, state and federal tax rules and regulations in effect at the time, these meals (the

value of the meals) may have a taxable consequence to the foodservice worker. Employee meals are not necessarily the same menu items offered by the restaurant.

Ethnic Foods

Food normally associated with certain nationalities or religious groups. These foods may be prepared by an outside caterer and brought into an institution for service by the in-house caterer if such catering is not able to provide these services for any reason.

Exclusive Rights Agreements

Cultural institutions may have exclusive pouring rights agreements with a soft drink manufacturer (or other vendor or manufacturer of a food or beverage product) whereby the cultural institution must exclusively use this manufacturer's branded products at specific contractual prices. These agreements provide marketing funds as well as cooperative advertising and promotion for the manufacturer and the institution.

Exclusive/non-exclusive catering

Exclusive catering restricts all catering at the specific location to be provided by one caterer. Non-exclusive

catering will allow two or more caterers to be used for any catering needs.

Exhibition Cooking
Food that is cooked in full view of the guest at a catered event or in a café.

External Catering
Catering services provided to groups and organizations (for profit and not-for-profit corporations) and others that may or may not be related or associated with the cultural institution but are not part of the cultural institution.

Facility Rental
The rental of venues (lobby, galleries, dedicated event spaces, meeting rooms, etc.) within the institution. Often includes catering services.

Facility Rental Fee
A rental fee charged to groups and organizations that rent venues to have private events at cultural institutions.

FF&E
Furniture, fixtures, and equipment including all of

the furniture, fixtures (improvements to the space such as draperies, wall treatments, light fixtures) and equipment within foodservice areas.

Financial Evaluation

The review (like an audit) and evaluation of financial controls, reporting and accuracy of historical reports.

Fiscal Year

Can be any 12 months such as July 1 through June 30; can also be 12 accounting periods (13 four week periods or quarterly periods each of which have four, four and five weeks). Restaurant and foodservice operators most commonly work on an accounting period basis, while cultural institutions commonly work on calendar months. Most foodservice operators can provide separate client reporting based on the client's accounting basis.

Food Cost

The ratio of dollars of food purchased to revenue, expressed as a percentage. Unless certain paper products are directly related to the service of food (such as disposable plates, carton, etc.), they should not be included in food cost.

Foodcourt

Similar to a cafeteria foodservice operation. Looks more like a foodcourt in a mall where there are food and beverage stations and each station has its own identity with a national brand or a brand that might be developed and proprietary to the foodservice operator (or owner).

Foodservice Contractor

A foodservice company that specializes in operating restaurants (and catering and related food and beverage services) in cultural institutions, public attractions, corporate office (corporate dining), college, school or university, convention center, stadium, hospital or similar facility where the owner of the facility outsources this service.

Foodservice Facility Designer

A foodservice consultant that provides the design and layout for the restaurant/café kitchen, serving area including details on all proposed equipment based on industry best practices.

Foodservice Operator

An independent foodservice contractor that operates the institution's restaurant, café, cart(s), catering and

possibly vending machines. This operator collects all receipts (cash and charge sales from the restaurant, catering and other services), pays all direct costs and expenses (food, beverages, staff, staff benefit costs, operating supplies, insurance, etc.). The foodservice operator may be a national or regional foodservice contractor or local restaurant, caterer or hotel.

Franchise Agreements

Contracts in which the franchisor grants the franchisee the right to use the franchisor's name and method of doing business. This is commonly done with branded concepts. Franchise and licensing agreements are very similar.

Franchisee

This is the foodservice operator that signs an agreement with the franchisor to use their branded concept.

Franchise Fee

The fee (usually defined as a percentage of revenues) paid to a Franchisor (or Licensor) for the use of their concept, supplies, trade dress and systems. Usually related to branded concepts (i.e. *Pizza Hut*, *Subway*, *Burger King*, *Starbucks*, *Panda Express* and the like).

Franchisor
Owner of the brand (branded concept).

Free Pouring
Dispensing of liquor where the bartender manually (without any automatic alcoholic beverage dispensing equipment) pours and estimates the amount of liquor needed for a drink.

Front Of The House
Comprises all areas the guests contact, including the dining room, serving area (in the case of a foodcourt or cafeteria style service), corridors, elevators, restaurants and bars, meeting rooms and restrooms.

G&A
The same as administrative and general expenses defined above.

General Insurance
All types of insurance not related to employee benefits or extended coverage on the premises or contents including, but not necessarily limited to security, fraud/forgery, fidelity bonds, public liability, food poisoning, use and occupancy, lost or damaged articles, and partner's or officer's life insurance.

Gratuity
This is the amount paid to foodservice employees by customers, either directly, in cash or added to a charge sale ticket or charged by a catering company to their client/customer. If charged by a catering company the gratuity is then dispersed to the caterer's employees. This gratuity may be allocated to servers, chefs, bartenders and others. A gratuity should not be confused with a *service charge* which may or may not be paid to the foodservice workers at the employer's discretion in most cases.

Gross Operating Revenue
Total payments received from customers (restaurants, carts and catering) for goods and services.

Gross Profit
Gross operating revenues minus cost of goods sold.

Gross Sales (Sales)
All revenue less (net of) applicable sales tax.

Health Department
Local city, county and/or state agency that inspects all licensed restaurants and foodservice operations, normally once annually and provides written report

to operator and sometimes letter grading (i.e. A, B, C, etc.) based on the results of the inspection.

Hospitality Industry
Wide range of businesses, each of which is dedicated to the service of people away from home; businesses that emphasize personnel's responsibility to be hospitable, hosts and managers of services offered.

Impulse Sales
The consumer behavior of buying a product not originally sought out. Usually these items are strategically placed at the point-of-sale and are add-on sales or related products (potato chips at a deli, cookies at the cash register, etc.).

Incentive-Fee
Arrangement requiring that the foodservice operator take risk, usually in the form of placing a percentage of their fee(s) at risk based on the fiscal performance of the foodservice operations. Applies to management fee contracts.

Incumbent Operator
The individual or company (contract foodservice provider) currently providing food or vending services to the client.

Indirect Subsidy

These are costs generally associated with the occupancy of a facility (such as rent, building/equipment maintenance, security, utilities, insurance and property taxes) and management/administrative overhead charges (such as those for human resources, purchasing and contract administration support).

Internal Catering

Catering services ordered, paid for and used by the cultural institution (owner/client) for its own meetings, member, new/opening exhibitions, development and other purposes.

Kiosk

A usually stationary and permanent (but sometimes removable) small stand with limited interior food preparation and assembly that has one or more windows (pass-out areas) for the purpose of selling coffee, espresso and related coffee beverages with the possible addition of cold bottled beverages, and bakery and other snacks. Cooking is possible in a kiosk and generally local health departments place similar requirements on a kiosk as are placed on a permanent restaurant or café.

K-Minus

Foodservice industry term for a foodservice facility, which has no kitchen. Usually food is brought in from a central kitchen.

Labor Intensive

Usually relates to a large foodservice facility that, due to its layout and/or possible size in relationship to the number of customers it serves, requires extra foodservice staff to operate, clean and service the facility over and above what would be considered standard or normal. This term can also be applied to a complex menu item that requires several steps, or processes, to prepare.

Lease

This term usually applies to commercial restaurants that lease space from a landlord for a long fixed term with a capital investment by the foodservice operator. Leases are distinctly different from foodservice agreements and contracts commonly used in most cultural institutions.

Licensee

This is the foodservice operator that signs an agreement with the franchisor to use their branded concept.

Licensing Agreements
Contracts in which the franchisor grants the franchisee right to use the franchisor's name and method of doing business. This is commonly done with branded concepts. Franchise and licensing agreements are very similar.

Licensor
Owner of the brand (branded concept).

Loose Equipment
Defined as pots, pans, kitchen utensils, tableware (plates, glasses, flatware) and any other small, portable or loose equipment not defined as FF&E. Loose Equipment is also sometimes referred to as *expendables*.

Maitre d´
Usually the dining room manager who oversees the entire operation of the dining room. Applies to restaurants and catering events.

Management Fee
This is the fee that a contractor receives for managing an account. This management fee is usually in addition to the G&A fee and would be considered the

foodservice operator's profit.

Management Fee Contract
Where a foodservice operator operates the institution's restaurant (which may include catering, carts, and vending machines) for a guaranteed fee (profit/income). Under this type of contract profits, if any, from all food and beverage services operated by operator are usually shared by the operator and the institution. The institution is normally responsible for any operating loss (also called subsidy). The operator will usually guarantee a mutually agreed upon annual operating budget for the food and beverage services up to a percentage of their guaranteed fee. See also *Management Fee vs. Profit & Loss Contract* at the end of this section.

Marketing
Includes all selling and promotion costs, direct mail, donations, souvenirs, advertising, public relations and publicity, franchise fees and royalties or commissions, and market research (surveys) covering the restaurant and/or catering and special event activities at the cultural institution. This expense is usually shared by the foodservice operator (if outsourced) and the institution.

Meeting Planner

Also called *Event Planner*, this is the person who coordinates every detail of meetings and conventions. Meeting planners can be independent contractors or part of a large corporation that has an in-house meeting planning department.

Menu Cycle

Repeating an established menu in a predetermined rotation. Generally, this is done every four or five weeks but can be done seasonally as well.

Menu Mix

This is a listing of all the menu items served in the restaurant with a count of how many of each item is sold during a given meal day-part. This is important to know what is selling and what is not for menu planning purposes. The menu mix is also used to establish an "ideal, theoretical or potential" cost of sales when using standardized recipes and cost cards.

Minimum Guarantee

Where a foodservice operator or approved caterer guarantees the institution a minimum annual dollar amount, usually against a percentage of gross operating revenue, whichever is greater.

Net Profit

Gross operating revenues less all controllable and direct expenses, including if applicable any fees paid to the foodservice operator, before income taxes.

Off-Premise Catering

This is the act of preparing food (and beverages) at a central kitchen and transporting the food to the site where it will be served. Some caterers will transport food fully cooked and ready to serve while others will pre-prepare the food and do finish cooking at the catering event site.

Office Coffee Service

Coffee, and other hot beverages offered to employees outside the café, or cafeteria facility, such as pantries, or break rooms, located on individual floors or on a single floor of offices.

On-Site Foodservice

Foodservice operations principally located in particular societal institutions, such as cultural institutions, hospitals, colleges, schools, corporate offices, penal institutions, nursing homes, the military, and industry; formerly known as institutional foodservice.

Outsourcing

Where the owner of a cultural institution, public attraction, corporate office (corporate dining), college, school or university, convention center, stadium, hospital or similar facility contracts with a foodservice operator to operate their foodservices.

Participation

The percentage of daily/annual visitors that use the foodservice operations. Calculated using the customer counts recorded in the foodservice operations divided by the attendance.

Payroll Tax and Benefits

Payroll taxes (FICA, FUTA, state unemployment, and state health insurance, social insurance, (i.e., worker's compensation insurance, welfare or pension plan payments) accident and health insurance premiums, and the cost of employee instruction and education, parties, and meals.

Per Capita Revenue

Total restaurant (including café, restaurants and carts; any location where visitors purchase food and/or beverage) revenue divided by the total annual attendance at the cultural institution.

Point-Of-Sale (POS)
Computerized (cash register) system that allows restaurants and bars to pre-set menu prices and menu items and has the capability to provide management various operational reports for a given period of time. Also referred to as the point where food and beverages are transferred to a visitor.

Pre-Opening Expenses
Expenses incurred before the foodservice operation opens including but not limited to travel, office, printing, advertising/promotion, training, lodging, meals and payroll for the pre-opening team.

Price-Value Relationship
The customer's perceived value as it relates to the cost of the product versus the value received.

Private Catering
Same as *External Catering* above. Normally for outside groups and organizations that stage events at cultural institutions.

Profit
Profit is defined to a foodservice operator as total contribution from the foodservice operations. This

is a combination of its administrative and general expense and management fee (if a management fee contract) or profit. A foodservice operator's profit expectation as a percentage of gross operating revenue is a minimum of five to ten percent. Lower percentage is applicable to foodservice operations with higher gross operating revenue.

Profit-Sharing Contract

An agreement where the foodservice operator and the institution share in bottom line profits.

Profit and Loss Contract

A contractual arrangement whereby the contractor is responsible for the financial operation of the foodservice. The risk is placed upon the contractor to make money in the operation without a subsidy from the organization. Where a foodservice operator operates the institution's restaurant (which may include catering, carts, and vending machines) on a profit and loss basis. Under this type of contract the operator usually pays the institution a percentage of its total revenue ranging from about 5% to 15%. See also *Management Fee vs. Profit & Loss Contract* at the end of this section.

Proposal
A bid submitted by a contract foodservice provider that includes a complete description of the services to be provided and the fees that will be charged for such services (Management Fee Contract) or commissions that will be paid (Profit & Loss Contract).

Purchasing Specifications
Standards established by the restaurant (and catering) department for the food, beverages and supplies purchased to insure consistent quality; also called *specs*.

Quick Service
Most commonly used in the retail restaurant world, i.e., Quick Service Restaurant (QSR). It is a style of service where the customer walks up to a restaurant or foodservice counter, orders their food/beverage, pays and is given their meal very quickly.

Replacements
Replacement of all linen, china, glassware, flatware, and kitchen utensils.

RFI (Request for Information)
Oftentimes the first step a cultural institution will

do when starting a formal Request For Proposal. A RFI will ask for operator information, background, qualifications but not a specific proposal for the purposes of pre-qualifying them to participate (or not) in the entire RFP process.

RFP (Request for Proposal)

When an institution is outsourcing or considering outsourcing, a request for proposal document is prepared which provides prospective operators with background and current information about the business opportunity as well as a detailed and organized method to respond to the RFP. This is important to insure proposals received are as comparable as possible.

RFQ (Request for Qualifications)

A request for qualifications asks companies to submit their qualifications to perform a described level of foodservice. RFQs are only required if you have no other way to pre-qualify prospective foodservice operators.

Restaurant

Café (small, limited menu) or large, full-service menu offering sit-down, table (waited) service and/

or buffet, cafeteria and/or self-service.

Revenue: Net
Gross food and beverage revenue (sales) net of sales tax.

Revenues: Restaurant (including Snack Bar and Coffee Cart)
Includes Food and Beverage (alcoholic) sales/revenues usually accounted for separately.

Revenues: Special Events
Includes Food and Beverage (alcoholic) sales/revenues as well as other products and services that are sold to customers (users) of special events. This includes but is not limited to: Flowers, Décor, Entertainment, Valet Parking, and Service Staff.

Royalty
Similar to franchise or licensing fee. An amount normally based on a percentage of gross sales that is paid to the franchisor or licensor for the right to serve their product(s) and use their name, trade dress and the like. Also applicable when restaurant/foodservice operators partner with, for example, a celebrity chef and the terms of that relationship require a monthly

fee for services.

Salaries and Wages
Includes the salaries and wages, extra wages, overtime, vacation pay, and any commission or bonuses paid to employees.

Sales Mix
An item-by-item and/or sales group (such as entrees, beverages, dessert, etc.) list showing the number and/or dollar amount of menu items or group(s) of menu items sold for a specified period of time.

Self-Operation
Where the owner of a cultural institution, public attraction, corporate office (corporate dining), college, school or university, convention center, stadium, hospital or similar facility operate the restaurant, café, cart(s) and/or food and beverage catering services with their own employees and management. The owner also handles all cash (and accounts receivable) and pays all bills and costs associated with these services.

Servery
In a cafeteria or foodcourt, the area where the food is

actually served and picked-up by the customer.

Service Charge
It is also the add-on charge, usually as a percentage of the food and beverage subtotal provided on a catering billing. This charge is intended to cover the caterer's overhead expenses and is retained by the caterer. This should not be confused with a *gratuity*, which is normally required (by law) to be fully paid and distributed to the caterer's staff unless the caterer indicates this to the customer and designates that all or a portion of the Service Charge is paid to catering staff. Not a gratuity or tip paid to catering staff.

Smallwares
All those items necessary to support the preparation and service of food with a per piece value of under a predetermined fixed amount. Smallwares include such items as pots, pans, serving utensils, china, glassware, serving platters/bowls, carving boards, etc. Smallwares, *expendables* and *loose equipment* would be synonymous.

Snack Bar
Walk-up, quick-service, hand-out, permanent location that offers mostly pre-packaged, or quick to

prepare, food and beverages.

Special Events

Any food and/or beverage related event at the cultural institutions regardless of whether it is an internal or external event.

Special Event Department

A department within the cultural institution that is usually staffed and operated by the institution that handles the master calendar for special events, facility rentals, approved caterers, and all related details as it relates to the implementation and execution of special events at the institution. This department oftentimes also has the responsibility for advertising and marketing the institution for external special events. Occasionally this department is outsourced. Some cultural institutions outsource all or part of the management of this department to foodservice operators that are also providing the in-house restaurant and catering services when catering services are provided on an exclusive basis.

Subcontractor

The use of another vendor, subject to client/owner prior approval, to provide services that the primary

RESTAURANTS, CATERING AND FACILITY RENTALS

operator was contracted to provide. This may be specialized caterers, cart operators, vending machine operators and other vendors.

Subsidy: Direct
To provide dollar support to pay foodservice direct and indirect operating expenses over and above the dollars (gross operating revenues) received from sales.

Subsidy: Indirect
Oftentimes the cost of utilities (gas, electricity, fuel, water and sewage), trash disposal (dumpsters), security, janitorial, telephone, repairs and maintenance to building and FF&E, bookkeeping and accounting and other similar expenses are absorbed by the institution and not charged directly to the foodservice operations. These in-direct costs and expenses are, in fact, costs and expenses associated with the operation of the foodservices and should be tracked and/or considered, especially by institutions that are planning new or expanded foodservices.

Sustainable Practices/Sustainability
Includes but is not limited to sourcing food, beverages, supplies and services locally (normally within 150 miles of the foodservice operation).

Using sustainable materials in the build-out of the restaurant/café and for disposable ware if used, in the café, restaurant and catering services. Recycling and composting among other "green" activities as mutually agreed between the client/owner and the foodservice operator.

Tax Exempt Revenue Bond (TERB) Funding

Many US cultural institutions fund all or part of an expansion or building project with tax exempt funds. When the portion of the building(s) built/ developed with TERB funds include restaurant, café and/or catering services, the US Internal Revenue Services (IRS) requires a management fee type of Agreement (contract) with the food service operator. Client/owners that use TERB funding to build-out/ develop restaurants, cafés and/or catering/event facilities (and gift shop) should consult with the legal (bond) counsel to learn the ramifications as it relates to outsourcing the operation of the foodservices, catering and/or gift shop.

Utilities

Gas, electricity, fuel, water, removal of waste, and sometimes telephone.

Vendor
Supplier of food, beverages, equipment and non-consumable supplies. Also called *supplier*.

Virtual Meal
A typical meal that might be ordered from a menu. This is often used to compare the cost of a meal at one institution to a similar style meal at another institution for benchmarking purposes.

Visitor Demand
The percentage of total annual visitors that are expected to use the foodservice operations. See *Participation*.

Management Fee vs. Profit & Loss Contract

Applicable to both Contracts
The following terms and conditions may vary slightly in each of the contract types based on individual negotiations between the parties:

- Independent contractor relationship.
- All foodservice employees are employees of the foodservice operator.
- All revenues (sales) and expenses are collected and banked by operator and paid by operator.
- Term and termination.
- Insurance requirements.
- Operator operational responsibilities.
- Owner operational responsibilities.
- Operator capital investment requirements (what FF&E is provided by operator).
- Owner capital investment requirements (what FF&E is provided by owner).
- Owner has right of approval of on-site foodservice manager.
- Operator secures all required business licenses and permits in name of operator (depending on state laws and the desires of the parties, the Alcoholic Beverage License can be in the owner name)

- Operator will remove any foodservice employee not acceptable to owner.

Key Contract Terms & Conditions Differences

Profit & Loss Contract:

- Operator pays owner a commission (rent) based on a percentage of gross revenue, sometimes with a minimum dollar amount by department (restaurant, catering, vending machines, etc.) based on a sliding scale (the higher the gross revenues the higher the percentage commission).
- Owner has no financial risk or administrative responsibility for foodservice operations.
- Operator establishes food and beverage selling prices; annual adjustment permitted under the contract subject to owner prior review and approval (such approval not unreasonably withheld).
- Owner's audit responsibility is limited to sales (revenues) in order to verify gross receipts reported and commission received.

Management Fee Contract:

- Operator receives a guaranteed fee for its services based on a percentage of gross

revenue, usually about 5%. Operator also receives profit sharing based on a mutually agreed percentage split (usually 75% to owner and 25% to operator; sometimes the split is after the owner receives a certain percentage of net profit, usually 5%-10%).

- Operator maintains a separate bank account covering owner's foodservice operations. All income from the owner's foodservice operations is deposited in this account and all bills/invoices, payroll, taxes, insurance, etc. applicable to the owner are paid from this account.

- Owner has primary financial risk (and upside); operator is guaranteed a profit (fee).

- A portion (usually 10%) of operator's fee is put at risk based on a "guaranteed annual budget" provided by operator based on owner's projected annual attendance.

- Operator "recommends" food and beverage selling prices; annual adjustment permitted under the contract subject to owner prior review and approval.

- Owner's audit responsibility includes complete P&L (all income and expense items), recommended to be done on an annual basis.

About the Authors

Arthur M. Manask, FCSI is founder and CEO of Manask & Associates, a leading earned income consulting firm since 1993 that provides management advisory services to cultural and other institutions that have in-house restaurants, facility rentals, catering services and gift shops. Clients in the cultural sphere include museums, botanical gardens, historic homes, aquariums and zoos. Other hospitality industry clients include business corporations, colleges, casinos, restaurants, clubs, hotels and schools.

Art has personally worked with distinguished cultural institutions including the National Gallery of Art, the Minneapolis Institute of the Arts, Friends of the National Zoo, the National Aquarium, Monterey Bay Aquarium, The Field Museum, Chicago Botanic Garden, Ravinia Festival, Phipps Conservatory and Botanic Gardens and Los Angeles County Museum of Art among many others for many, many years.

He has more than 30 years' experience in the foodservice industry. His experience includes sixteen years as President and owner of his own foodservice management and off-premise catering companies, fourteen years experience in senior operating positions with two international

foodservice organizations, and twenty years heading Manask & Associates. His multi-unit operating experience includes corporate dining; school and college dining; leisure and recreational foodservices; museum restaurants and cafés (including opening and operating cafés and catering services at the Getty Museum in Malibu, CA and the Los Angeles County Museum of Art when the museums originally opened); on-premise, off-premise and special event catering; commercial restaurants; and tablecloth dining.

Art is a past chairman and member of the Board of Directors of the California Restaurant Association. He is also a former member of Young President's Organization and current member of World President's Organization. Manask & Associates' professional affiliations include American Association of Museums, American Society of Technological Center, Society for Food Service Management, Foodservice Consultants Society International and the American Zoo and Aquarium Association among other national, regional and state cultural institution trade associations.

Robert D. Schwartz is a principal of Manask & Associates, since 2003 and works with cultural

institutions throughout North America. Rob has over 30 years experience in the hospitality business that covers contract management with ARAMARK and Sodexo as well as private restaurants. He received his MBA from the Broad Graduate School of Management at Michigan State University and majored in Hospitality Management. He received his BA from Alma College (Alma, MI) with a Business Administration major.

Rob's experience covers operational and financial management for foodservice in businesses, hospitals, colleges, and cultural institutions. Some of his client projects include, but are not limited to: Zoo Atlanta, Calgary Zoo, Indianapolis Museum of Art, Peoria Riverfront Museum, Cincinnati Museum Center, Amgen, Inc., RAND Corporation, National Aquarium – Baltimore, Canadian Museum for Human Rights – Winnipeg, Paramount Pictures Studios, and Children's Museum of the Upstate. His international experience includes three years in Mexico focused on the Maquiladora industry on the border as well as project consulting and analysis in Argentina. Rob is fluent in Spanish.

About the Contributors

Don Avalier FCSI, FMP is a Principal of Manask & Associates, a consulting firm that provides management advisory services to cultural institutions and the hospitality industry.
www.manask.com

David Greenbaum FAIA, LEED AP bd+c is Vice President of SmithGroupJJR, a company that provides architectural design, engineering and master-planning services to museums, collections care facilities, performing arts, and visitor attractions.
www.smithgroupjjr.com

Stephen Hosa and **Shirley Hosa** are co-principals of Hosa Design Associates, providing new and creative design solutions for restaurants, hotels, private clubs, and cultural institutions. Stephen focuses on planning and design, and Shirley on interior design.
www.hosadesign.com

Mistie Lonardo is President of EyeSpy, a company that provides evaluations, analysis tools, and consulting services to the hospitality industry.
www.theeyespy.com

Kelley McCall is a Museum Facility Rental and Event Director.

Rudy Miick MA, FCSI, CMC is President of Miick & Associates. His consulting is focused on opening/start-up, performance improvement and growth in the foodservice/hospitality, resort and manufacturing industries.
www.miick.com
www.miickinstitute.com

About Manask & Associates

Founded in 1993 by Arthur M. Manask, Manask & Associates are the leading earned income consultants to cultural institutions, including museums, zoos, aquariums, botanical gardens, historic homes, corporations, colleges, schools and the hospitality industry. This consulting team has foodservice and gift shop principals located coast-to-coast to conveniently service client engagements in the United States and Canada.

Art's professional background includes many years in the restaurant, foodservice, hospitality and catering industry as an owner/operator. He has been actively involved in industry organizations including as past chairman of the California Restaurant Association, and currently Manask & Associates is very active with the American Association of Museums and other cultural institution trade associations.

Manask & Associates focuses on improving the financial and operational performance of their clients' restaurant, foodservices, facility rentals, and/or gift shop services, while enhancing customer perception and visitor experience.

Consulting services offered by Manask & Associates (and The Manask & Associates Hospitality Group) include:

- evaluation and needs assessment;
- self-operation versus outsourcing;
- contract negotiations and compliance;
- financial evaluations;
- expansion/renovation programming and planning;
- facility rentals, special events and catering services;
- benchmarking with other cultural institutions;
- market research and customer surveys;
- food safety and sanitation compliance;
- sustainable practices;
- financial/contractual evaluation;
- gift shop layout and programming;
- gift shop customer service and sales training;
- recruitment consultation and support;
- and gift shop consultation on e-sales and off-site stores.

Over the years Manask & Associates has acquired an extensive list of exceptional clients including:

- National Gallery of Art
- The Field Museum
- National Zoo (Friends of the National Zoo)
- Science Museum of Minnesota
- The Minneapolis Institute of Arts
- Phipps Conservatory & Botanical Gardens
- National Aquarium Baltimore
- Chicago Botanic Gardens
- Saint Louis Art Museum
- Great Lakes Science Center
- Children's Museum of Houston
- Ravinia Festival
- Arena Stage – The Mead Center for American Theater
- National Trust for Historic Preservation (Lyndhurst)

To view the complete client list please go to:
www.manask.com/clients

Manask & Associates

W: www.manask.com

T: (International code) (800) 686-8813

E: ArtManask@Manask.com

Index

Also from MuseumsEtc

Museums at Play:
Games, Interaction and Learning

Editor: Katy Beale

ISBN: 978-1-907697-13-5 [paperback]
ISBN: 978-1-907697-14-2 [hardback]

Order online from
www.museumsetc.com

Museums are using games in many ways – for interpretation, education, marketing, outreach and events. *Museums at Play* showcases tried and tested examples from the sector and seeks to inspire further informed use of games. It also draws on relevant experience from other sectors, and on the experience of game designers and theorists. It looks at learnings from other disciplines and explores the possibilities of interaction using gaming within museums. Some 50 contributors include specialists from world-class institutions including: British Museum, Carnegie Museum of Natural History, Children's Discovery Museum of San Jose, Conner Prairie Interactive History Park, Museum of London, New Art Gallery Walsall, Science Museum, SciTech, Smithsonian Institution, Tate, and Walker Art Center.

Social Design in Museums: The Psychology of Visitor Studies (Two Volumes)

Author: Stephen Bitgood

ISBN: 978-1-907697-19-7
and 978-1-907697-32-6 [paperback]
ISBN: 978-1-907697-20-3
and 978-1-907697-33-3 [hardback]

Order online from
www.museumsetc.com

In some 900 pages, this important work distils the exceptional insights and advice of one of the world's leading thinkers in the field of visitor studies, Stephen Bitgood, a pioneer in the field of social design. Spanning both theory and practice, Social Design in Museums is guaranteed to have you thinking afresh about the fundamentals of your organisation's interface with the public. Its contents are crucial to an understanding of the learning process within museums - and an essential step towards enhancing your institution's effectiveness

"If museums are going to take seriously their role as (informal) educational institutions, they will have to pay much more attention to the kinds of work represented by this valuable collection." *Harris Shettel, Museum Evaluation Consultant, Rockville, Maryland, USA.*

Interpretive Master Planning (Two Volumes)

Author: John A Veverka

ISBN: 978-1-907697-23-4
and 978-1-907697-25-8 [paperback]
ISBN: 978-1-907697-24-1
and 978-1-907697-26-5 [hardback]

Order online from
www.museumsetc.com

Author John A Veverka is one of the world's leading consultants in interpretive planning, training and heritage tourism, with experience spanning over 30 years and taking him all over the world. *Interpretive Master Planning* presents - in two comprehensive volumes - a wealth of information on how to plan and design interpretive facilities and services. The lively text uses anecdotes, case histories and interactive examples to illustrate all aspects of interpretive planning. This is the most comprehensive reference book on the subject, an invaluable resource for designing interpretation that really works.

"Here is knowledge based on years of national and international interpretive planning projects... a classic work by an author who does interpretive planning every day." *Gary R Moore, MetroParks, Columbus and Franklin County, Ohio, USA.*

Creativity and Technology:
Social Media, Mobiles and Museums

Editors: James E Katz, Wayne LaBar
and Ellen Lynch

ISBN: 978-1-907697-11-1
[paperback]
ISBN: 978-1-907697-12-8
[hardback]

Order online from
www.museumsetc.com

This book brings together papers given at a major conference organised by the Center for Mobile Communication Studies at Rutgers University and Liberty Science Center Presented by leading thinkers and museum experts, the papers provide an incisive, up-to-the-minute analysis of trends in the use of mobile devices by museum audiences, with a special focus on outreach efforts to under-served communities.

"This important collection of essays delves into a complex and exciting world, and makes a key contribution to this developing field." *Dr. Lynda Kelly, Head of Web and Audience Research, Australian Museum, Sydney.*

"This book shares perspectives and findings that will help practitioners navigate this new learning terrain." *Marsha Semmel, Institute of Museum and Library Services, Washington DC.*

The MuseumsEtc Collection

Books

Alive To Change: Successful Museum Retailing
Contemporary Collecting: Theory and Practice
Creating Bonds: Successful Museum Marketing
Creativity and Technology: Social Media, Mobiles and Museums
Inspiring Action: Museums and Social Change
Interpretive Master Planning: Philosophy, Theory and Practice
Interpretive Master Planning: Strategies for the New Millennium
Museum Retailing: A Handbook of Strategies for Success
Museums and the Disposals Debate
Museums At Play: Games, Interaction and Learning
Narratives of Community: Museums and Ethnicity
New Thinking: Rules for the (R)evolution of Museums
Rethinking Learning: Museums and Young People
Science Exhibitions: Communication and Evaluation
Science Exhibitions: Curation and Design
Social Design in Museums: The Psychology of Visitor Studies
Sustainable Museums: Strategies for the 21st Century
The Interpretive Training Handbook
The New Museum Community: Audiences, Challenges, Benefits
The Power of the Object: Museums and World War II
Twitter for Museums: Strategies and Tactics for Success

Videos

Cocktails and Culture: Cultivating Generation Next
Museums | Inclusion | Engagement
Planning and Designing for Children and Families
Real-World Twitter in Action

Colophon

MuseumsEtc Ltd

Hudson House
8 Albany Street
Edinburgh EH1 3QB
UK

PO Box 425386
Cambridge
MA 02142
USA

www.museumsetc.com

ISBN: 978-1-907697-40-1

This edition first published 2012

Edition © 2012 MuseumsEtc Ltd
Texts © the authors

The paper used in printing this book comes from responsibly managed forests and meets the requirements of the Forest Stewardship Council™ (FSC®) and the Sustainable Forestry Initiative® (SFI®). It is is acid free and lignin free and meets all ANSI standards for archival quality paper.

Typeset in Underware Dolly 10/16 and Adobe Myriad Pro 9/14.

A CIP catalogue record for this book is available from the British Library.

CPSIA information can be obtained at www.ICGtesting.com
Printed in the USA
LVOW10*1813180216

475695LV00014B/84/P